CAÑAR

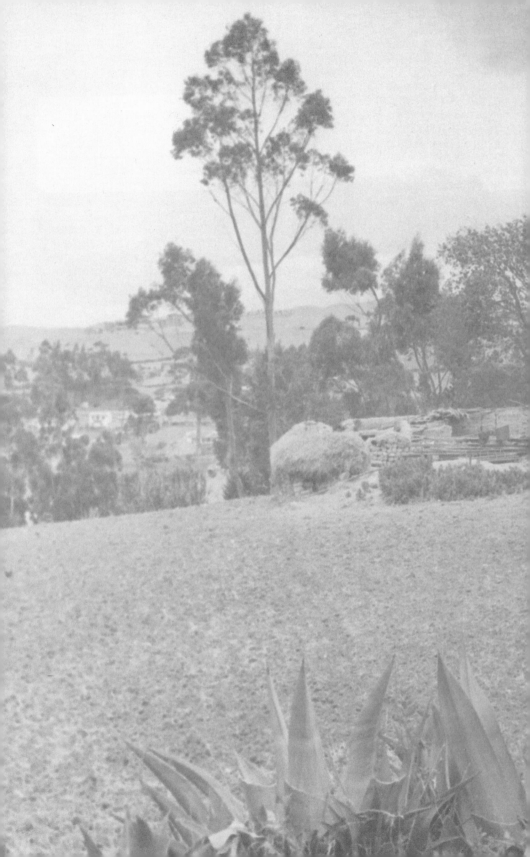

Cañar

A Year in the Highlands of Ecuador

JUDY BLANKENSHIP

UNIVERSITY OF TEXAS PRESS
Austin

Requests for permission to reproduce material from this work
should be sent to Permissions, University of Texas Press,
Box 7819, Austin, TX 78713-7819.

♾ The paper used in this book meets the minimum requirements
of ANSI/NISO Z39.48-1992 (R1997) (Permanence of Paper).

LIBRARY OF CONGRESS CATALOGING-IN-PUBLICATION DATA
Blankenship, Judy, (date)
Cañar : a year in the highlands of Ecuador / Judy Blankenship.
p. cm.
ISBN 0-292-70928-5 (hardcover : alk. paper) —
ISBN 0-292-70639-1 (pbk. : alk. paper)
1. Cañari Indians—Rites and ceremonies. 2. Cañari Indians—
Social life and customs. 3. Cañari Indians—Pictorial works.
4. Cañar (Ecuador : Province)—Social life and customs. I. Title.
F3722.1.C2B53 2004
305.898′09866′23—dc22
2004010930

FRONTISPIECE: CAÑAR LANDSCAPE

For Michael, always at my side,

for Cosmo and Paiwa,

the next generation

and in memory of

Mama Vicenta Quishpilema Pichisaca

Contents

Acknowledgments

Above all, my profound thanks go to those Cañari individuals who have greatly enriched my life, both professionally and personally. José Miguel Acero and Antonio Guamán, my first photography students, welcomed me as a teacher and introduced me to the Cañari culture. Their families graciously, if cautiously, received my partner Michael Jenkins and me into their midst, allowed me to make their portraits, and with time became our good friends. In 1992, after our first year in Ecuador, Isidoro Quinde and María Juana Chuma invited us to work in Cañar as volunteers with their newly formed organization, INTI (National Institute of Indigenous Technology). Without these early friendships, I would never have been given the opportunity to photograph in the indigenous communities around Cañar, much less undertake a decade-long documentation project.

A Fulbright grant for teaching and research allowed us to return to Ecuador in 2000. Awards from several other institutions, including the Organization of American States, the Oregon Arts Commission, and the Thanks Be to Grandmother Winifred Foundation, made it possible to extend our stay to a year. In Quito, thanks go to Susana Cabeza de Vaca, executive director of the Fulbright Commission, who welcomed us so warmly, and to Susana Chiriboga, program coordinator, who took care of so many details to soften our landing.

The Cultural Affairs Program of the United States Embassy in Quito, then directed by Susan Crystal, funded five photography workshops in indigenous communities around Ecuador in 2000–2001. I owe special thanks to Marta Alban, who as cultural affairs assistant was instrumental in laying the groundwork for the workshops and helped at every stage to make

a complex project successful. Contributions of photographic equipment and supplies came from Fuji, Ilford, Polaroid, and Kodak. At Kodak I'm especially grateful to Grace Tillinghast of Community Relations & Contributions for her generosity and enthusiasm for the project.

In Cuenca my institutional partners were the Museo del Banco Central and the Universidad de Azuay. At the museum, where my exhibit "Los Cañaris Hoy" is on view, I owe thanks to Andrés Abad, Jorge Dávila, and Támara Landivar. At the university, Francisco Salgado, vice-rector of academic affairs, has been unfailing in his support of my projects.

Friends and colleagues in Cuenca whom I value greatly include Livia Cajamarca, Alexandra Kennedy, Carlos Rojas, and Stuart White. I am especially grateful to the anthropologist Lynn Hirschkind for her friendship, support, and the intellectual acumen that has served as a compass for my own work. Thanks also to Deborah Truhan, for both professional advice and the comfort of her apartment.

Our year in Cañar was much richer for the presence of our *compadres,* José Miguel Acero and Esthela Maynato, and our little goddaughter, Paiwa. Estudio Inti, the commercial photography studio in Cañar operated by José Miguel and María Esthela, was a constant center of creative activity and inspiration.

For her friendship and collaboration in helping me record traditional songs in Quichua and document other aspects of Cañari culture, I am grateful to Mercedes Guamán Mayencela. José Miguel Chuma, newly graduated as an agronomist but committed to the traditional principles of Andean agriculture, tried to teach Michael how to plow with a yoked team of oxen and became a good friend in the process.

I want to make special mention of Mama Vicenta Quishpilema Pichisaca, the matriarch of the Chuma family and always a willing subject for my cameras. Her prediction that we would not see her again was sadly true; she died in December 2001, a month after we left Ecuador. But I will always think of her as the spirit of this project. Her daughters Mercedes, Mariana, María Juana, and Vicenta have been invaluable collaborators over the years in helping me chronicle their indigenous traditions, especially those on the point of disappearance.

Blue Earth Alliance, a nonprofit foundation in Seattle, Washington, that supports photographic projects on endangered cultures, threatened environments, and social concerns, deserves thanks for all they do, and for their sponsorship of the Cañari project the past four years.

Jim Pepper Henry curated my first U.S. exhibit, "The Cañari of Southern Ecuador," at the Interstate Firehouse Cultural Center in Portland, Oregon,

and he remains a staunch supporter of my work as assistant director of community services at the Smithsonian's National Museum of the American Indian.

The voice of Theresa May, editor-in-chief at University of Texas Press, was the first I heard on my answering machine upon returning from Ecuador, expressing warm support for my book proposal. It has been a pleasure to work with her, Allison Faust, and Mary LaMotte at the Press as the project took form. Thanks to Sherry Stein for creating the maps, and Heather Watkins for coming up with a beautiful cover proposal.

To the many readers of my letters home who believed there was a book in them — foremost among them my mother, Adelene Blankenship (the original letter writer), my sisters Char de Vazquez and Sherry Stein and my son Scott Maddux and his wonderful Susanne — I offer loving thanks.

For reading the manuscript at various stages and making valuable suggestions I am indebted to several good friends: Nancy Henry, Jerry Krepakevich, Joel Weinstein, and Andrew Wilson. Thanks also to Cheryl Hartup, associate curator at the Miami Art Museum, for always championing my photography work.

Finally, it is to Michael that I owe the greatest debt of gratitude. Without his willingness to pick up and move to Ecuador for a year and his unwavering good humor and encouragement of my work while creating his own projects once there, I would never have pursued such an adventure. May we have many more.

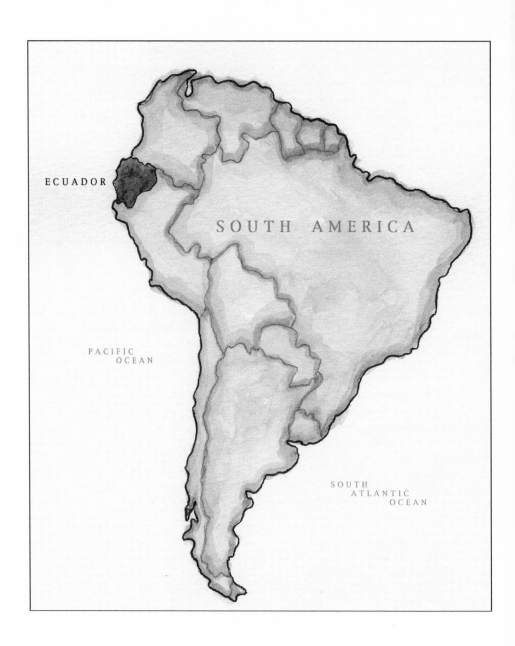

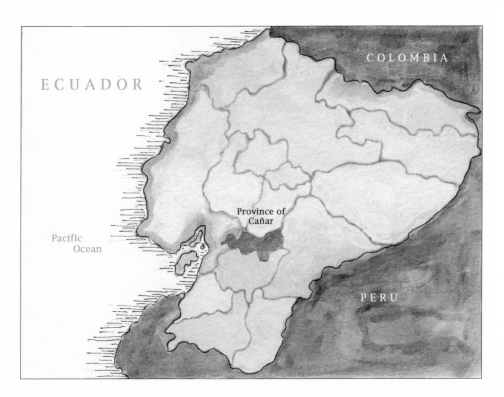

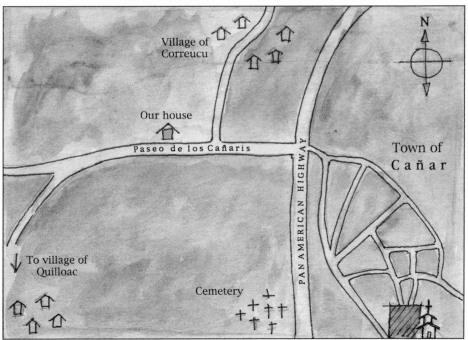

Introduction

WHEN CHANCE TOOK ME to Cañar for the first time in the early nineties, I could not have imagined that for the next decade my life would be tied to this remote, beautiful spot in the highlands of southern Ecuador. I had come to South America from Costa Rica, where for the previous six years I worked for a Canadian development agency as a documentary photographer and adult educator. I had also met my husband, Michael Jenkins, there. When my last contract ended and it was time to think about making a life together in the United States or Canada, we realized we weren't ready. There was so much of Latin America still to explore. After years in a demanding job, my dream as a photographer was to have the luxury of time to live in an indigenous village somewhere in South America and make an ethnographic record of community life. The local people would welcome me to their cloud-shrouded hamlet high in the Andes (my romantic vision went), and once they got to know me, I would be invited to photograph them at work and at leisure, in their ceremonies, rituals, fiestas, weddings, baptisms, and funerals.

Although my background is in the social sciences, I wasn't interested in doing academic research. Rather, I wanted to create a visual record of a time and place in the tradition of early documentary photographers Dorothea Lange, Walker Evans, and Mexican photographer Mariana Yampolsky, adding the influence of writer John Berger, pioneering visual anthropologists John and Malcolm Collier, and contemporary photographer/educator Wendy Ewald. Simply put, I wanted to participate as much as possible in the daily life of a place, among a group of people who would be my collabo-

rators, show me how they perceived their world, and allow me to record it in photographs, oral histories, and video and audio recordings.

Michael, always game for a new adventure and not that anxious to return to the world of work and responsibility in the north, was enthusiastic. We had no funding, but we had enough savings to give us a year in South America. But where? We studied a map and shared quick superficial impressions: Colombia was too unsafe, Brazil too big (and we don't speak Portuguese), Bolivia too cold, Peru too unknown, and Chile and Argentina too far. So through a process of elimination we chose Ecuador, the smallest of the Andean countries. Nestled between Colombia to the north, Peru to the south and east, and the Pacific Ocean to the west, Ecuador straddles the equator (hence its name). About the size of Oregon—Michael's home state—the country is carved by the long spine of the Andes mountains into three regions: the Pacific coastal lowlands; the eastern jungles of the Amazon Basin, known as the Oriente; and the mountainous highlands, or Sierra, populated largely by Quichua-speaking indigenous peoples (spelled "Quechua" in the other Andean countries). We agreed that the Sierra (what a lovely word!) was where we wanted to be.

Several months later, as our plane descended over a sea of red-tiled roofs into the lush green highland valley of Cuenca, Ecuador's third largest city, I got the feeling we had chosen wisely. A walk around the cobblestone center of the city, founded by the Spanish in 1557, confirmed my first impression. With its impressive colonial-style architecture, centuries-old churches, convents, shady plazas, and colorful markets, Cuenca charmed us immediately. We decided that this lovely city, situated at 8,335 feet, would serve as our base while we searched for the village where we would live.

We checked into a hotel overlooking the Tomebamba River and began our search. But after a week of daily forays into the countryside, Michael and I realized that we had no idea how to go about finding our mythical place. While the villages we had randomly chosen to investigate within an hour's bus ride of Cuenca were picturesque, they seemed to have little to do with indigenous life, or at least that life as we had imagined it. We heard no one speaking Quichua and saw no distinctive costumes, two indicators of indigenous identity in highland Ecuador. After the second week, during which we moved to a much more modest hotel across the street, Michael and I had to admit that we were getting nowhere. After the third week, frustrated in our search, crowded into a hotel room with all our gear, and getting on each other's nerves, we were having serious doubts about our plan. "The *indígenas* don't live around here," someone finally told us. "You'll

find them in the provinces to the north and south, in Cañar, Chimborazo, or Saraguro."

By then, our evening walks around Cuenca had become the highlight of our futile days, and we were falling in love with the place. Strolling through the graceful plazas and peering into flower-filled interior patios, we asked ourselves why we shouldn't just alight here for a while and give ourselves time to explore the area.

And so we settled into a life very different from the one we had imagined, in a spacious rented house alongside the Tomebamba River, a few blocks from our hotel. Michael planted a garden and I set up a darkroom with the hope that a project would materialize. And it did. Within a couple of months, through a contact from my Canadian agency in Costa Rica, I met a group of social-science researchers who had just been funded for a six-month project in the province of Cañar, about two hours from Cuenca. When they learned I was free and looking to volunteer, they asked me to participate as a photographer. The study would be carried out in partnership with a newly formed indigenous organization called INTI (National Institute of Indigenous Technology). Two young Cañari men associated with INTI, José Miguel Acero and Antonio Guamán, had been hired as research assistants to conduct interviews and take photographs in Cañari villages. My job was to train them in photography and oral history skills.

The first meeting took place in Correucu, a tiny hamlet a mile or so outside the town of Cañar. A cluster of small adobe compounds surrounded by fields of potatoes and corn and ringed by eucalyptus trees, Correucu was a poorer, less picturesque place than I had conjured in my imagination, but it was an indigenous community nonetheless. The reality was even more intriguing than my fantasy.

Seven or eight members of INTI had gathered at the house of José Miguel's mother, Mercedes Chuma, to meet *"los académicos,"* as they referred to us. All were very reserved and formal. José Miguel and Antonio greeted me nervously. Both were in their early twenties and dressed in traditional clothing: handwoven, red wool ponchos over white cotton shirts embroidered on the sleeves and collars, black wool pants, and the distinctive round white felt hats of the Cañaris. Their hair was pulled back in long neat braids down their backs. The two young men seemed hopeful that these small jobs might open the door to opportunities beyond the endless toil of plowing, planting, and harvesting. (For one, this would become a reality; for the other it would remain a dream.)

The meeting went on for hours and hours. But I was patient, having

learned during my years working with grassroots groups in Central America that process is as important as content when trying to get something done or make a decision. Short, efficient meetings are considered a barbaric custom of North Americans.

In mid-afternoon we took a break, and as I sat outside in the sun I watched one of the women, María Juana, spinning wool. Under one arm she held a stick wrapped with a bundle of raw fleece, which she pulled with one hand while with the other she twisted a thin thread of wool onto a drop spindle. Like the other women, she wore several layers of brightly colored wool skirts, a satin embroidered blouse, and a short black shawl over her shoulders held by a decorative pin. Swathes of red beads adorned her neck, and elaborate filigreed earrings swung with her movements.

My photographer's eye registered a picture-perfect moment, so after we had chatted stiffly for a few minutes, I asked María Juana if I might take a photo. She didn't speak, or even look at me, but slowly shook her head no.

My cameras stayed in my bag that day, but this was a defining moment that I would never forget. In asking to take a photo, being denied, and acknowledging the refusal, the terms of my relationship to this place and its people, even at this early stage, had been established: I was an outsider, *una extranjera*, present by invitation only, and I could not expect to take photos without explicit permission. Not, that is, if I wanted to have continued contact.

Today, more than ten years later, I still do not take photos uninvited in Cañar, other than the occasional Sunday market shot. Even now, when I've become a familiar figure in Cañar, market women will often duck their heads if they see my camera. This is serious, not playful, resistance. The woman is thinking, "Why should that woman with the camera carry away an image of me, and offer nothing in exchange?" Fair enough. Reciprocity is integral to Andean culture, and it is only through the painstaking process of building relationships that I am able to make meaningful photographs.

In an incident that took place months after that first meeting, I learned another lesson. I was sitting beside the road chatting with a Cañari woman as she stripped pea pods from dried vines. As her children walked up the road toward us, I asked the mother if I could take their photo. She shook her head no, and said something about how a photograph can be used by enemies to cast the *mal ojo*, or evil eye. When I responded that I would give her, and no one else, copies of the photos, she replied, doubtfully, "Yes, but what will you do with the *negatives?*"

The research project with INTI was over quickly, but I realized I had two eager photography students in José Miguel and Antonio. When they

proposed that we continue working together, I agreed without hesitation. Every other week I met them in Cañar, and we would go out into the countryside for a lesson in using the camera. On alternate weeks, the two young men came to Cuenca, where I introduced them to the mysteries of my darkroom, and Michael presented them with the spectacle of a man preparing lunch in the kitchen.

Our first year in Ecuador drew to an end. We had made a few Cañari friends and enjoyed a pleasant year living in Cuenca, but I had taken very few photos. As we were getting close to our departure date, we received a formal visit from the directors of INTI, Isidoro Quinde and María Juana Chuma, inviting Michael and me to stay in Ecuador and work in Cañar as volunteers with the group. We didn't think about it long. Here was the opportunity for which we had come to Ecuador, and although it had taken a year to find it, we felt in no hurry to leave.

Our second year in Ecuador was very different from the first. We kept our house in Cuenca, but rented another place in Cañar, a two-room storefront in a ramshackle row of taverns, shops, and houses on the outskirts of town along the Paseo de los Cañaris, the road that leads into the countryside and the indigenous communities. From this place, where we spent weekends, our vision of participating in the life of an indigenous community seemed closer. Michael worked with INTI members on organic garden and terracing projects and gave workshops on constructing and using a low-cost, high-efficiency, wood-burning cooker. I gave photography classes, and as the year went on, our storefront became a regular meeting place and social stop on Sunday market day. I set up a makeshift studio in our bedroom and invited those who dropped in to sit by the window for a portrait. At first, almost everyone politely refused, saying their clothes were not right, or they wanted their children with them, or they weren't feeling quite up to par that day. I made clear that the offer stood, and as the year wore on people gradually began to ask for family portraits or invite me to their houses or into their fields (although why I wanted to photograph people at work remained a mystery to everyone).

Michael and I left Ecuador after two years, determined to come back to Cañar someday. In 1997, we returned for a brief visit at the invitation of José Miguel and his wife Esthela. In their first communication with us in four years, they wrote that they had become "real" photographers and were now proprietors of a thriving commercial studio in Cañar. They'd also had a baby daughter, Paiwa, and asked if we would be godparents.

I returned to Cañar alone in 1998 to help organize my exhibit, "Los Cañaris Hoy" (The Cañari Today), at the national ethnography museum

in Cuenca and give a three-day photography course for indigenous partici-
pants. During that trip, as I saw the enthusiasm of my students and visited
Cañar to reconnect with old friends, I realized that my teaching and docu-
mentary work was not yet done. In fact, it seemed only to have just begun.

I came home committed to finding the funding to return to Cañar for
another year. In 2000–2001, Fulbright and Organization of American States
grants allowed us to do this. This book is the story of that year.

Old Friends

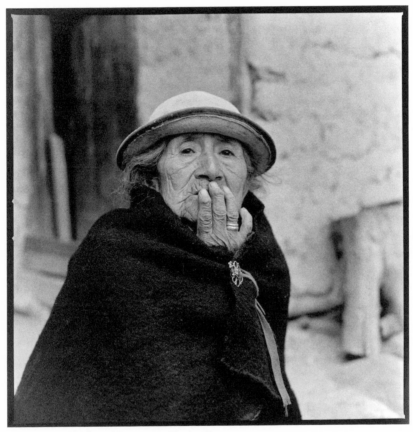

VICENTA QUISHPILEMA PICHISACA (MAMA VICENTA)

WE WAKE VERY EARLY at the Hostal Irene, the bare-bones hotel where we've paid four dollars to spend our first night in Cañar. Our bordello-style bed with its heart-shaped, red-flocked, chrome-scrolled headboard is hard as a rock, with one flimsy blanket and a long, thin, tightly rolled pillow that Michael and I shared. Amazingly, we slept well, but now it's too chilly to stay in our room. We dress quickly, let ourselves out of the main gate of the hostel (really just a house with a few extra bedrooms upstairs and a com-

munal bathroom), and walk through the quiet streets of the town, looking for breakfast.

It's a brilliant cloudless day in October 2000. Although we are at more than ten thousand feet in the Andes (10,150, to be exact), the unfiltered sun and extra exertion it takes to walk at this altitude quickly warm us. These are the dry months, when the equatorial sun gives the highlands a halfway comfortable climate (although the temperature can swing thirty degrees in the course of a day), but six months of cold, rainy weather are ahead of us, when the temperature will hover in the fifties and low sixties and drop into the forties and even thirties at night.

Cañar's market day was yesterday, Sunday, and hardly a soul is stirring this morning. As we walk through the cobblestone streets where yesterday stalls were set up for a few hours and then disassembled, we see discarded produce, scraps of paper, and other market debris swept into neat piles at the curbs. An old woman dressed all in black bends over one pile, scanning the refuse with an expert eye and delicately picking out bits of fruits and vegetables, which she slips into a plastic bag on her arm. Her chickens, and maybe a pig, will eat well today, I think. By her clothing and her hairstyle I know she is a town woman, a mestizo, and not *indígena*.

These southern highlands of Ecuador have been the territory of the Cañari people for at least three thousand years. At one time, before they suffered two conquests in quick succession in the fifteenth and sixteenth centuries, the Cañari were the most powerful tribe in the region, with a highly developed culture of gold and silver metalworking, ceramics production, weaving, and advanced agricultural methods. The Incas invaded from Peru in 1463, brutally subjugating the Cañari. Fewer than one hundred years later, the Spanish conquistadors defeated the Incas and laid claim to much of the Cañari region. The town of Cañar was formally founded in the sixteenth century.

Today, the province of Cañar is one of the country's poorest (and Ecuador ranks as one of South America's most impoverished nations), with an indigenous population of about twenty-five thousand. Scattered in small remote communities at high elevations, the Cañari farm meager plots of eroded, rocky land and tend a few sheep or cattle. The town of Cañar, situated on the side of a broad central valley, is the commercial hub of the region, with a population of about ten thousand. Almost all the town folk are mestizo—people of mixed European and native heritage, but who clearly identify as non-Indian.

We pass an antique dump truck grinding its way along the street near the

old market. Three garbage collectors walk slowly behind the truck, carrying huge twig brooms and pushing fifty-gallon barrels on wheels that serve as rolling garbage cans. The men are swathed in tattered clothes, with scarves or handkerchiefs over their faces to guard against dust and odors. As we get close, one of the men stops to sweep the street and I ask if I might take his photo. He shakes his head no, but with such a disinterested expression that I persist in asking, "May I take a photo of your broom, then?" He wordlessly hands his broom to Michael, who poses with a goofy grin, holding the broom upright with the bushy twigs fanning out beside his head. The garbage collector stands by with arms crossed, watching impassively. Michael hands the broom back, thanks him, and we walk on down the quiet street.

In the old part of town, where a loose grid of cobblestone streets are laid out around a small park, two- and three-story buildings sit cheek by jowl, with storefronts that open directly onto the street and living quarters above. Some are ancient adobe structures with tile roofs, leaning so precariously that they might soon fall down and slowly sink back into the earth from whence they came. Others are newer, made of concrete block or crude brick and partially finished or half-painted. One or two neo-colonial "gems" sit primly on the square, left over from a more prosperous time, but even they lean slightly off-plumb; this is a region of faults and unstable lands. One architectural conceit of these "city" houses is the tiny, flimsy wooden balcony built around an upstairs window, where a tattered lace curtain is often seen. Even with a few newer concrete buildings, such as the bank on the square, Cañar feels frozen in some indefinable time.

On a side street we see an old carved door wedged horizontally between two posts to serve as part of a crude fence. I stop to take a photograph and am reminded of the doors of San Miguel de Allende, Mexico, where one of my sisters lives. These doors are so colorful and charming that coffee table books have been created about them, and tourists pay for walking tours just to see them. "This place is the antithesis of San Miguel," I say to Michael as we stand looking at the battered door. "No obvious charms. That's why I like it."

"Totally without pretensions," he agrees. "Absolutely no potential as a tourist town. That's why *I* like it."

SINCE WE LANDED in Ecuador a week ago and flew from Quito to Cuenca, we've been staying in a friend's small apartment, sorting out our boxes and bags and preparing to move to Cañar. We've come today to look for a place

to live, but the first thing we want to do is visit two of our oldest and best-loved Cañari friends: Mercedes Chuma (Mama Michi) and her mother, Vicenta Quishpilema (Mama Vicenta).

After a quick breakfast of scrambled eggs and Nescafé at the only open café we can find (no one eats breakfast out here), we take a cobblestone street down the hill, cross the two-lane Pan-American Highway, and within minutes are on the Paseo de los Cañaris, the gravel road that runs west into the countryside. We walk the gauntlet of one-story storefronts opening onto the street, positioned to grab the last business of the *indígenas* as they head to their small communities in the mountains. Many stores, regardless of their purpose, also offer last opportunities for *tragos,* alcoholic drinks, signaled by a small table and a bench or a couple of chairs just inside or outside the door. As in the town, mestizos own these businesses.

There are the blue double doors of the small storefront where we lived on weekends eight years ago. It has been converted back to a grocery store. We turn right off the Paseo onto a rutted road and walk half a mile or so into the country, toward a scattering of mud-and-thatch houses along the road. Here is the tiny *comuna,* or village, of Correucu, where most of the extended Chuma family lives on small parcels of land. The third compound on the right is Mama Michi's, and her dun-colored, ramshackle house looks much as I remember it. A small two-story adobe and an attached kitchen with a roof of thatched straw somehow accommodate her numerous adult children and grandchildren. I wonder, as I have many times in the past, where everyone sleeps.

Around the house a collection of lean-to sheds and outbuildings gives shelter to chickens, pigs, and a cow. Some provide food for the family, while others are being raised to sell in the animal market when cash is needed. The perimeter of Mama Michi's small property is marked on one side by tall, shaggy eucalyptus trees, and on the other by a field of potatoes that dips away toward her brother's house.

The doors to the house are open, as they always are when anyone is at home; Mama Michi sees us and comes outside. "*¡Qué milagro!*" What a miracle! she exclaims with a big smile that shows a new front tooth where a gap used to be. "You're here again." She is dressed in the distinctive clothing of a Cañari woman: a brightly colored wool skirt with embroidered edges called a *pollera;* a short wool cape over a blouse and sweater, and a white felt hat. Her round face is a little more lined than when last we saw her, but her hair is still thick and black, hanging down her back in a long braid.

"How are you, Mama Michi?" I ask, stooping to give her an awkward hug—she stands about four feet ten inches. "*Estoy harta con pacientes!*" she says,

which roughly translates as "I'm up to *here* with patients!" She throws her hands in the air and gestures to the house behind her, where I can see people sitting and lying on rush mats on the dirt floor of her main room. Following the death of her husband, Serafín, four years ago, Mama Michi began to work as a *curandera* (or *yachaj* in Quichua), a native healer, and we've heard that she is enjoying a lively practice and even a degree of fame with mestizos as well as with her indigenous neighbors. She does look tired, but I can also see pride in her face.

We leave Mama Michi to her work; we'll see her later, after we visit with her mother. She sends her granddaughter, Pacari, a bright-eyed little girl with a very dirty face, to accompany us.

A rough path behind Mama Michi's house leads up a steep rise to Mama Vicenta's small compound, which perches on a hill overlooking the valley. We find an enamel pan of incense smoking just outside the wooden door of her sleeping room, but there is no sign of our favorite grandmother. When Michael and I first came to Cañar eight years ago and became acquainted with the Chuma family, Mama Michi was the first to allow us a guarded glimpse into Cañari life, but it was her mother who accepted us unquestioningly. Even though Mama Vicenta speaks mostly Quichua and could understand little of our Spanish, she allowed me to take her portrait when few others would (albeit not without many delays due to the weather, her arthritis, or the state of her clothes), and she is still one of my favorite subjects. I've always had the impression that Michael and I amuse her, these two crazy *gringos* who like to sit on the bench in front of her house and watch the world pass by on the road below. Which is exactly where we are now, waiting for her to appear.

Mama Vicenta's ancient adobe house is in a state of slow collapse. Someone has propped a eucalyptus pole under the beam that holds up the roof, and a V-shaped rift about fourteen inches wide at the top has opened in one outside wall, as though it's been split with a giant axe. I glance into the dark interior of an open door and see bags of grains and a basket of potatoes. An adjacent room with a closed door serves as Mama Vicenta's kitchen, where she cooks over a wood fire in one corner of the dirt-floored room and keeps her collection of *cuyes*, guinea pigs, safe and warm in the dark until it's time to eat them. She used to have pigs and sheep, but she told us three years ago that she has grown too old to handle them.

After a few minutes the wooden door to Mama Vicenta's sleeping room opens and she comes out, half-bent over, tying one heavy, gathered wool skirt over another to guard her old bones against the cold. When she sees us she throws her hands in the air just as her daughter had and exclaims,

"*¡Qué milagro! ¡Qué milagro!*" A smile beams out of her creased face, and those eyes I remember so well light up with pleasure.

With a sigh, Mama Vicenta sits down on a low wooden box and leans against the adobe wall of her house, the sun directly on her face. I surreptitiously look her over. We have heard from her grandson, José Miguel, that Mama Vicenta nearly died this past year, and she does seem to be much older since I last saw her, reduced both physically and in her material circumstances.

In addition to her wool *polleras*, she wears several old sweaters under a raggedy cape-like shawl called a *wallkarina* in Quichua, which is made of homespun wool and closed over her chest today with a safety pin. (Had she known we were coming, Mama Vicenta would probably have changed into a newer version of this clothing and added a decorative pin with a ribbon to hold her cape.) Long, wrinkled kneesocks keep her legs warm, and she has on the usual woman's footwear: cheap, black plastic Mary Janes from the market. On her head she wears a battered round white felt hat, with her signature touch: the front brim is crimped up at a forty-five-degree angle to give her a clearer view of the world.

We ask her how she's been doing; in a matter-of-fact voice Mama Vicenta recounts her various health crises. I don't understand all of it, but in her mixture of Quichua and Spanish I hear ". . . fell down the ravine behind my house," and with her gestures we understand that she injured her back. "*Mi columna . . .*" she says, holding up two fingers like claws. Her two daughters who live in Cañar, Mama Michi and Mariana, took her for treatment in Quito, a ten-hour bus ride away, where two other daughters, María Juana and Vicenta, live. She stayed for two weeks, she says, and didn't get better, so they brought her back to Cañar, where she almost died before Mama Michi cured her with native medicine and massage treatments.

"Mama Vicenta, how old are you now?" I ask after a pause in the conversation. "About eighty-two," she says with a sigh, running her hands over her face, "Too old! When will I die, when will I die? Nobody knows, nobody knows." She repeats it like a chant. In response, I murmur that she surely has some good years left, and to strengthen my point I ask about her older sister, Mama Jesús, who lives a couple of kilometers away. "Still alive at ninety, but blind now," Mama Vicenta says dismissively. I remember that she doesn't get along with this sister and almost never sees her, so the subject is dropped.

"Would you like some potatoes or *ocas?*" Mama Vicenta asks very formally. We tell her not to bother, knowing she'll have to cook them, but when she asks us again a few minutes later Michael replies that we would

be happy to eat some *ocas* (a cousin of the potato, something like a Jerusalem artichoke). In a Cañari home, hospitality dictates that a visitor never refuse an offer of food, no matter how little food there is, how much trouble the host takes to prepare it, or how little appetite the guests might have. Mama Vicenta slowly pushes herself up and begins to gather bits of wood in the yard. "No one has time to cut down a tree for my firewood," she says querulously, gesturing to the tall eucalyptus trees all around her house.

She disappears through a small wooden door into the darkness of her kitchen and comes out fifteen minutes later with an enamel plate full of shriveled *ocas* and a few small potatoes. Michael pulls a cheese that he bought in Cañar out of his backpack, cuts a few pieces onto the plate, and gives the rest to Mama Vicenta. As is the custom, she disappears back into the kitchen, leaving her guests to eat alone. My first bite suggests a touch of mold, and Michael's grimace confirms that the *ocas* are indeed old. I sidle over to the ravine beside her house and toss them over the side. Michael soon follows. It's terrible to waste food, but it would be worse to leave it. We eat the potatoes, although they are also a little worse for the wear.

Mama Vicenta reappears and I steer the conversation to her house. She says she thinks it is about eighty years old; it was here when she and her husband bought the land just after they were married. "Now my house is falling down," she shrugs, gesturing to the splitting wall, "and no one has time to help me." She says this with a tone of resignation that I often hear among the Cañari. It conveys that one can do nothing against the forces of fate, be it an illness, a lightning strike, or inattentive family members.

We all agree, however, that her vantage point is perfect: a panoramic view of everyone who passes and everything that happens in the little valley below. She also has the added benefit of the afternoon sun to warm her bones. We gaze into the distance, where we can see a man plowing his field with a pair of yoked oxen. When Mama Vicenta identifies the man, Michael comments that her eyesight is sharp. She nods, pleased. Her old eyes still work fine, she says.

Just as we are saying goodbye, Mama Michi appears over the edge of the hill, a relaxed smile on her face. All her patients have gone, she says, and now she can spend time with us. Would we like to come to her house and have some potatoes? We follow her down the path and into the windowless main room of her house. This is the very room where I first met Mama Michi eight years ago, on the day I came with the team of Ecuadorian social scientists from Cuenca to talk about the INTI research project.

Then, the room had been cleared of everything but a few stools and benches for the meeting with *los académicos*. Now, it is filled with the parapher-

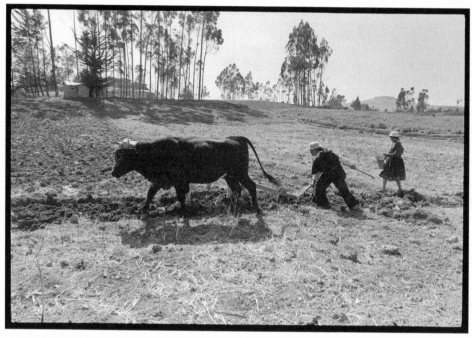

PLANTING AND PLOWING WITH WOODEN PLOW AND OXEN

nalia of Mama Michi's new trade. On a big table in one corner, among a per-
plexing array of deities and offerings, I see bunches of dried herbs, bottles
with liquids, a Buddha, a Virgin Mary, a ceramic clown, and two burning
candles. In another corner, in a glass-fronted cabinet, there are labeled pack-
ages and bottles, the *remedios*, medicines and potions, that I assume Mama
Michi sells to her patients.

Michael and I sit on low wooden chairs with our knees at nearly chest
level. I wonder for the hundredth time why all the roughhewn chairs here
seem to have eight-inch legs? Probably because they are bought so cheaply
in the market, and Cañaris are accustomed to sitting close to or on the
ground. Mama Michi sets a miniature table in front of us, settles onto a
low bench, and fills us in on her recent history. She still works at the native
medicine clinic in town two days a week, but she wants to resign because
more and more people are coming to consult with her at home as her fame
as a *yachaj* spreads. Many prefer to be treated at night, she says, when the
"medicine is stronger," and this means she's exhausted from the long hours.
She's even been invited to do healings in other provinces, she adds proudly,

then shakes her head and concludes glumly, "It all makes me so tired, I'll probably die before my time."

She tells us a long story about how she was invited to Canada last August for a conference of four thousand native healers from around the Americas. Apparently she went to a meeting in Quito at the invitation of her sister, María Juana, where she connected with a person from a Canadian agency who arranged the invitation. Mama Michi was to be the only native healer from Ecuador, she said, but since she is illiterate and can't travel alone, they decided to send her sister along with her. Mama Michi doesn't know which Canadian province she visited, but when she describes sleeping in a teepee we guess that it was Saskatchewan or Alberta. She was such a hit at this gathering, she says, that she has been invited back to Canada to do a "healing tour" later this year.

"Three things I couldn't get used to," Mama Michi concludes, "were the light at night, the food, and the language." (That about covers the total experience, I thought.)

Zoila, one of Mama Michi's daughters, appears with a big bowl of steaming potatoes. Michael and I embrace her fondly, as we have known her since she was a teenager. The sleeping baby wrapped in a shawl on her back is Rantin, she tells us, and he's fifteen months old. Pacari, his older sister, is four. I can see that Zoila is pregnant with a third child, but as is the custom I make no mention of this.

We eat the potatoes, which are fresh and delicious, drink beer mixed with Coca-Cola, a favorite daytime drink in Cañar, and talk with Zoila about her situation. Benedicto, her young husband, recently tried to make the illegal migrant's trip to the United States and was caught and jailed in Guatemala. After several weeks he was sent back to Ecuador, and he's now dealing with a *coyote*—a local agent who makes the arrangements for such journeys—to try again.

"Benedicto's father mortgaged the family's land to a local moneylender to pay for his trip—about nine thousand dollars," Zoila says. "*¡Dios mío!* And then the *coyote* demanded extra money to get Benedicto out of jail in Guatemala." She goes on to say that the debt is now about twelve thousand dollars, and Benedicto is frantic to get to the United States to find a job so he can begin to pay it off. "Otherwise his father will lose the family's land," she concludes. Michael and I sit silent, stunned at the amount of money this must represent for a poor Cañari family.

"The life of my daughter is tragic," Mama Michi says flatly, while Zoila sits impassively beside her. "Barely twenty, she will soon have three young

children. She's living in a half-built adobe house several kilometers away, in San Rafael, near Benedicto's parents, without water, electricity, doors, or windows, and no means of support." Mama Michi wants Zoila to come live with her, she says, where she'll have help with the children and food and support from her family. But Benedicto objects to this plan; he wants his wife to stay close to his parents while he's in the United States.

Michael and I are indignant. I think we know Zoila well enough to express our opinion, and add, half joking, "Maybe we should talk to Benedicto, as we are practically your godparents." Mama Michi and Zoila laugh, and in the pause that follows Zoila says very formally, "I have wanted to ask you a favor for some time now, since this baby was born. I was going to write a letter but I never got around to it, what with the children and building the house and all. But I want you to be *padrinos* to my son, Rantin."

Michael and I sit silent for a moment, not sure how to answer. To be godparents in Latin America is a heavy social and religious responsibility, and we will not be around for most of Rantin's life to fulfill our duties as *compadres*, co-parents, to Zoila and Benedicto. But, as in many other delicate social moments, Michael seems to know just what to say. "It's a great honor to be asked. We'll have to think about it for a few days and we'll give you our answer on Friday, when we come back to Cañar."

This pleases everyone, and we have another toast of beer and Coke before gathering up our things and climbing the long hill back toward town to catch the bus for Cuenca.

Killa Raymi:
Festival of the Moon

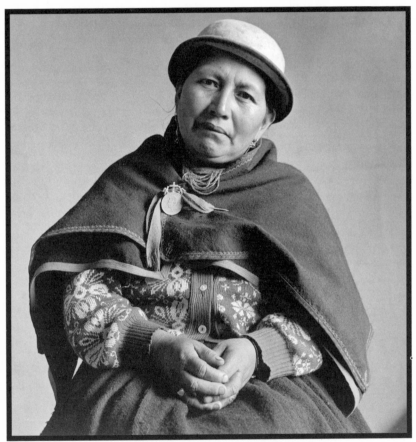

MERCEDES CHUMA QUISHPILEMA (MAMA MICHI)

IT HAS BEEN ANOTHER uncomfortable night on the thin mattress at the Hostal Irene. We are still sorting out our things in Cuenca, but now we're here in Cañar at the invitation of José Miguel to attend the Festival of the Moon, or Killa Raymi, which is to be held later today at the nearby archeo-

logical site Los Baños del Inca (the Inca Baths). José Miguel's music and dance group, Los Chaskis, will be performing, along with other cultural groups from all over the region.

Michael and I are awake by six and out briskly walking the streets by seven, trying to keep warm and killing time while waiting for one of the few restaurants to open. Cañar is always cold and bleak in the morning, and everyone but the street cleaners with their bushy brooms—plus a few dedicated drinkers who didn't make it home last night—tends to stay inside until nine or ten, when the shops open and the sun warms the air.

As we pass two men sitting on the curb recovering from a night of drinking, heads bobbing down toward their knees, Michael says, "I think that Cañar must the most depressing place in the world to be an alcoholic. To wake after a night of bootleg liquor and oblivion to this cold, stark place would be enough to drive one to . . . well, drink."

I nod in agreement but say nothing. The family violence, accidents, early deaths, and health problems caused by drinking in the Cañari community is a subject too painful to talk about this morning.

For breakfast, Michael wants to try a hole in the wall he spotted the night before as we walked from the bus to the hostel. The sign, "Exelent Chiken," intrigued him. I'm dubious, but we walk down the street to check it out. It's still closed, but when the woman inside sees us peering through the window she motions us in and escorts us to a wobbly metal table with folding chairs.

"What'll it be?" she asks, heaving a big plastic tub of raw red meat from the table.

"*Café con leche* and scrambled eggs," I say, looking around doubtfully. The coffee, lukewarm milk with a teaspoon of Nescafé powder, is barely drinkable, and my enthusiasm for the eggs is quickly dampened by the bins of dead yellow-skinned chickens that continually pass our table as a man unloads them from a truck at the curb. We later realize that the place is a meat market, with a few tables squeezed in for those who want to stop for a bite of "exelent chiken."

After our unappetizing breakfast, we head down a cobblestone street to visit Estudio Inti, where José Miguel and his wife Esthela will be readying their business for the day. The festival won't kick off until later this afternoon; we have the whole day to kill.

There are no customers yet, so we find Esthela sweeping the sidewalk in front of the studio and José Miguel working behind the counter, sorting and packaging photos in small plastic bags. As with almost every commercial establishment in Cañar, most of the front of Estudio Inti rolls up to

open to the street. Passersby can see display cases of music cassettes, cameras, tape recorders, toys, and hundreds of photos stuck up on the walls—those that have gone long past the date when they were due to be picked up by clients. As always, Esthela is impeccably dressed in Cañari clothing, her thick black hair in a long braid down her back, a round white hat on her head. José Miguel also has the braid that marks him as *indígena*, but today he is dressed in black jeans, a sweatshirt, and a baseball hat, indicators both of his relative prosperity and his fashion awareness of the world beyond Cañar (I notice the jeans are authentic Levis).

We greet one another formally as *comadre* and *compadre*—our mutual terms of address because we are godparents to their little daughter, Paiwa—and exchange stiff hugs (hugging is not a Cañari custom, but they know we seem to like it). José Miguel invites us into the back room, past the mirror and small table with a water spray bottle where people check themselves out and slick down their hair before stepping into the studio for a photo.

Cañar is a mestizo town, and Estudio Inti is one of very few indigenous-owned businesses. Although the main work of the studio is making color snapshots of customers in the little back room and photographing events such as graduations, soccer tournaments, baptisms, and weddings, José Miguel and Esthela quickly discovered when they opened the studio four years ago that their customers don't simply drop in to pick up their photos. They linger over the glass case with the music cassettes, request to hear selections, and ask to take a closer look at a cheap Walkman behind the counter. Or they stay simply to chat. Here, Cañari customers can speak Quichua, leave their full market bags while they finish their shopping, or rest on the blue-painted bench before heading back to their homes in the country.

Hung on one wall of the back studio is a newly painted backdrop that José Miguel says he ordered from a local artist. It is an Alpine scene with mountains, a waterfall, and a house where Heidi might have lived. I ask where he got the idea and he replies that he finds his themes on calendars. "Our clients like a change every now and then." I tell him that my favorite is still the original backdrop that he painted himself a few years ago, which depicts a rainbow over Ingapirca, the famous Inca ruins in the mountains above Cañar, and the magnificent head of an *indígena* man suspended in the sky.

José Miguel lifts the new backdrop and invites Michael and me to step in behind it, where four stools have been set up in the tiny airless space. Esthela joins us, carrying four small glasses and a large bottle of beer. José Miguel pours and we toast, saying what a miracle it is that we are together

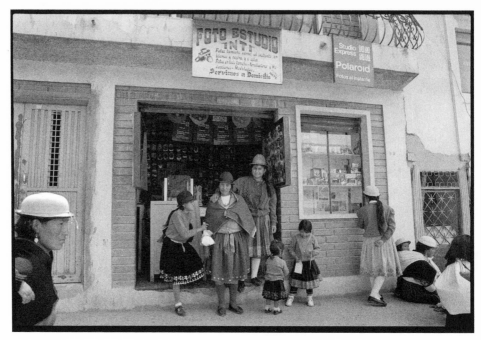

FOTO ESTUDIO INTI

again. As we sit talking, customers begin to arrive out front and either José Miguel or Esthela slips out to tend to them. At one point, as we sit hidden and quiet behind the backdrop, José Miguel brings a client into the studio to make a photo. I can tell by the man's voice that he has been drinking. "Do another one," I hear him say. "It's for my son in New York."

José Miguel is waiting for the members of his music group to arrive so they can rehearse for tonight's performance. The shop is getting busy, so Michael and I go back to the Hostal Irene to read and rest for what we expect will be a long, cold night at Los Baños del Inca. We know from experience that no Cañari event starts on time or ends early.

At four we are back at the studio to wait for Mama Michi. She's not on time, of course, but Paiwa is there, brought to the studio by a teenage cousin. Esthela asks if I would like to accompany my goddaughter to a child's birthday party just down the street. I say yes, pleased at the chance to be alone with this little five-year-old. Paiwa greets me shyly and calls me Marca Mama, a child's affectionate term in Quichua for her godmother.

About fifty children and half as many adults are crowded into a small unfinished patio for the party, which is complete with disc jockey and blaring speakers. When I see that Paiwa is the only indigenous child there, I

worry that she might be intimidated. But she crosses the crowded room with aplomb, hands over her gift to the boy's mother, and immediately begins to dance Cañari style, standing in place and demurely swinging her embroidered *pollera* back and forth. Her face is expressionless beneath her white hat. I sit on the sidelines, and when Paiwa is not dancing she allows me to hold her stiffly on my lap.

Between songs, the disk jockey announces that this birthday must be a very important event because an *extranjera*, a stranger, has come from afar. "Welcome to Cañar!" he calls out. I'm served cola and cake, but Paiwa won't touch either. What an interesting child she is, I think. I'm anxious to know her better.

When Michael and I were in Ecuador three years ago for Paiwa's baptism, she was a squirmy, bad-tempered two-year-old who found these two tall strangers terrifying. She wanted nothing to do with us. Even so, at the church Michael and I alternated holding her heavy little body while she twisted, sweated, and grasped for her mother as an amiable priest carried out an interminable baptism ritual.

Later, after an hour of waiting for Mama Michi, Michael and I start walking down to her house, but just as we cross the Pan-American we see her and Mariana, her teenage daughter, rushing toward us, thick wool skirts swinging like bells. Both carry baskets wrapped in shawls on their backs. When I mention how heavy her load looks, Mama Michi tells me it is filled with food for the musicians and dancers.

We climb back up the hill and take a bus to the small town of El Tambo, about fifteen minutes away on the Pan-American, where we hire a truck to take us to the Inca ruins, which perch on a hillside about two miles outside town. The road is an old elevated railroad bed, a rough track barely wide enough for the truck, and I'm nervous about the steep drop-off into the cornfields on either side. I have read about this railroad, a short-lived project of mid-twentieth-century engineers who thought that Ecuador should be linked from one end to the other by rail — a foolish vision that failed to take into account the country's violently shifting lands and equatorial rains.

The spectacular setting of Los Baños del Inca overlooks the green valley of the Cañar River, which cuts a swath through the mountains before dropping to the coastal lowlands and the Pacific. When we arrive around six, the festival is in full swing. Small carts of food vendors ring a grassy field, their glowing kerosene lanterns and little bells giving the site a carnival air. Most of the crowd, a mix of mestizos and *indígenas,* is gathered around an elevated stage at one end of the field where a group of musicians plays Andean music. Behind the stage, a huge inflated plastic liquor bottle, plastered with the

name "Zhumir," bobs on a rope tether. About twelve feet tall and illuminated from the inside, it glows in the dusk like a giant totem. Here is the symbol of the new deity/devil, I think—the cheap distilled cane alcohol that contributes to the high alcoholism rate of the Cañari.

We are at about eleven thousand feet, and I'm already cold as the sun heads for the horizon. I'm wearing two long-sleeved T-shirts, a sweater, jacket, gloves, and a hat, and I have a down vest and wool scarf in my backpack. Michael is dressed much the same, his pack bulging with extra clothing. I can't believe it when I see others wandering around in thin shirts or short-sleeved T-shirts. In the meadow behind the stage, a Shuar Indian from the Amazon, naked to the waist, practices his drumming with a small crowd gathered around him. Clusters of dancers, mostly young women, are practicing their steps or putting on costumes. We walk over to see the Inca "baths" behind the festival grounds, so-called because they are a series of carved stone outcroppings with shelves that look like seats and a water channel running between them. They were, in fact, not baths, but a ceremonial site that was part of Ingapirca, built by the Incas in the fifteenth century and now the most important archaeological ruin in Ecuador. Unfortunately, a small adobe house constructed by a later landowner still stands directly on top of the ruins, a literal testament to the succession of conquests the Cañari people have suffered, first by the Incas and then by the Spanish, all within about sixty years.

José Miguel told us earlier that before the Incas arrived, the Cañaris worshipped the moon as their deity; thus he thinks Killa Raymi is a more authentically "native" festival than Inti Raymi, the celebration of the sun that the Inca conquerors imposed on the Cañaris. I later learn that Killa Raymi was an Inca festival as well—as neither the Cañari nor the Incas had written language, and the early Spanish chroniclers were not always reliable, it is difficult from this historical distance to sort out the cultural practices of the two groups.

Michael and I stand near the stage watching a dance troop from Chimborazo, a neighboring province, until we're shivering. We make another brisk round of the grounds to warm up. The crowd has grown, and we've lost track of Mama Michi and Mariana.

Once darkness falls, it becomes immediately apparent that there is not enough electrical power to both amplify the live music and illuminate the dancers. "Oh yeah," Michael nods sagely, "this is a common problem at events like this, where the organizers string power cords from nearby houses or rent generators that are too small." Music groups on the stage continue to play with amplification, but the dancers in the cordoned space below

perform in near-darkness, with only one dim spotlight and the glow of the giant Zhumir bottle.

We finally spot Mama Michi and Mariana sitting on the ground close to the dance area, and I wade through the crowd and settle down to join them, happy to be enveloped by the body warmth of a tightly packed audience. Michael stays in the back, looking a bit rotund wearing the extra clothes he's brought in his pack, plus a windbreaker on top of it all and a watch cap on his head.

Los Chaskis were scheduled to arrive at about six and perform soon after, but they don't show up until close to nine. "Problems getting everyone together for the truck ride," José Miguel says with a shrug when Michael and I run into him in the dark on yet another round of brisk walking. By then, the hours of standing and sitting have left us thoroughly chilled to the bone and exhausted, but we say nothing; we are guests here. "Hopefully you'll get to play soon," Michael says weakly.

Mama Michi and Mariana now sit patiently on the ground off to one side of the stage, near where the Chaskis are preparing for their performance. We join them, sitting cross-legged, and I look enviously at the many wool skirts Mama Michi and Mariana have tucked around their legs to keep warm. Unlike us, they understand that part of enjoying any local event is the hours of patient waiting and watching, and they seem to know how to make themselves comfortable. The baskets of food sit beside them untouched, waiting for the celebratory meal after the show. Michael and I are ravenous and have been for hours—I'm sure everyone is—but it would be impolite to buy food from the vendors when we are to be included in the post-performance feast.

Finally, the Chaskis dancers are called to the roped-off area in front of the stage. Performing to a cassette rather than live music, eight young men and women dressed in their best Cañari clothing go through the steps of a "traditional" dance that looks something like a quadrille. José Miguel has asked me to bring my video camera, and in the dim light I do my best to record the dance from the stage. Little Paiwa suddenly appears beside me, swinging her skirts to the music, looking impassively out at the audience.

The Chaskis musicians are poised to play next, but at that point a voice from the stage announces that there is not enough power to continue the event. They will try to fix the problem so those groups waiting can still perform, but Michael and I know better. In one of our keep-warm wanderings we ended up backstage, where we saw a technician sitting in front of a great snarled tangle of wires, his head in his hands. I am sorry for José Miguel. His group of five musicians worked so hard rehearsing for this concert.

After the announcement, cars, trucks, and private buses immediately roar to life and begin pulling out of the festival grounds. But scores of people also stay and continue to stand quietly in the darkness, facing the stage. Michael and I are gathered with the knot of Chaskis musicians and dancers and their families and friends. The young people, still excited from their performance (or near performance, in the case of the musicians), are laughing and joking, their faces flushed.

Finally, Mama Michi announces that we should go ahead and eat, even though the musicians haven't played. She lays a white cloth on the ground, and she and Mariana dump out several baskets of potatoes, corn on the cob, and bits of cooked guinea pig, making small mountains of food and setting a bowl of hot sauce in the middle. We all fall on this bounty, but with a certain delicacy. Sitting or standing around the cloth, we take turns leaning in to take a small piece of potato or section of corn, dip it in the sauce, and move back to eat. It's about ten o'clock by now, and I speak softly to Michael, telling him that I am seriously cold and worried that we've made no arrangements for a ride back to Cañar. Michael, happy with the food, is not worried, and he says we should not mention the ride problem to Mama Michi, as that will make her feel responsible. We will wait to see what happens.

The food is quickly gone. More cars and trucks pull away into the night, and the crowd dwindles. There is silence from the stage; the festival appears to be over. Mama Michi, now obviously tired, says that since we don't have a ride we will have to start walking back to Cañar. Although I know it's a good fifteen kilometers away, I feel only relief at the thought of moving, of getting warm. The young dancers want to stay, however. To them the night is still young, and post-performance adrenaline keeps them buzzing. (This is the country equivalent of going to a club, I think.) As for the musicians, José Miguel says maybe they'll still get a chance to play (they don't).

Our small group of walkers, in addition to Mama Michi, includes her daughter, Mariana, her nephew Felix and his wife Alegría, who has a baby on her back, and their five-year-old son, Inti. We strike out in velvety darkness, except for a dancing spot of light from Michael's flashlight. I'm annoyed at myself for forgetting mine; Michael is so parsimonious with his batteries that he switches off the flashlight when a car passes by. Mama Michi says, with a little sarcasm, that it's too bad the festival was scheduled during the dark phase of the moon. It's such a relief to get the blood flowing that I'm not complaining, and everyone is surprisingly cheerful.

We stumble down the rocky road to the Pan-American Highway with only one mishap: Mama Michi slips and falls flat on her back, giving a great

laugh. On the highway, cars, trucks, and buses speed by like demons in the night, and frequently we are forced to jump off the shoulderless road into the bushes. Michael tries to wave down some of the trucks and buses with his flashlight to catch a ride, but they are gone before they see us. Finally, a small, slow truck does stop and the driver, who says he has been at the festival, invites us to climb into the back. We ride to Cañar in relative cold comfort, crouching in the truck bed with the wind whistling over our heads.

On the edge of town Michael and I pile out, calling goodnight and offering to pay the driver, who refuses the money. We walk through the empty streets to the Hostal Irene, where, after climbing over the tall wrought-iron fence because the gate is locked and we have no key, we settle into our hard narrow bed by eleven, so very happy to be there.

CHAPTER THREE

A House in Cañar

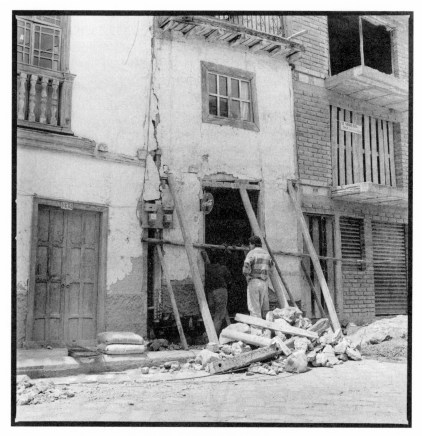

OLD HOUSE FALLING DOWN

TODAY WE ARE IN Cañar to finish negotiating for the house we spotted earlier this week, and I'm surprised at how nervous I feel. I really want this house—it's on the Paseo de los Cañaris, not far from the storefront where we lived eight years ago and in a perfect location on the edge of town where the roads come in from the country. The concept of renting is still relatively new to Cañar, and I'm amazed that we found a place so easily. After

walking by a house without curtains and peering in to see that it was empty, we tracked down the landlady (with the help of Esthela), arranged to take a look, and told the landlady we wanted it, all within a few hours.

When I first knew we would be living in Cañar this year, I imagined us in one of those dark, old, two-story adobe buildings in the center of town—most likely over a storefront—or in a falling-down mud-and-thatch house in the country (though an inhabitable empty house in the country is almost unheard of in this area). In either case, I figured our living quarters would be dark and chilly and cramped. In the country we would be unlikely to have any of the amenities that we associate with modern life, other than electricity: no indoor running water, heat, bathroom. In fact, most Cañari country houses do not have even a latrine; people use the great outdoors, as they have for millennia.

But the house we found on Monday has it all: running water, electricity, a bathroom, even a phone line. When the owner, Nelly Cantos, first showed us the house, she unwisely revealed that the last tenant, the municipal property registry office, had paid twenty dollars a month for the past three years. Therefore, logically, we offered thirty dollars. Nelly said she would have to talk to her husband, Víctor, a *migrante ilegal* in Queens, New York. Thus began a week of negotiations. We would call each day from Cuenca to see what Víctor had said the night before, and he always told Nelly to hold fast at fifty dollars, which would nudge us to increase our offer by five dollars each time.

One day Nelly said—rather unconvincingly, I thought—that she had other people interested, and even though I didn't believe it, I immediately felt anxious about getting the house. I hate the tension of uncertainty, the waiting and back-and-forth haggling; I would have agreed to fifty dollars the first day. Michael seems to love it, however; he says to quibble as a buyer shows respect for the seller. So today I wait impatiently in Estudio Inti with Esthela, sitting on the blue painted bench that belonged to us when we lived in the storefront, while Michael goes down the hill to have the final talk with Nelly.

Soon he's back at Estudio Inti with a glum look, making a shrug that says, "What could I do?" But there's a half smile lurking, and I know his tricks well. "It's ours?" I ask. "Yep," he says. Nelly had firm orders not to waver, so we have the house for a year at fifty dollars a month.

By two o'clock that afternoon we are sitting with Nelly in a lawyer's office on the town square. She has insisted we draw up a legal contract, which is very formal for Cañar, where in our experience things are usually arranged

by a handshake, but since Michael and I also like the idea of having the protection, however dubious, of a paper agreement, we happily go along. The lawyer, whose name is Wilson González, according to the plaque beside his door, is one of the legions of *abogados* in Cañar. All, with only one exception that I know of, are mestizos—that is, non-Indians—and all, without exception, call themselves "Doctor." They work from one-room offices that open onto the street to more easily serve drop-in clients, which is how most people take care of legal business here.

Dr. González's office is a plain affair, one small room in a row of one-room offices on the narrow street facing the town square, which is boarded up for "municipal improvements," according to the sign on the fence. The lawyer sits at a small desk while a young woman with cat-eye glasses and red lips and nails mops the wood floor. The acerbic, solvent-based cleaning paste she is using is so strong that my eyes immediately begin to water. When she sees us, she stops mid-swipe and props the mop in the corner of the room.

El doctor, a slim, middle-aged man dressed neatly in a suit, stands to greet Nelly, whom he appears to know. She tells him our business. He bows slightly, gestures for us to take seats on the plain plastic chairs lining one wall, and assumes his position at a small typewriter table across the room. His assistant, the young woman, sits decorously on a small stool at his side.

"Passports and *cédulas* please!" Dr. González suddenly barks. The assistant stands, crosses the room, collects our passports and residence cards, and returns to her post on the stool. The lawyer snaps two sheets of plain paper with a carbon into a tiny manual typewriter, runs his hand slowly over his mustache a couple of times, closes his eyes for a moment as though thinking, and then begins to type furiously, hunt-and-peck style, with his two index fingers.

As we sit waiting, I turn to Nelly, as she seems open and friendly. A pretty mestizo woman of about thirty, her cut and curled hair, makeup, jeans, and bright nylon jacket all suggest that she knows a world beyond Cañar. She tells me that Víctor has been in New York for more than seven years as an undocumented immigrant. He works in construction, in a well-paying, steady job, and lives in Queens, where hundreds of thousands of illegal Ecuadorians have established a mini-Ecuador. Nelly says she joined Víctor for four years, until last year, and she too had a good job, making jewelry in Manhattan. I ask why she came back. *"Por la niña,"* she replies, for the child. She has a little girl named Wendy, seven years old, whom she left in the care of her mother. Nelly adds that Víctor is coming home for good

in December. "The family has been apart too long," she says. "Víctor left right after Wendy was born, and he doesn't even know her."

I nod sympathetically. This is a familiar story. *Migrantes* make the perilous journey to the United States accepting that years will pass before they will see their children, parents, or spouses again. The initial cost is so great (in the early 1990s, Víctor would have paid seven or eight thousand dollars to a *coyote* to get him to New York) that a visit home is too expensive — returning to the States would involve another *coyote*'s fee, which is now closer to ten thousand dollars.

Doctor González pauses, closes his eyes a moment, strokes his mustache, and asks, "Who will pay for repairs?"

"*Yo, la dueña,*" says Nelly. I, the owner. The lawyer types furiously.

"What is the roof made of?" he asks. "How many rooms? What is the telephone number? Who are the neighbors?" Nelly patiently gives the answers. I suppose these questions are important in a place where there are no street numbers and often no streets, only a house with a red roof next to the car mechanic's shop and across from Doña Teresa's store, where one can buy freshly killed chicken daily.

Nelly tells me that she and Víctor own another rental house in our immediate neighborhood; both are investments made with their U.S. dollars. She and her daughter live with her mother across the street from our house, behind a store.

Every once in a while, the lawyer makes a mistake and the assistant, watching intently over his shoulder, grabs a correction pencil from a ceramic Santa boot sitting on the desk. She hands *el doctor* the tool, much like an attending nurse in an operating room. He rolls the papers out with an expert snap, flips the carbon aside, rubs out his error, rolls the papers back in, and types the correction with extra pressure, eyes close to the paper, fingers coming down extra hard.

When it is time to add our difficult names to the end of the document, the assistant spells them out, carefully enunciating with her red lips and pausing after each letter. With a twist of his wrist, Dr. González shoots out the papers, extracts the carbon with a flourish, and gestures for us to come over to the large desk and sign the document. His assistant hands us a pen and points with a long red nail to indicate where we are to sign.

I glance at the last sentence: "This rental contract is ratified by these signatures in Cañar, Ecuador, on the 27th of October, 2000, by duplicate, but with only one effect." I love that: "by duplicate but with only one effect." As though there might in theory be two houses, two Nellys, two sets of us. The lawyer's name does not appear anywhere on the document, nor is

there a notary's stamp or seal. In fact, he doesn't keep a record; the assistant hands one copy to Michael, the other to Nelly. The agreement is between us, and the lawyer will have no further part in it.

As we step into the street, Dr. González stands leaning against the open door, gazing out at the boarded-up square. He strokes his mustache and smokes a cigarette with the satisfied expression of a man enjoying a job well done. I hear Nelly ask him his fee: sixteen dollars.

WE WALK BACK TO take another look at our new home. Alone in the house for the first time, we make a clear-eyed tour and see how shoddily built it really is. Constructed about twenty years ago, we guess, the house is made of concrete block, a standard construction material for newer town houses, with a red roof of cement/asbestos panels. A brick facade on the two sides facing the street and a small entry patio with a black wrought-iron fence give the house a few touches of grace, at least from the outside. Inside, the concrete plaster walls are rock-hard, pockmarked from people trying to hammer in nails, and badly in need of fresh paint. In the kitchen, some of the lower cabinet doors hang by one hinge, while the upper cabinet doors are stuck fast, with missing knobs and hinges. But this doesn't matter, because the cabinets are hung too high for anyone to use, which is curious because Michael and I are a head taller than most people in Cañar. The floor is colored concrete tile.

Above a stainless-steel sink, a single cold-water spigot sticks out of the pink tile wall. "Good pressure!" Michael says with satisfaction, turning the water on full blast. There is no fridge or stove, but Michael (the cook in our family) declares the kitchen workable, even with broken cupboards and minimal counter space. He'll buy a two-burner gas cooker and a counter-top oven in the market in Cuenca, he says. Under the sink is open space for two tanks of natural cooking gas, a standard arrangement.

This will also have to be my domain for developing photographic nega-tives, I think, eyeing the faucet. Three years ago, we built a darkroom for José Miguel in a small rented space near his studio, which I will also use this year, but it has no running water. I can haul water for making prints, but running water is necessary to wash the developed negatives.

We walk through the other rooms. A single forty-watt bulb dangles at the end of a cord hanging from the ceiling in each room. Michael clucks with disapproval at light switches that spill out of the walls, swinging by their wires. He points out a hole in the concrete floor by the back door where someone dug for a pipe, shaking his head that anyone would bury water pipes in solid concrete.

In the two bedrooms, built-in drawers are stuck tight and closet doors refuse to open or shut. In the dark hall that runs between the front and back rooms, the translucent plastic ceiling tiles intended to let in light from a skylight in the roof are cracked and covered with twenty years of grime.

But at the end of that dark hallway is a wonderful thing: a bathroom! I never expected to have an indoor bathroom in Cañar, and I have to take a close look to make sure it's real. So it's windowless and dark, with an unattractive blue toilet, a broken turquoise toilet seat, a miniature blue sink, and bizarre floor tiles with an embossed design of splashed water. So it has a single fluorescent strip for light and an ominous executioner's switch with cords running to a showerhead. It's an indoor bathroom!

Back in the living room, I see that termites have finished off most of the crude moldings where the walls meet the floor and, judging by the neat little piles of sawdust, also seem to be at work on the built-in bar and shelves. Cheap wood floors in every room but the kitchen will require constant waxing with the same nasty concoction the lawyer's assistant was using to keep the dust down.

"What's that on the ceiling?" I ask Michael, squinting up at small gobs of . . . yes, chewing gum. Remembering that this had been a municipal office for the last three years, and knowing the Latin American propensity for paperwork, I imagine some disaffected, underpaid clerk shooting gum onto the ceiling with a paper clip and rubber band instead of registering property sales. Days later, we find handfuls of official-looking papers stuffed in drawers and cabinets in the kitchen, which I attribute to the gum-shooting clerk.

Still, we are enormously pleased with the house. With large windows in nearly every room, it is full of light. Too full, at the moment. There are five big windows facing two busy streets, so we will be in a fishbowl until we have curtains. We immediately begin to take measurements and try to devise a method to hang "window treatments" from the rock-hard walls. (Michael ends up designing an ingenious system of wires and clothespins that requires minimal involvement with the concrete surfaces.)

We'll be just fine here, I think. A minimum of fix-up, a couple of beds and some inexpensive tables, stools, and benches from the market, and we'll be ready to go to work. After years of renovation projects on our house in Portland, I'm happy to live for a year with scuffed walls, non-functioning cupboards and closets, and a single cold-water spigot. Low maintenance and no emotional involvement appeals to me.

Also, I confess, I am comforted by the thought of the small, eighth-floor apartment in Cuenca that we have arranged to rent from a friend while

she lives in the United States this year. It will be a perfect retreat when we need hot showers, a good bed, a telephone (the line in Cañar turns out to be disconnected), bad movies, occasional concerts, restaurants, and privacy—which will be, at times, what we need the most. As well, for me, Cuenca will be the source of bookstores, office supplies, photo materials, a post office, and Internet service. For Michael, the city offers a modern supermarket full of items unavailable in Cañar, such as olive oil, balsamic vinegar, tomato paste, wine, and imported cheeses. After the shopping is done he'll have the Cafecito, a small cafe and backpacker hangout run by a Spanish couple, where he can feed his passion for chess with plenty of living, breathing partners, a welcome contrast to his solitary electronic game.

HOW THIS COUNTRY LOVES its paperwork! *Trámites* (tra-mee-tes), the Spanish word for official transactions. When I was first learning to speak Spanish years ago in Costa Rica, I innocently pronounced it "traumites," to the great delight of my friend Ana, who said I made it sound like just what it is in most cases: trauma-inducing paperwork. This morning, we went to the police station in Cuenca to make official our presence as foreigners in this country. A young policeman in a pressed brown uniform attended us in a private office: "Passports please? Copies of visas? Two photos? Address? Do you have children? Only one? What is his name? Scott? Okay! Eight dollars please." Stamp! Stamp! "Come back tomorrow."

We have just completed *el censo*, or census, which gives us permission to be residents in the country for a year, the duration of our visas. Tomorrow, we will return to request permission to *leave* the country. That will cost five dollars. Our friend Isabel, who owns a travel agency, has instructed us to pay close attention to this particular *trámite*. Clients of hers from Canada, two doctors doing volunteer work in the jungle, did not, and after they overstayed their visas they were not allowed to leave the country until Isabel had a talk with the national chief of immigration in Quito. Ecuador being a small, I'll-scratch-your-back-if-you'll-scratch-mine sort of place, Isabel's father is no doubt an old school friend of the national chief of immigration, or maybe her second cousin is married to the nephew of the minister of the interior. In any case, we heed her warning and return the next day to secure permission to leave Ecuador in one year's time.

Afterward, we go for lunch at the nearby Hotel Príncipe, where we are the only guests in the beautiful glass-covered courtyard of a converted, colonial-style house. An old waiter shuffles over, pulls out his pad and pencil, and gravely says to Michael, "Sir, what is your name and passport number?" I leaf through the file of papers from the immigration office and read off

Michael's passport number. The waiter carefully copies it on his pad. "Now, what would you like to order?"

After we finish eating, the waiter asks Michael to sign the bill, even though we are paying in cash. "Why all the *trámites* for lunch?" I ask. "We don't remember this from when we lived here before."

"The new tax law," the old man says impassively. "Now the government says we have to report every transaction so it can collect taxes. *¡Qué cosa!*" What a thing!

We saunter back to the apartment through beautiful *Parque Calderón,* the main plaza, pleased with all the red tape we've navigated this week: a year's contract for a place to live, permission to remain in the country—and leave it when the time comes—and with our lunch today, we've even made a small contribution to the government's tax base. *¡Qué cosa!*

The Day of the Dead

EDELINA MOROCHO AND ANTONIO GUAMÁN

TODAY, EL DÍA DE LOS DIFUNTOS, the Day of the Dead, marks the beginning of our new life in Cañar. Michael has hired a truck to haul our things from Cuenca, and early in the morning he and the driver, Octavio, load our bags and boxes from the apartment and then pick up the chairs, tables, benches, stools, food cabinet, mattresses, blankets, dishes, pots, gas hot plate, and filing cabinet we bought yesterday at the open-air market. But the woman who owns the furniture stall is not there to open her store-

room, and according to the vendor in the next stall, our things have been moved to another storeroom. Michael, irritated, calls me at the apartment from a pay phone in the market to report this news. Patience is not one of his virtues when he's focused on a goal. He and Octavio can only wait, he says, and we'll meet up later in Cañar. There will be no room for me in the overloaded truck, so I'm taking the bus.

I put the apartment in order, make a few phone calls, pack my cameras, and catch a cab for the bus terminal, where I'm lucky to find an empty seat on Transportes Cañaris, one of two lines that run to Cañar every thirty minutes. I sit down with a sigh, stow my pack under the seat, and open my book. One of the things I love about riding buses in Ecuador is the time it gives me for concentrated reading. Today, it's a novel by Edna O'Brien, a great Irish writer. I've brought a stock of books that I must try not to read too fast, but friends coming in a few months have promised to bring me more.

Two hours later, I'm striding along the Paseo de los Cañaris toward our new house when I hear Michael yell my name from a dark doorway. I follow his voice and find him sitting with an old man in one of the tiny one-table taverns in the row of storefronts that line the street. Both men are drinking beer and looking very happy.

"Why are you *here?*" I ask, gesturing down the street toward our house, where I can see boxes and furniture piled up outside the door. "Nelly has gone to church for the Day of the Dead mass," he says, "and she's taken the house keys with her, even though I called yesterday to let her know I would be here with a loaded truck between ten and eleven." For some reason, Michael speaks to me only in Spanish, as though the old man sitting beside him is a friend who shouldn't be left out of our conversation. I ask him questions in English: "Is it really okay to leave all our things out there?" He answers in Spanish: *"Sí, está bien. Todo está dentro de las rejas."* Yes, it's okay, everything's inside the fence. I glance skeptically toward the house. Somewhere in that pile is my laptop, not to mention thousands of dollars of photography, video, and sound equipment. I decide to trust that no one will bother our things. We're on a main street and people stream by, coming in from the country for the Day of the Dead.

Michael introduces me to Luis, the owner of the tavern and Nelly's brother. Luis assures us that Nelly will be back any minute, but after a pause he adds, "Although maybe she'll go to the cemetery after the mass." Why Nelly couldn't have left the keys with Luis, who lives next door to her and across the street from our house, we don't ask.

After a few minutes we see Antonio Guamán, one of my original photography students from our first Cañar stay, walking by with Luz María, his oldest daughter. We yell, and Antonio says he's come to take me to the cemetery to visit Adelina's grave.

Antonio looks much the same as when we saw him last three years ago, when his world was falling apart. His light skin is still badly sunburned and scabby (he's whiter than many who consider themselves "white" in this town), with lips permanently darkened by the Andean sun, two front teeth missing, and a perpetual puzzled/hurt expression in his eyes. In December 1997, while we were in Cañar for a visit, his fierce, beautiful wife Adelina died of head injuries after a fight with an old aunt over something that Antonio referred to vaguely as "jealousies." He said they had both been drinking for several days. In addition to their two little girls Luz María and Pacha, Adelina left two other small children, Sisa and Nicolás. Luz María, whom we've known since she was a shy little five-year-old who spoke only Quichua, is a teenager now, and she greets me confidently with a handshake and a kiss.

I leave Michael happily drinking beer with the old man and keeping vigil over our worldly goods and head toward the cemetery with Antonio and Luz María. Throngs of people crowd the streets, jostling for space with the trucks, cars, and vendors' carts that line the road. Mestizos and *indígenas,* young and old, country and city folk—I don't think I've ever seen so many people out and about in Cañar, not even on market day. Antonio quickly threads his way through the dense crowd and I keep a sharp eye on his bobbing white hat. Not all *indígenas* from Cañar wear white hats; those from other regions of the province wear green, brown, or dark blue fedoras. Luz María follows me, occasionally touching my hand to point me in the right direction.

Cañar's municipal cemetery sits on a rocky hillside on the edge of town, just beyond a small brown river. A few eucalyptus and pine trees have been allowed to stand around its perimeter, giving the place a slightly park-like air that is sadly missing elsewhere in Cañar. From a distance, the cemetery looks like a miniature city. Tall white walls containing coffin niches march up the hillside like high-rise apartment buildings. These days, most people are laid to rest in these burial niches, each just large enough to hold a coffin, which makes economic sense in a country where land is scarce and few have money to buy burial plots. The older part of the cemetery, where we go first to look for Antonio's father's grave, however, is nothing but grassy hummocks. Ragged paths wend pell-mell around the graves, and white crosses

and crude stones stick out at crazy angles. Some graves seem to be sinking away, and others are perilously crowded on top of one another; probably the unstable land of the hillside has shifted.

It is midday, the sky is clear, and the sun is intense at this altitude. Ice cream vendors walk among the crowds calling *"helados, helados,"* adding a carnival air. Everywhere, people sit on the graves or stand around them in their best clothes, chatting or eating snacks. They have come to town today—some from as far away as Quito—to honor *los difuntos,* family members who have died, and to tend to their graves. The Catholic Church on the square will hold several masses where, for a small payment, the name of a departed loved one will be read to the congregation. Families move en masse from graveyard to church and back again. The ritual is played out in Cañar as a day for relaxation and socializing, similar to the way the pre-Hispanic Cañaris might have celebrated this time as a harvest festival. (The Spanish missionaries who came after the conquest co-opted the indigenous festivals by introducing Catholic feast days at the same times.)

In the older part of the cemetery, some people are hard at work digging with shovels or picks to free a half-buried cross or grave marker, while others pull weeds or arrange bouquets of flowers or light candles. We don't find Antonio's family at his father's grave, so we head for a newer section of graves in the outer edge of the cemetery. I have a hard time following Antonio through *las multitudes,* as he calls the crowd, because I'm trying to both watch my feet on the hummocky paths and gaze around to take in the spectacle at the same time. I'm carrying three cameras in my backpack that I dare not take out, but my eyes register everything. Finally, we see Mercedes, Antonio's sister, at the far end of a walled rectangle of niches, surrounded by family. As a friendly gesture to remind me who is who, Mercedes formally introduces me to each adult and child by name; I have met everyone at least once over the years. When I last saw this family, Adelina had just died and her two youngest children were badly malnourished and underdeveloped. Now they look healthy, but they are still very small for their ages. When little Nicolás sees me he raises his arms to be picked up and clings to me like a monkey—a very unusual gesture for Cañari children, who are usually terribly shy and reserved. He weighs nothing.

"Would you like to see Adelina's *tumba?*" Antonio asks. He leads me through the crowd and points to a niche about two feet square in the very bottom corner of the wall. He unlocks a cracked glass door and we kneel down to look inside. I see paper flowers, a couple of poems to "Mama," and a black-and-white portrait I had taken of Adelina the first time she and Antonio came to visit us in Cuenca. Antonio has cropped the photo, clip-

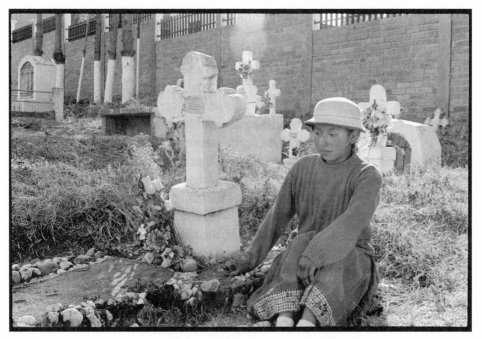

MARIANA, MAMA MICHI'S YOUNGEST DAUGHTER,
AT HER GRANDFATHER'S GRAVE

ping out the head and shoulders to fit into a little paper frame, which sits at an odd angle on the floor of the niche. Antonio straightens it and tries futilely to pull the broken piece of glass back into place before he locks the little door.

At Mercedes's request, I take some photos of the family. She groups her relatives in various combinations: Antonio's four children with Mercedes and her mother, then Mercedes's mother and her aunt, then Mercedes and her sister, Rosa. It's not the best time for photos, with the cramped space, harsh midday sun, and throngs of curious people on top of us, but when in Cañar I never turn down an invitation to take photographs.

Afterward I treat everyone to ice creams—not really ice cream, but a meringue-like concoction that never melts—and we troop back over to the family plot in the old part of the cemetery. Along the way I stop to greet people I haven't seen, extending invitations to visit us later in our new house. Here's Mariana Chuma Solano (Mama Michi's younger sister) and her three teenage children standing in front of the niche of their husband and father, Juan Carlos. Michael and I knew him briefly eight years ago, before the soccer game and fatal kick to the stomach that led to his death

a few days later. And there are Mama Michi and her family sitting on the grave of her husband, Serafín, who died two years ago of alcoholism and the lingering complications of a police-inflicted injury. I am reminded that this is a culture of tragic deaths and an overabundance of widows.

We pass by Adelina's mother and two sisters, who are working with shovels to dig out the covered grave of their father and husband. There, sitting alongside and watching the action, is Adelina's very old grandmother, whom I photographed in 1993 and also in 1997, when Adelina died. Antonio told me at the time that she had begged to take Nicolás, still a baby, and keep him "until she died." (Antonio's family took Nicolás back several months later when *he* was almost dead of malnutrition.) I smile and nod, remembering that she speaks only Quichua, and the grandmother gives me a toothless smile in return.

We sit awhile on Antonio's father's grave until, by some signal, everyone knows it is time to leave. Mercedes, Rosa, Antonio, and Luz María walk back with me to the house while the younger children go home with their grandmother. Michael is hauling the last of our things through the front door. He says that Nelly finally appeared three hours late, without so much as an apologetic shrug.

With the help of our guests, it takes all of five minutes to install our lightweight furniture, boxes, and bags in the house. We set up the tables and stools in the *sala,* and Michael goes one way down the street to get beers while I go the other for fresh rolls. I make sandwiches while Michael gives Mercedes the small chess set he had promised three years ago to bring her. In Quichua, she explains the basics of the game to Antonio, Rosa, and Luz María, who sit rapt through her long description.

The sun, the beer, the altitude, the reunions in the cemetery—I'm exhausted. Once Antonio and his family leave, I flop down on the stacked mattresses in our bedroom to read my book. Ah, a short nap would be so delicious.

Shortly, however, others begin to arrive. Mariana with her three teenage children: Alexandra, Maritza, and Juan Carlos; Mama Michi with her daughter Zoila; and the three grown children of Mama Michi's brother: Ranti, Purificación, and Mariana. Michael and I know everyone from when we lived here before, though some of the younger ones were children and I wasn't always sure of who was who. Now, each person greets me formally with a handshake and mentions his or her name, as though we are meeting for the first time.

The women carefully set their loaded shawls or baskets down outside the door before entering. Each is dressed in her best clothes: embroidered

blouse, bright wool skirt, and new white felt hat. The young men wear sports clothes—fake Nikes, sweatshirts, and black jeans. For them, it is not cool to wear traditional Cañari clothing except on the most traditional occasions. We sit around the two wooden tables in the *sala*, using every single chair and stool and bench we bought yesterday. Michael serves beer and cola, and as I watch I feel a sudden rush of well-being to have old friends here in our house and to know that this is the beginning of a year of working together. This has been my dream for a long while, to be right here in the midst of the cycle of plantings, harvests, marriages, baptisms, births, and—as it will sadly turn out before the year is done—deaths. While we won't exactly be neighbors with the Cañaris, our new house is located at the intersection of the roads to the two villages, Quilloac and Correucu, where almost all of our friends live. I imagine casual comings and goings, drop-ins on trips to and from town, walking out to the villages to visit.

My reverie is interrupted by a question from Mariana, Mama Michi's sister. "And where do you sleep?" she asks politely, looking around the *sala*. After another question of a similar nature, and significant glances between the women, I realize they want a tour. As I show the rooms, the women examine the place with critical eyes but little comment. Mariana feels the handmade wool blanket we bought in the market in Cuenca yesterday and remarks on how much work it represents for the weaver. "How much did this cost?" she asks shyly. Everyone peers into the tiled bathroom, serious and silent. In a culture where even outdoor latrines are rare, to have an indoor toilet in the house, next to where you cook, seems a little obscene, I think.

Finally, back in the *sala*, Mama Michi asks what we are paying in rent. Michael and I have our story ready. After an elaborate lead-in (we know it is too expensive, we tried to negotiate a lower price, this will be both our work and our living space, etc.), Michael says that we are paying fifty dollars a month. A couple of the younger people gasp, but the older women nod their heads, and Mariana says that for an entire house, with all these rooms, we are paying a fair price. I'm reminded that until recently the indigenous world was largely a culture of barter and trade, not cash. Fifty dollars still represents more than the average monthly income of most country Cañaris, and for many there is no income to speak of, only the meager return from selling potatoes or carrots in the Sunday market. The thought of paying fifty dollars a month for a place to live must seem outrageous.

As our guests prepare to leave, Mama Michi crosses her arms, looks around with authority, and says that what the house really needs is a *limpieza*, a ritual cleansing, to rid it of its "bad energy."

"Yes," I say, "we should banish the spirits of those municipal bureaucrats who used this house as an office for three years." Everyone laughs. Tomorrow, Friday, is an auspicious day for a *limpieza*, Mama Michi says. She and Mariana will come around sundown, the best time for such a ritual.

OUR FIRST MORNING in the new house. We wake at six under about twenty pounds of blankets, but our night still would have been cold had we not slept plastered together. Tonight, more blankets. My guess is that the nighttime temperatures inside the house are in the mid-forties. I make a mental note to get a thermometer so I can know how brave we are. From our bedroom window I see a promising wedge of blue sky over the neighboring roofs, which motivates me to jump out of bed and into my clothes, but not before Michael has made coffee. It's delicious, camp-style, boiled coffee from a big red enamel pot we bought in the Cuenca market.

Yesterday, Michael set up his kitchen with two gas countertop burners and a big, box-like, white enamel oven that he says will make excellent pizza and bread. Three beat-up looking tanks of gas about two and a half feet tall live under the counter, with control valves and a tangle of hoses running to each stove and the oven. Not a pretty sight, but Michael was particularly delighted with the high-pressure gauge he installed on one of the gas stoves, which allows an extra blast of gas. "I'm cookin'!" he yelled excitedly, as the ten-inch flame leapt into the air.

As luck would have it, the morning sun falls directly on the small table in the eating area next to the kitchen, and here I sit with my *café con leche*, watching the action in the street. I see young girls walk into town, neatly dressed in their wool *polleras*, embroidered blouses, and white hats; a man on a small shaggy horse heads for the country; a very old woman, stooped and stumbling, walks by with a stick. That might be ancient Mama Jesús, Mama Vicenta's sister, whom I photographed years ago. I remind myself to visit the family to see if I can make another portrait.

After breakfast, Michael leaves with his shopping list to explore what the small stores in the center of town have to offer in terms of household goods, while I clean the windows and cut curtain lengths from a bolt of white cotton. He comes back an hour later with a broom, dustpan, hammer, hand drill (to reset the broken front door lock), and hacksaw (to shorten the legs of the countertop stove). In the afternoon, we make a trip into town together and come home with a plastic bucket, a silverware holder, a tray, a dish drainer, a pitcher, and a broom. It's beginning to feel like home.

La Limpieza

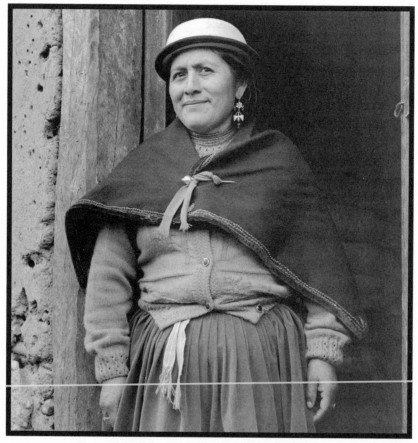

MARIANA SOLANO, COMMUNITY NURSE

IN CAÑARI CULTURE a *limpieza*, or ritual cleansing by a *yachaj*, is considered essential when someone moves into a new house or opens a business, after a death, or when life goes seriously wrong. Robbery, illness, crop failure, a cow's death, or simply a personal run of bad luck—anything that can be attributed to evil forces (*mala energía*), bad air (*mal aire*, the origin of the word malaria), or even a spell cast by an envious neighbor (*envidia*)—qualifies. Michael and I have never seen a *limpieza*, but we are honored to have this

ritual performed on our house today by Mama Michi. It means our Cañari friends want to protect us, but more importantly, it marks a new level of acceptance into a facet of the culture that so far has been hidden from us.

Assuming that this will also be a social occasion, Michael and I shop for cookies and the makings of *canelazo,* the hot alcoholic drink that is served at any important event. At the last minute I buy a length of checked red oilcloth to cover the tables.

As sunset nears I put on the one skirt I brought to Cañar, and Michael shaves. We are as nervous as if on a first date. At around five thirty Mama Michi's sons, José Miguel and Pablo, arrive carrying a couple of buckets, several bottles filled with liquids, and a small charcoal brazier. Mama Michi can't come; she's been called to an important meeting about her native medicine clinic, but Pablo, who José Miguel tells us is Mama Michi's apprentice, will preside, and Mama Michi's sister, Mariana, and Mariana's daughter will assist, along with José Miguel. Mariana soon arrives with Alexandra, a serious young woman who is studying agronomy at the University of Cuenca. Both carry armfuls of herbs, flowers, and wild plants. I smell rue and recognize stinging nettle and a blooming plant that looks like belladonna, but that is the extent of my local plant knowledge. Everyone is dead serious and busy with preparations, so I don't interrupt with questions.

Pablo works on the front patio mixing liquids from the bottles, while José Miguel sets up the small charcoal brazier and lights the coals; the piney smell of incense immediately wafts into the house. I am intrigued to see Pablo in this role. When I first knew José Miguel, Pablo and Serafín were boys around ten or twelve, two of many children around Mama Michi's compound. During my visits back to Cañar I would see them hanging out in some ill-defined region of the house or the yard, doing no work that I could see (although most likely they were required to help out in the fields). Esthela has told me that as adults the brothers "have learned to drink," a local expression for those who hit the bottle too frequently, and in fact, when I run into them at Mama Michi's, they often look *chuchaqui*—hung over. I have felt, probably unfairly, that they have none of the charm and curiosity and drive of José Miguel. But here, to my eyes, is a new Pablo, busy giving instructions to his assistants, confidently mixing concoctions for the *limpieza.*

Pablo says I can take photos only of the preparations, but not once the ritual begins. I grab my camera and run in and out of the house trying to capture a few images in the waning light: José Miguel fanning the brazier on the patio, Pablo shaking his bottles, Mariana and Alexandra in the *sala*

sorting the herbs and plants into piles on the floor and tying them into crude brushes.

Now it is time to begin, and Pablo directs the show. We must move counterclockwise around the house, he says, indicating a corner of the front room as the starting point. He will go first with the liquids and Mariana will follow with the plant brushes. José Miguel will come next with a bucket of water, and Alexandra will bring up the rear with the incense burner. Michael and I stand awkwardly in the middle of the room, not knowing if we should participate or just watch. It's near dark and I offer to turn on the lights, but Mariana says the *limpieza* is more effective with the lights off.

I ask whether we will know if any bad spirits are present and Pablo and Mariana nod knowingly. "We'll know by the heaviness in our arms," Mariana says, holding up her brush.

Pablo walks to a corner of the *sala*, takes a mouthful of liquid from a bottle, and with a *whoosh* blows a cloud of spray up and down the wall. He moves quickly around the room and into the hall, his head going up and down as he appears to blow the atomized liquid over every surface in the house (a fact I confirm the next morning when I find a dried milky substance everywhere). The mixture smells something like Listerine—sharp and acerbic, but pleasant. I'm sure it has an alcohol base, as do most liquids used in Cañari rituals. When I realize what Pablo is doing, I run into my office, close my laptop, put away a couple of cameras, and look around to see if there is anything else I don't want sprayed. Michael does the same in the kitchen, just ahead of Pablo.

Mariana follows Pablo, smacking the walls with the herb brushes, stooping low to the floor and reaching as high up the walls as her four feet-something height will allow. Bits of leaves and flowers fall to the floor and scatter on tables and countertops. José Miguel comes next, holding the bucket in one hand and splashing water up and down the walls with his other. Alexandra is last. Her job is to set the smoking brazier in the center of each room for a few minutes so the smoke can reach any nooks and crannies that the liquid or brushes have missed. The smell of incense fills the house.

Once all the rooms have been covered, Pablo opens the door to the back patio and sprays the back exterior wall of the house. Then he walks quickly through the house and out the front door, spraying the front exterior walls and windows. Meanwhile Michael has found hot coals burning the wood floor in the cluttered storeroom where he keeps his clothes and tools; without comment, he stamps them out and checks the other rooms.

As everyone finishes, we gather in the *sala*. Alexandra sets the brazier in the center of the room. "Now," Pablo says, looking at Michael and me, "each of you must be cleansed." He directs me to stand in the open front doorway, facing in. Mariana hands him the herb brush and he takes a big mouthful of the liquid from the bottle; I know what is coming and close my eyes. Pablo sprays me and brushes my body up and down, from head to feet, front and back. It stings a little, but I suppose that's good—one should feel a *limpieza*. I try to be alert to any other sensations, but I'm too fascinated by the process—too much the documentarian, I suppose—to feel anything. Then Pablo does the same to Michael. It's all very fast, as though slowing down might give the bad spirits a chance to get to work again.

Afterward I ask Pablo and Mariana if they felt any *mala energía* in the house, and Mariana nods yes. *"Muy pesado,"* very heavy, she says gravely, shaking out her arms. José Miguel also shakes his arms as though he has been carrying a heavy load, and Pablo adds that he feels a weakness in his legs. Mariana turns to Pablo to say that now it is time for her *limpieza*. She takes off her shawl and outer sweater and stands in the doorway. Pablo sprays and brushes her twice—perhaps because of the heaviness in her arms she needs a double cleansing. But who will cleanse Pablo, I wonder?

Later I learn more about the *limpieza* ritual from Mama Michi. She tells me that *yachajs* are always at risk of absorbing, or "catching," the condition or problem being treated, and that is why they must have periodic cleansings, which have to be performed by someone of equal or greater power as a *yachaj*. Mama Michi could cleanse Pablo, for example, but he could not effectively cleanse her. Mama Michi says she goes to a *yachaj* in another province every few months for this reason.

When we are all cleansed and back in the *sala*, I assume our ritual is over, but Pablo takes a packet of herbs and resins and deposits a pinch in each of our hands. He demonstrates how we should press our closed fist to our hearts and then our foreheads, then circle it around our heads and bodies. Then he says, "Make a wish and throw the resin on the brazier." Make a wish? I react like a child, wanting to wish for something foolish, but I think we are probably supposed to use this opportunity wisely, so I simply wish that we'll have a productive year here. The brazier is smoking like crazy with our offerings, and Pablo shows us how we should kneel in front of it and use our hands to sweep smoke around us. We each take a turn; the house is soon full of smoke and my eyes are stinging.

The ceremony over, Michael brings out the *canelazo* (a delicious hot toddy made with water, cane alcohol, lemon, cinnamon, and sugar) and the cookies we bought in the market. He does the ritual toast, handing one small glass

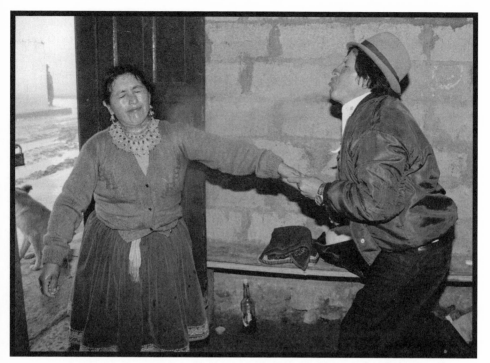

LIMPIEZA OF MARIANA BY *YACHAJ* IN COMMUNITY OF GENERAL MORALES

around to each person in turn, beginning with the most important person—Pablo in this case—and then refilling it for Mariana, and so on. *"Salud,"* we say before drinking. *"Dios se lo pague,"* may God repay you, each person says to Michael, handing back the glass. Michael and I thank everyone separately for helping to cleanse our house and our bodies of *mala energía.* A payment is customary for a *limpieza,* and although Michael and I talked about this earlier, we hadn't decided on anything other than agreeing that we'd rather not use money. Now, Michael spontaneously remembers he has a new Swiss Army knife in his things, and he gives it to Pablo, who seems very pleased.

Finally, Pablo tells us what to do with all the *desechos,* or debris left over from the ritual—bits of flowers, leaves, and dead coals scattered around the house. We should leave everything in place until tomorrow, he says, and then sweep it all towards the center of the house, not out the doors. We are to collect everything in a bag, tie it up, and set it outside the fence, off the property, for the garbage pickup. We are not to leave anything that is "contaminated" inside the house. Pablo and Mariana gather up the plants and herbs, and Pablo runs down the street and throws them into the river

ravine near the Pan-American. The plants used in a ritual cleansing hold the bad energy and must be thrown away so they cannot infect anyone else.

The next morning we do exactly as we were told. Michael sweeps and gathers all the bits and pieces and sets the bag in the garbage basket outside the fence. I spend a couple of hours cleaning the windows and wiping down the walls, tabletops, and other surfaces that are covered with Pablo's spray, hoping all the while that I am not wiping away our good luck.

OUR FIRST MARKET DAY. As we sit drinking our morning coffee in the *sala* we watch an incredible parade of people and animals heading either toward town, where the Sunday market fills up the major streets, or in the opposite direction into the country, where an open-air animal market is conveniently located next to the community slaughterhouse. Whichever way the people go, they all seem to pass by our windows, and I'm newly delighted at the lucky location of our house. It's like an endless slide show out of *National Geographic.* We still have no curtains, so while our large windows provide great viewing from the inside, those outside can also look in, of course. Fair enough. For the moment, we live in a fishbowl and curious passersby can check out the novelty of the only *gringos* in town, living in the old property registry office. I hear a high-pitched squeal I can't identify, and a minute later we see a Cañari family sedately pass by dragging a mutinous pig on a rope toward the animal market. The pig seems to divine its fate, and whenever it sets its four feet rigid, refusing to budge, a child marching behind pokes it with a sharp stick.

I measure and cut curtain lengths for what seems like hours before we walk into town to hand them over to a seamstress, or *costurera*, who has a little cubbyhole shop that opens onto the street. Asked what she will charge to hem the lengths, she cocks her head and looks puzzled for a minute before saying, "One dollar per curtain." This comes to twenty-three dollars, which we know is an outrageous amount, but we let it go.

In the new economy of Ecuador—a bankrupt country that two months ago switched to the dollar as its national currency in a desperate attempt to control galloping inflation—everything seems to cost a dollar. The problem is partly that people are not easily able to convert the old currency, *sucres*, into dollars. Not knowing what to charge, many vendors simply decide on one dollar. A taxi ride is a dollar, and so is a haircut, a beer opener, a potted plant, or a toothbrush. Some of these prices are ridiculous, but seventy-five or eighty cents sounds like too much, and making change is difficult.

Before the switch, the *sucre* was so devalued that people had grown accustomed to thinking in millions (forty dollars equaled one million *sucres*,

making a liter of milk about twelve thousand *sucres*). In rural areas like Cañar, most market people still quote prices in *sucres* and together with the customer work out the conversion to dollars. Shopping takes a long time and is very sociable.

We go on to the market, where we buy some luxury items: baskets for food storage, rush mats for the bedside, two houseplants, and a mirror. "Buy the one from the U.S.," the street vendor says to me with a wink as we stand looking at the great array of mirrors on his table. "Those from Colombia will make you look too fat, or skinny, or ugly." We laugh, but his ploy works and I buy the mirror made in the United States. On the way home, we stop by the Estudio Inti for an inexpensive radio and cassette player. José Miguel and Esthela will not allow us to pay full price for anything, no matter how much we insist. (Then, when the cassette player stops working soon after, we feel we can't complain, nor can we replace it without them noticing.)

Back at the house, we relax. Michael plays his electronic chess game and studies the Quichua dictionary. He's delighted to find the word for fart: *supi.* I am guiltily rereading *Under the Tuscan Sun,* by Frances Mayes, because I like her spare and elegant style in recounting an adventure in a foreign land. But I'm amused at the contrast in our experiences: while Mayes writes of restoring a three-story villa in beautiful Tuscany that cost God knows how much, I write of our crudely built, fifty-dollar-a-month house in a homely Andean town. While she writes of sandblasting chestnut beams, restoring brick floors, and painting rooms pristine white, I write of hanging curtains with clothespins and picture wire and reinserting electrical switches into crudely cut holes in the wall. While she writes of walks along the Roman road to Cortona for an espresso in the square, I write of walks to the animal market alongside squealing pigs and ragged sheep, some dragged cruelly along by a rope tied to one leg. Still, our impulse remains the same—to make more of our singular experiences by re-creating them in words so that they may be shared with others.

A Dinner to Honor
the Dead, and Us

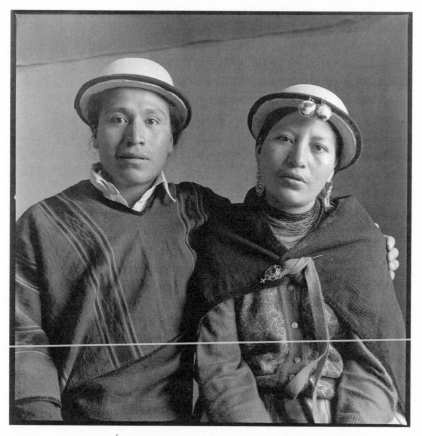

JOSÉ MIGUEL ACERO AND ESTHELA MAYNATO

EARLIER THIS WEEK, Esthela invited us for dinner on Friday night in an offhand manner that suggested a casual get-together. She said they wanted to welcome us back to Ecuador as *compadres*, godparents, and also to celebrate the Day of the Dead. Friday afternoon, I run into José Miguel and he mentions that before the dinner we are expected at the main church on the

square for a special mass that Esthela has arranged to honor her and José Miguel's dead fathers, and their baby son who died some time ago. This is only the second time I have heard mention of the child who was the reason José Miguel and Esthela married as teenagers. The first time, years ago, was when Esthela told me only that he was a fine, healthy, five-month-old baby who had died suddenly in his bed.

We get to the church thirty minutes late, expecting to find the mass half-finished, but it hasn't yet begun. The church interior is dark except for a couple of dim lights, and I see only a few people in the front pews. Then I remember that this is an irregular mass, like a wedding mass, paid for by various families as part of the traditions around the Día de los Difuntos. Maybe it won't begin until all the main players—or payers—are present. I spot Mama Paula, Esthela's ancient mother, and Paiwa with her little cousins; we slide into a pew next to them. Paiwa looks sideways at us shyly and smiles a little smile. She is still getting used to these strangers in her life, deciding what she thinks of us.

Within a few minutes the lights come up in the sanctuary and I see Esthela on the dais helping the sacristan lay out the altar cloth and light the candles. This is surprising, as I've never known Esthela or José Miguel to take the slightest interest in the religious rituals of the Catholic Church. Maybe this is the deal when one pays for a mass, I think—the "client" gets to help with the preparations. Other people drift in, a mix of mestizos and *indígenas*, until the church is a quarter full. Esthela sits with us, and José Miguel slips in at the end of the pew just as the mass starts.

Father Jesús, the gray-haired priest from Spain, begins the mass. He's been in Cañar as far back as I can remember, and I've never liked him, with his condescending, finger-wagging attitude toward his parishioners, especially the rural *indígenas*. My feeling was reinforced one day a few years ago, when I accompanied Mama Michi to a church office to make arrangements for Zoila's wedding. While we were waiting, I witnessed Father Jesús outright refuse to marry a young indigenous couple, with both sets of parents standing by. "Come back when you are twenty," he said crossly, turning to a pile of paperwork on his desk. He must have known the young woman was pregnant, which in indigenous culture is a common and socially acceptable reason for teenagers to marry. Thirty minutes later we ran into the same family group at the civil registry, where the young couple was patiently waiting their turn to say their vows in front of the notary and make their union legal. Although premarital sex and pregnancy are accepted among the *indígenas*, unwed motherhood is not. Most young couples marry quickly with a civil ceremony, then later—sometimes years later—arrange for a church

wedding on one of the Sundays each month when indigenous couples marry en masse.

Watching tonight's mass for the dead, I consider the ironic juxtaposition of the rituals we've been a part of today. A couple of hours ago, during the *limpieza*, Michael and I knelt in front of a charcoal brazier, scooping protective smoke over our bodies and touching our hearts and heads, actions not that different from the incense and gestures of the mass. And there's the connection between Pablo's alcoholic spray and holy water—I suddenly remember watching a priest in New Mexico sprinkling water on cars in a chapel parking lot to bless them. I wonder how many of our Cañari acquaintances really believe in the tenets of the church, or if they only adhere to those customs that make sense to them: the church is the place you go for weddings, baptisms, and blessing the dead. Before the separation of church and civil law in the twentieth century, the church was the only place one could legally register births, marriages, and deaths. Also, according to our Cañari friends, until recently the church dictated that only Christian names could be given to children if they were to be baptized in the church. Thus, most men and women we know have "María" or "José" in their names, and some, for good measure, have both—we know at least two men named José María. But many of the children of the present generation have Quichua names such as Inti, Coya, Toa, Curi, and Paiwa—names from the Cañari and Inca past. I awake from my reverie to see that communion is being offered by Father Jesús. Only one *indígena* goes to the front.

Mass over, our little group walks to a street corner a short distance away, where others, who I assume are relatives of Esthela, soon join us. We stop under a streetlight and everyone stands chatting in the short, breathy rhythms of Quichua. Michael and I wait, a little off to the side, not sure what is happening. Esthela has run off in one direction, José Miguel in another, and everyone but Michael and me seems to know why we are waiting—not an unusual moment for us in many social situations here in Cañar. Paiwa and several other young children stand solemnly on the edge of the group looking around wide-eyed; it comforts me to think that maybe they also are puzzled at what's going on.

After twenty minutes or so, José Miguel runs back to the street corner with a cardboard box filled with liquor and soft drinks, and Esthela also arrives shortly, breathing fast, with a load on her back wrapped in a shawl. Now it's obvious that they were buying things for our dinner—apparently the event is neither small nor casual. I should have remembered that in social situations Cañaris are extremely humble, preferring to downplay an occasion as nothing significant when in fact they might have put months

of planning into it. To be proud or ostentatious is to invite misfortune or envy, a powerful source of "negative energy" in the indigenous world.

José Miguel leads us down through the town to the Pan-American Highway, where he hires one of the trucks lined up at the bottom of the hill to take us to the house he and Esthela share with Mama Paula. He insists I ride up front with the driver, a privilege I happily accept, as it's a chilly night. Michael climbs into the open back with the others, and in a few minutes we are jolting down a rutted road full of potholes, heading into the country.

This will be our first visit to José Miguel and Esthela's house since our return to Cañar, and I watch for familiar landmarks. There is only a sliver of a moon; it's nearly pitch-dark. After a couple of kilometers we stop at an indistinguishable point in the road—no, wait, there's a stone wall; I must remember it for the next time we visit. Everyone piles out and loads up with boxes and bags and backpacks. Paiwa and her little cousin take off running down a rocky path between two fields and we all follow, walking in single file. An irrigation ditch runs beside the path, which pitches downward, and I can hear the water rushing by. Everyone but me seems to step sure-footedly in the dark, and I begin to stumble, slide, and lurch. I hear murmurs of concern all around— "cuidado, cuidado"—and somehow I manage to stay upright. How can everyone see? Once again, I have forgotten my little Maglite. Michael tells me later that he found the walk beautiful. Bringing up the rear, all he could see in the darkness was a line of bobbing white hats as the group made their way.

We walk for about a half kilometer, jumping over the irrigation canal, picking our way up a rocky lane, and climbing a short rise before finally coming to the ancient wooden doors that lead into Mama Paula's walled compound. A tethered cow munching on a pile of straw looks up and sighs heavily as I step over the threshold. To my left is the large, windowless adobe structure where José Miguel, Esthela, and Paiwa live—just one room really. To my right, I can hear animals snuffling around under a shed roof, probably pigs brought in for the night. At the far end of the courtyard, a long adobe building stretches from wall to wall, with Mama Paula's sleeping quarters and storeroom on the left, and the kitchen on the right. I peer into the blackened interior of the kitchen and see several women busy around an open wood fire. One crouches close, roasting two *cuyes*, or guinea pigs, over the flames on a forked stick, smoke curling around her head. Paiwa runs in to join them, and I long to be in there too, to warm my hands by the fire and watch the women cook and listen to their jokes.

"Pase, pase adentro," José Miguel says, come in, come in, as he opens the door into his and Esthela's part of the compound. A large table sits in the

middle of the dirt-floored room, which has a double bed along one wall and a couple of tall chests along another. A TV sits high atop one of these chests, a VCR and tape recorder on the other. A single bulb over the table gives off a dim light.

I know this room well. It is where the fiesta after Paiwa's christening was held three years ago, where we came to eat and drink and dance all night. At least *some* of us did. By previous arrangement with José Miguel and Esthela, Michael and I were excused from the party around one a.m. to sleep for a few hours in the storeroom on a mattress purchased expressly for the event, because, as José Miguel explained apologetically to the assembled guests, "the godparents have special needs." We joined the party again early the next morning and finally staggered back to our hostel in the afternoon, exhausted and sick from too much food and drink, but happy to have become Paiwa's godparents and pleased to have held up through the twenty-four-hour celebration.

José Miguel rushes to bring in chairs and we sit down at the large, oilcloth-covered table. Michael and I are directed to sit in the center, along the wall facing out, and I have an uncomfortable feeling that we are the guests of honor. The room becomes more crowded as others join us, probably relatives who live nearby, until we are about fifteen guests. One toothless old grandmother sits across from me, sharing her chair with a young boy; another woman sits on the floor Cañari style, with her skirts wrapped around her legs to keep warm. A young girl leans against her and watches the proceedings with large inquisitive eyes.

Taita Fabian, the oldest male relative in Esthela's family, carries in a big pitcher of *chicha*, a traditional homemade corn beer that is slightly sour but delicious when freshly brewed (and wickedly alcoholic when allowed to ferment). I recognize this diminutive man from Paiwa's baptism fiesta three years ago. Uh oh, I thought, I'll have to be on my best behavior tonight. The night of the baptism one of Taita Fabian's jobs was to make sure that everyone kept drinking. Before the event, Michael and I had been rather alarmed when we were told that the custom, or rather the imperative, at a baptism fiesta is that the godparents dance and drink "until they drop." We did our best to keep up with the *canelazos,* but when I knew I couldn't drink anymore I began to pretend to drink and then surreptitiously toss the stuff under the table or bench where it was quickly absorbed by the dirt floor. I thought no one would notice in the dark, because by that point most everyone was either dancing to the loud music of a cassette player or in a stupor. But Taita Fabian saw me and shouted for all to hear, "The godmother is spilling her drink!"

Now, I remember that embarrassing moment as Taita Fabian serves first Michael and then me a large cup of *chicha* and formally greets us as Paiwa's *padrinos.* Everyone watches as I say *salud,* look around at each person at the table, empty my tin cup, shake the last drops on the floor as an offering to Mother Earth, and hand it back to Taita Fabian with the customary refrain, *"Dios se lo pague."* May God repay you. He moves around the table, serving each guest from the same cup.

At about eight o'clock Esthela serves a tray of animal crackers and hard candies. Everyone must be as hungry as I am, but each guest delicately takes one of each as the tray goes around the room. Next, José Miguel produces a bottle of some green liquor and we take a shot glass of what tastes like crème de menthe. Several people, including me, grimace as we down the medicinal-tasting drink.

Following the crème de menthe, Esthela carries in trays of champagne, with real champagne glasses! She must have found them in one of the fancier stores in Cañar. Once we are all holding a glass, José Miguel makes a touching toast acknowledging his dead father Serafín Acero, Esthela's father Santiago Maynato, and José Miguel and Esthela's first child. For the first time I hear the baby's name: Santiago Serafín, after the two grandfathers. José Miguel turns to Michael and me and welcomes his *compadres* back to Ecuador; we raise our glasses and drink the champagne, a sweet domestic wine that goes down easily.

More *chicha* follows . . . and more animal crackers and candies. I'm ravenous, and the others must be too, but everyone sits and talks quietly as though we have all the time in the world. Which, of course, we do. Cañari ritual events are never rushed, but measured, savored, and experienced, with plenty of food, drink, dancing, and music. A wedding fiesta lasts three days and nights, as do the rituals around a funeral; a baptism should be two days, a dinner never less than five or six hours.

During a lull, José Miguel turns on the TV. Into the VCR he puts a seventeen-minute video I made several years ago to accompany a photography exhibit, "The Cañari of Southern Ecuador," which traveled in the United States and Canada. I had forgotten he has a copy. We all crane our necks to watch the images of the people and countryside we know so well. The film has ambient sound, so there's no narration to distract, only the music of José Miguel's former musical group, Taita Inti.

I'm fascinated to see the Cañaris watching the film; this is a new experience for me. As a series of scenes flash quickly by—a group of women digging potatoes, the animal market, street activities, children in school—everyone watches passively, but when the camera lingers on a young woman

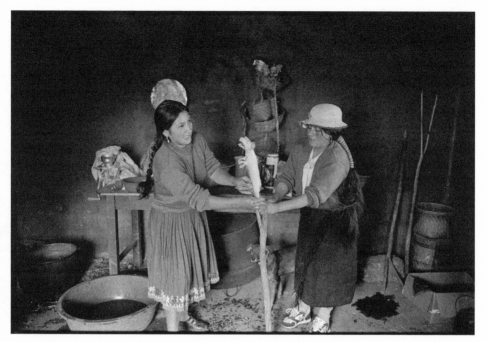

ALEXANDRA AND ZOILA PREPARING A *CUY* FOR ROASTING

to record each step of swaddling a baby, the guests, especially the older people, grow animated and begin to comment. It seems that for them most of the film is edited way too fast. Unaccustomed to watching the quick cuts of television, this audience obviously prefers real time. So, I realize, do I.

Food begins to appear at about nine o'clock. Enamel basins piled with potatoes, *mote* (hominy), and fava beans, all staples of the highland diet, are set in the middle of the table. The guests sit and wait for a signal to start, and Antonio, a teenage cousin of José Miguel's who is helping Esthela tonight, rushes in from the kitchen with two bowls of soup. He serves Michael first, then me, slowly working his way around the table, running across the compound to the kitchen for the next two bowls. Everyone continues to sit politely with hands in laps until finally one of the elders, Don Pablo, says that we should go ahead before the food gets cold. I fall on my soup, which is delicious, with tender chicken and cauliflower in a well-seasoned broth. I know this is only the beginning of the meal, and that I'll regret it later, but I can't help cleaning the bowl.

While waiting for the next course we eat the hominy and fava beans, taking small handfuls from the big basins in the center of the table and popping them into our mouths; the food is still slightly warm, and delicious.

The formality that preceded the meal has loosened up. Taita Fabian serves a second and third round of *canelazo*—at some point he has switched from *chicha*, which is mildly alcoholic, to the stronger stuff. After several rounds of drinks, I see the old woman across the table nodding off, while the young boy sharing her chair anxiously tries to keep her from falling. After a few minutes, two men gently lift the old woman and set her on the floor against a wall, where she continues peacefully dozing.

Finally, Antonio sets a huge platter in front of Michael. On top of a pile of potatoes lies a quarter of a chicken, a large piece of what is probably mutton, and stretched out on top of it all, browned to perfection, a large guinea pig, or *cuy*. Spread-eagled, its crisp little head and four paws are out-stretched as though it has just made an indelicate belly flop from the sky. I get its twin. The other adults at the table are served half a guinea pig, those sitting around on the floor get quarter sections, and the children bits and pieces, all on plates heaped with potatoes.

We eat with our fingers. The chicken is well-done and tasty and I eat some of it first, along with the potatoes, which are fresh and delicious. As etiquette requires that I eat as much as possible, and with gusto, I ignore the mutton and turn my attention to the *cuy*. I have, at times, enjoyed *cuy*, when it is young and tender and toasted to a crisp over an open fire, although I've never learned to enjoy the bits favored by most Cañari: the crispy little feet and crunchy head with its mouth stretched back to reveal a row of tiny teeth. Tonight, however, the meat is fatty and tough. I tear it apart and spread it around on my plate so it looks like I'm eating more.

Soon I give up and sit back, stuffed, although a huge plate of food remains in front of me. I glance at Michael's plate; he's in the same situation, and a glance around the table shows that almost everyone has a large amount of food left on their plates. When Taita Fabian gestures at me from across the table with a brimming metal cup of *chicha* and keeps gesturing after I demur, I quietly beg Michael to drink it for me. Valiantly, he does, and when he is served the next big cup I feel a twinge of guilt. Michael pats his stomach and protests that he is *repleto*, but Taita Fabian insists. I groan inwardly as Michael gamely drinks again.

The old man sitting on my left, Don Pablo, whom I have never met, be-gins to speak about *chicha* in a beautiful mix of Quichua and Spanish. He is very dignified, meticulously groomed with a thin gray braid down his back and dressed in his handmade clothes: embroidered white shirt; heavy homespun wool pants; and a black wool *cushma*, a sort of sleeveless jerkin, tied over his shirt with a finely woven belt wound several times around his

waist. He describes the traditional process of making good *chicha*, which he says must come from corn at a particular stage of ripeness and after being prepared should sit for eight days. "The old ways are being lost now," he says, "and even the corn that makes the best *chicha* is not so plentiful." I understand only some of what he is saying, but when José Miguel sees me straining to listen, he leans across the table to translate.

The talk subsides in the dim light and everyone sits, sated and more than a little relaxed with food and drink. It's getting close to midnight, and people must be longing for their beds; I know I am. I still have a loaded plate in front of me, as do most of the other guests, but I'm more knowledgeable now about food protocol, so I patiently watch the others for cues. In our early years in Cañar, I would hand my plate with the leftovers to a child or return it to the women in the kitchen. Now I know that this was a grave breach of etiquette; as a guest I must always take any extra food home with me. It's not so different from the native potlatch traditions in the Pacific Northwest, I think, the point of a feast being lavish largesse and excess on the part of the hosts. Guests are expected to accept any gifts offered with the understanding that at a future time they will reciprocate in kind.

We sit quietly for ten minutes before I see a woman down the table delicately tip a plate of dry *mote* into her top skirt, tucking the hem of the skirt into the waistband to make a bag. Then I see Don Pablo hand his wife his plate of potatoes and *cuy*, and she wraps the food, along with her own, into a carrying cloth that she has pulled out of her shawl. All this takes place very discreetly, under the table or off to one side, as though to make a show of how much food you are taking home would be in bad taste. These leftovers will go to family members who aren't present, or will be eaten tomorrow while working in the fields.

Michael murmurs that we have forgotten yet again to bring plastic bags for the extra food, something we try to remember whenever we are invited to fiestas. We are saved when José Miguel comes in with a handful of plastic shopping bags. Loaded, ours must weigh more than five pounds, and I stash it in Michael's backpack. Slowly, the food on the table disappears; nothing is wasted.

It's finally time to make our farewells and go out into the dark night. Everyone shakes hands all around, saying very formally, "It was good to see you again." I am still unsure how most of these people are related to Esthela or José Miguel, or if in fact I have met them before. I find Esthela in the smoke-blackened kitchen across the compound, where she has spent the evening. Paiwa is slung on her back in a shawl, fast asleep, her long legs hang-

ing down. She is almost five now, and must be very heavy. "Wait a minute, *comadre*," Esthela says, as she picks up an enamel basin of *mote*. "I want to send this home with you."

I pull out of my backpack a large woolen shawl that my sister brought back from Nepal. One of the women shows me how to wrap the basin into the shawl, sling it around my shoulders, and knot it across my chest so I can carry the load on my back. At first the knot chokes me, and the edge of the basin digs into my back. All the women have a good laugh as I try to find the right adjustment. I think about the women I see every day striding gracefully past our house with enormously loaded baskets on their backs, bundles of live animals, and even gas tanks wrapped in their shawls. I must look awkward and a bit foolish, but I don't care.

Back in the main room, Taita Fabian insists on another round of *canelazo* drinks. More handshakes and farewells follow. The leave-taking finally over, Michael and I step through the wooden gates of the compound into the dark night. The tethered cow swings her head around to nod good-bye. Holding hands to steady ourselves, we stumble over the rocky path along the irrigation canal to the main road and begin the long cold climb to Cañar.

The Meeting

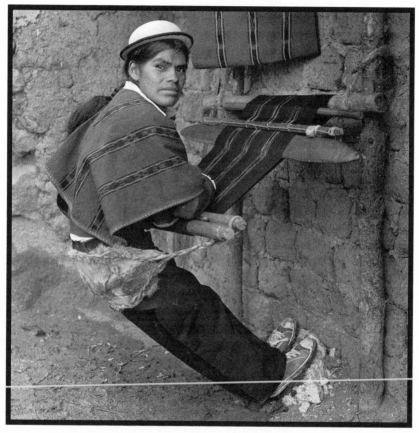

SANTIAGO QUINDE AT HIS BACKSTRAP LOOM

LAST WEEK, SEVERAL CAÑARI friends, among them José Miguel and his cousin Félix, approached us to request help in organizing a meeting to talk about creating a cultural foundation. It would be a legal entity, they said, dedicated to preserving and promoting indigenous music, dance, clothing, handicrafts, rituals, medicine, and agriculture—all the cultural wealth of Cañar that remains at the turn of the twenty-first century. Our Cañari friends talked to us about this idea years ago, and we are pleased it is still

alive. Michael and I agreed to hold the meeting at our house at seven o'clock on Saturday night.

We spent Friday in Cuenca, but early Saturday morning we catch a bus for Cañar to give Michael time to make two banana cakes for the meeting. He's been inspired lately by the tons of bananas that appear in Cañar each week on market day, sold from the backs of trucks at the end of our street. Ecuador is the largest exporter of bananas in the world, and I suspect that some of those that don't meet export quality standards get shipped up from the coast and dumped on local markets. Michael brought home his first ripe bunch the other day and declared them delicious.

Late Saturday afternoon, cakes cooling on the table, we walk into town for supplies: large sheets of blank newsprint, markers, disposable cups, coffee, and milk. It is the first drizzly day after a long anxious wait by the farmers for the rainy season. Below a dark sky, low clouds hang at rooftop level, and the few people who are out scurry along the narrow cobblestone streets covered with shawls or plastic sheets. We arrive back home wet and cold, but by seven we have had dinner and are ready for the meeting. I've waxed down the dusty floors in the *sala*, cleared the tables, drawn a big planning calendar to hang on one wall, and taped blank newsprint sheets for notes on another. A big pot of coffee heats on the stove—already mixed with milk and lots of sugar, the way everyone likes it—and Michael's two beautiful banana cakes are waiting on the countertop.

No one comes on time, of course. Manuela and Mariana, young women in their early twenties who are studying in Cuenca, arrive first. When they knock at seven fifteen, they seem slightly chagrined to have arrived before everyone else. They greet us formally and sit down primly on chairs in the *sala*. I put on a Silvio Rodriguez tape and Michael serves coffee. At seven thirty José Miguel, his brother Pablo, and another cousin, Ranti, arrive wet and tired from their soccer game. Then Aunt Mariana, who assisted in the ritual *limpieza* of our house a few weeks ago, comes in with her three teenage children, Alexandra, Maritza, and Juan Carlos. At some point I realize that Mama Michi has slipped in. She sits on the floor, with her legs straight out and her head against the wall. She looks tired.

All the women are dressed for the cold in layers of wool skirts, heavy sweaters, and black wool capes or shawls, and the room has that cozy, wet-wool smell. Even for a casual meeting, the women and girls wear swaths of choker necklaces made of red and gold or black beads and dangling silver earrings, some very elaborate, and of course they all have on hats. Next to them, I feel very plain and unstylish in my khaki pants, charcoal gray

sweater, and the modest two-string necklace of red beads I bought the other day in the market—my one nod to feminine attire in my new Cañar life.

Michael's banana cake and super-sweet coffee are a big hit. For most of those here tonight, coffee is a treat, but coffee with milk is real luxury. By eight about twenty people have arrived, everyone but Félix, the designated coordinator of the meeting and the one "who has all the papers," as José Miguel puts it. Everyone sits patiently on our wooden benches, stools, and chairs, or on the floor, quietly chatting. Some are looking over the color photos I took the other day at the festival of Killa Raymi. Others sit at a table playing with a deck of cards printed with saturated color scenes of mountains and beaches that we brought from Oregon. The room is cozy and warm with music and lights, and our guests are happy. For most, waiting is a pleasurable game, whether it's a long line at the bank, in a store, or standing alongside the Pan-American watching for a bus. Waiting means you have an excuse not to be working. You can watch other people, gossip with your friends, or simply sit idle—not something many country Cañaris have time for.

I know most of the people in the room as part of the extended Chuma family, from the village of Correucu. One couple I don't know, however, is José María and Narcisa, who have arrived with two little girls, one baby on her mother's back and the other in her father's arms. José María, a tallish man with a shy smile, is blind in one eye and has horrible scars on his neck. Later, Esthela tells me the story. He was injured in an incident that took place in Cañar in 1994 when a group of townspeople, enraged about an indigenous uprising and other long-standing resentments that had brought the Pan-American Highway to a standstill, burned down the main building of the Cañari cultural center in town. The confrontation left one Cañari dead and several others injured—including José María, who was hit by falling embers—and is such a painful chapter in the local history of racism that our Cañari friends prefer not to discuss it.

Just after eight o'clock, José Miguel decides to start the meeting without Félix. He begins with an introduction: "We are a Cañari people with a proud past and a living culture. We have our traditional music, dances, customs, medicine, handicrafts, and rituals, and yet these are not valued. In fact, they are being lost as more and more of us emigrate to the United States. We cut our hair, we leave behind our Cañari clothes, we lose our native language and forget our traditional customs. Lots of us have had ideas about what to do. We talk, we plan, we dream, we create associations and foundations and wait for funds to come and then . . . nothing. And while

we're waiting, our lives are passing. So we are here tonight to welcome Judy and Michael, *compañeros* who have come from afar to spend a year with us, and to talk about the work we can do together."

Long silence. Then, as I've learned is customary in meetings such as this, others repeat what has just been said. Aunt Mariana speaks next: "I would like to reinforce what José Miguel has just said and add . . ." Then a third refrain, much the same. Finally, a young man Michael and I are just getting to know, Ranti Chuma, a nephew of Mama Michi's who has just finished a college course in animal husbandry, takes up one of the markers and writes on the blank sheet of newsprint taped to the wall: "Cañar, November 18, 2000." Next to it he writes: "Objectives."

I suggest that he write "Create a foundation" as objective number one. With all due respect, Ranti replies, that would be a little premature. First we need to know who we are. "If we each talk about our past, our present, and our hopes for the future," Ranti explains, "we will better know where we want to go as a group." He suggests we go around the room and allow each person to tell his or her story. I am a little surprised, as most people in this room have known one another since birth. Still, the oral historian in me is grateful for the chance to hear the life stories firsthand.

José Miguel talks first, and at great length. I know his story best. Then I speak briefly, and in point form, trying to set an example. I conclude by saying, "In this year I hope to give a series of photography workshops in indigenous communities around the country and begin to build a network of native photographers." Michael is next, and he waxes eloquent about how grateful we are to be here among Cañari friends again. He briefly lays out his plans for the year: teaching workshops in electrical installation, a collaborative organic garden project, and English classes. Mama Michi, half-serious, requests that he also offer cooking classes. Michael demurs, half-serious, but adds that anyone can stop by anytime to cook with him.

Next, a surprise. One of the young women who arrived early is Mariana Chuma, Mama Michi's niece, and as she begins to speak about her life she almost immediately breaks into tears. She tells how her mother's illness forced her to leave high school and work at home, and how her older sister, Purificación, encouraged her to keep studying and not lose heart. Now she is in university in Cuenca, thanks to a private scholarship fund for Cañari women that was established in 1992. Her dream is to become a journalist someday.

Her Aunt Mariana, sitting next to her, speaks next and she also cries, remembering her husband's early death from a soccer injury that left her a widow with three small children. Her job as a midwife and community

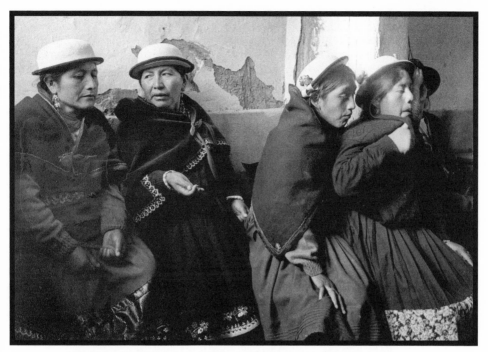

MARIANA SOLANO, MAMA MICHI, MARITZA SOLANO, MARIANA CHUMA

nurse barely sustains the family, she says, but in the future she hopes to pass on what she knows about native medicine, and learn more.

And on around the room, with nearly every woman or girl crying as she talks about her life. What's going on? I wonder. The stories are sad, to be sure. Almost all involve a missing parent, early death, alcoholism, abandonment, or being forced to drop out of school and go to work. But these are well-known histories, not fresh events. I've never seen the Cañari show emotion like this except at fiestas, after hours or days of drinking, and then it's usually the men who get morose or sentimental. Tonight it is the women who cry, and they have had nothing stronger than coffee.

It is now about ten o'clock, but everyone is alert and listening attentively. Even seventeen-year-old Juan Carlos, Aunt Mariana's son who never says a word, speaks with great eloquence. Félix, the visionary and keeper of the notes, has finally arrived two hours late, and he speaks last . . . and speaks, and speaks. Although his ideas are abstract in the extreme, with muddled, repetitive thoughts, everyone listens with great respect, and no one fidgets.

At about this point, José María's little daughter, who has been quietly sitting in her father's arms all night, toddles out to the middle of the room,

spreads her legs, and pees. No one seems to notice except her father, who suddenly whisks her out the front door, to her startled cries. Without a word Narcisa, the girl's mother, swabs up the puddles on the floor with her shawl (taking off the fresh coat of wax that I'd applied, I notice with a twinge of housewifely concern).

I catch Michael's eye, trying to read his mood. He hates meetings, in whatever form, and he has surely never in his life sat through a meeting this long. He looks tired but interested, and tells me later that he was genuinely touched by the stories and fascinated to watch how the meeting developed; he only found Félix's speech boring. "It reminded me a little of a Billy Graham revival, where you are swept along with emotion and the group dynamic becomes its own force," he says. "I knew it was important to allow the meeting to take its natural course."

I, apparently, do not know this. At the end of the personal story round, which takes almost two hours, I suggest that we make a list of objectives we want to achieve in the next year. Again Ranti Chuma responds, "With all due respect, Judy, it is a little too premature for that. First we should make a chart outlining everyone's abilities and aspirations, so we will know what resources we have available." Another sheet is tacked on the wall and we go around the room again, each defining our talents: musician, dancer, teacher, secretary, shaman, nurse, artist, athlete, agronomist, photographer, and electrician.

Now at last the time has come to define our purpose. Ranti writes *"metas,"* goals, on the newsprint and we quickly come up with ten objectives, ending with "Have another meeting."

I ask if our group has a provisional name. "How about *Fundación Chaskis,*" José Miguel suggests. I think that's an excellent choice. In Inca times, *chaskis* were the relay runners who kept all parts of the vast empire in communication and even carried fresh fish and other delicacies, should an Inca noble in Quito have a yen for a snack from Cuzco. According to local legend, the *chaskis* ran near here, on the Inca Trail. José Miguel's musical group Los Chaskis, which includes several young men in the room, has already adopted the name, and he explains that the group will be an integral part of the foundation.

It is midnight. Several people give closing speeches, recapping the meeting. Most listen carefully, although I notice that Aunt Mariana's eyes are closed and Mama Michi has been asleep for some time, her head resting on her chest. I can't believe people aren't restless and anxious to get home; many have miles to walk in the dark and cold. Even the little girl who peed, Lourdes, has stayed awake until the last few minutes. Now she lies asleep

in her father's arms. I am tired too, but strangely excited. For all my impatience at sitting through a five-hour meeting, I suddenly realize, looking at the covered newsprint around the walls, that we've achieved an amazing amount. Best of all, everyone seems energized and united. As the meeting breaks up, a group of young women gather around Aunt Mariana to talk about learning a traditional dance. Purificación asks for the broom and begins to sweep up all the mud that came into the room on people's shoes. Everyone stands and chats, reluctant to leave.

We agree to meet again in three weeks, and, by popular demand, Michael promises to bake another banana cake.

Greeting the New Year

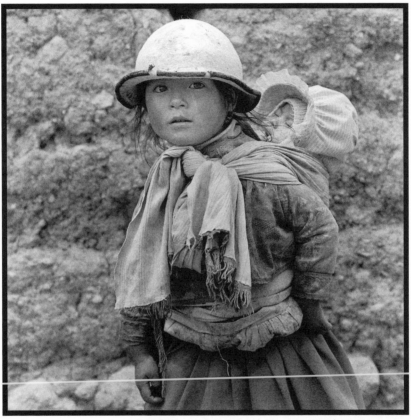

TRANSITO POMAVILLA, A NEIGHBOR OF MAMA MICHI'S,
WITH HER BABY SISTER

OUR CAÑAR NEIGHBORS ARE very curious about the two strangers who live in their midst. We deal daily with the owners of the small shops on Paseo de los Cañaris, and the neighbors living around us take careful note of our comings and goings. If they haven't seen us for a while, they ask politely what we've been up to. So, after an unusual absence of ten days over Christmas, Michael and I tell the same story endless times: our friends Sheila and Chris and their two boys visited from Canada, we all went to the coast for

the holidays, on the last day Michael ate some bad ceviche (raw marinated fish or shellfish) at a roadside stand, and he got very sick.

The neighbors and shopkeepers nod with knowing smiles. A bad experience with food at the coast is something everyone can relate to. That we should have stomach problems makes us more real, not just gringos who appear not to work, who can afford to rent a house for fifty dollars a month, and can go away for a week's vacation at the beach. No, we also come back with abdominal pains and diarrhea, just like every *serrano*, or person who lives in the highlands, who visits the Pacific coast and eats bad seafood.

Today it's New Year's Eve. We have been invited to Mama Michi's to see the old year out, but Michael is still sick. A couple days ago he visited our favorite medical laboratory in Cuenca for tests, and the results confirmed that the ceviche infected Michael with a serious case of *"amoebas, eritrocitos, piocitos, flora bacteriana aumentada con predominio de bacilos."* In other words, his gut is teeming with a flotilla of microscopic parasites and their nasty by-products, which adds up to amoebic dysentery and more. We've been to that lab for tests so often in the past couple of months that on this last trip the owner, Dr. Martha Miranda, felt she knew Michael well enough to give him a New Year's hug before she sent him upstairs to see her brother, Dr. José Miranda, a "cancer specialist" who never seems to have any patients but us. He interprets the lab results and writes prescriptions for a small fee.

A complicated regimen of four medications and strict orders not to drink have dampened Michael's enthusiasm for a New Year's celebration. As I put on layers of warm clothes, pack my cameras, and prepare to go to Mama Michi's, Michael stays cozy in bed under layers of blankets, quite content, reading *The Comedians* by Graham Greene. I almost envy him, knowing a long cold evening is ahead. He says to give everyone his regrets, and I tell him I'll be back home in time for a New Year's kiss.

I strike out for Mama Michi's at about five. José Miguel has asked that the family gather early so he can film us with his new video camera. Now that we are godparents to Paiwa, one of Mama Michi's grandchildren, and about to be the same to another, Rantin, Michael and I are considered honorary family members. José Miguel wants to send a tape with New Year's greetings to several family members in the United States: Mama Michi's daughter and two sons-in-law, plus others. In the last year or so, they have all made the hazardous trip north as illegal immigrants, and most live together in a West Coast city.

As I walk down the hill to Correucu, heavy coastal clouds roll in and settle to the ground, first in wisps and then solid as cotton wool. I can barely see the outlines of small adobe houses along the road, and the disembod-

ied sounds of children's voices close by are muted. As I near Correucu I see Vicenta, one of Mama Michi's sisters from Quito, standing in the road. I call out to her and she peers through the fog, straining to recognize me. "I thought you were a man!" she exclaims as I come near. We embrace awkwardly. As we walk together to Mama Michi's, I think how unlike a woman I must look to the folks around here. A tall, straight figure in black jeans and leather jacket, I am in stark contrast to the short roundness of the Cañari women in their vividly colored clothing and elaborate jewelry. "One day I'll surprise you and wear a skirt," I say. She laughs and so do I; we are both no doubt thinking the same thing: that I'll still be a tall, straight figure in an unremarkable black skirt.

Not all the family has arrived on time for the filming, so José Miguel announces that he's going off to play volleyball at the community field nearby. Sports are one thing the weather never interferes with here. This gives Vicenta and me a chance to catch up, and we settle onto the short chairs in Mama Michi's *sala* to talk. I have known Vicenta since the first time I lived here, when she was teacher in a bilingual country school not far away. Once I got to know her well, she allowed me to film and photograph one entire day at her school, where she taught classes in Quichua. Now, she works in Quito for the women's education program at ECUARUNARI, an indigenous organization; through her network she's helping me find students for my first women's photography workshop, to be held in Cañar in a couple of months.

Vicenta is the youngest of the four Chuma sisters—she must be about forty now—and the most educated. She not only graduated from high school, which put her ahead of most girls her age, she also had the (still rare) advantage of a college education in Cuenca. How Mama Vicenta and her husband José María were able to pay for this, I have no idea. While at university she married a mestizo man from Cuenca, a highly unusual choice for a traditional Cañari woman. But Vicenta's husband, Lautaro, has identified so completely with the Indian culture that he has become a shaman in recent years. He also works with ECUARUNARI. I ask Vicenta about Lautaro and their four children, and she says they have stayed in Quito. With the worsening economy and the rise in bus fares, they can't afford the nine-hour bus trip to Cañar for the whole family, so only she has come for New Year's.

We talk about the documentary work I am doing this year. I mention that I want to photograph the rituals and activities around Carnaval, the important fiesta coming up in February, and that I need permission to do this from the local village authorities. We talk about issues of ownership

of documentary material and control of the Cañari photography archive I am hoping to create this year. I listen carefully to Vicenta's views, as I see her as the most politically informed of the Cañaris I know. She cites many instances where both outsiders and those from local institutions, including Indian organizations in Quito, have come to Cañar to film or photograph cultural events, always with the promise of providing copies to local organizations. But, she says, there is not one videotape or photo in Cañar to show for it.

Mariana, the next-to-youngest Chuma sister and a community nurse and midwife, joins us in Mama Michi's dark, cold *sala*. As we sit talking, several small children tumble around and over us, quietly playing. Pacha and Nicolás, the two young sons of Delfina and Nicolás, are here visiting from a village about an hour away where they live with their other grandmother. Zoila's two toddlers, Rantin and Pacari, are here as well. Mama Vicenta, the matriarch of the family and mother of all the amazing Chuma sisters, has come in at some point, and she sits dozing on the bench beside us.

Later, I need to stretch my legs and keep warm, so I take a walk around Mama Michi's cluttered compound, where so many people make their home. I recall with amusement a recent day when I stopped in to greet her. When I asked her how she was doing, she said, "Aiiiiiii terrible! All these people have given me a headache and I can't think!" I counted those I saw in the yard, and those I knew to be living with her, and said, "Eleven." She just smiled with resignation and shook her head, but I thought she looked rather pleased with her abundant family.

Now I find her bustling about in the outside lean-to kitchen, cooking potatoes over a wood fire. Zoila is in the inside kitchen, chopping onions, her eyes streaming. Pablo, Mama Michi's son, is hanging a wet blanket on the clothesline strung across the yard, and I look up to see Serafín, another son, sweeping the floor on the rickety second-floor balcony. This is an unusual level of housekeeping activity, especially for two young men I've never seen doing any work around the house. "What's going on with all the cleaning?" I ask Mariana as I walk back into the *sala*.

She explains that it is the custom to thoroughly clean your house on the last day of the year. "You must wash everything," Mariana says, "your clothes, the bed linens, the floors, the pots and pans. Then, before the New Year begins, you gather all your old and useless things, such as shoes and clothes, and any trash around the house, and burn it all on an outdoor fire right at midnight." After that, she explains, it is important to start the year by purifying all the rooms of the house with incense and blowing around

the alcohol concoction that is used for *limpiezas*. "All this will bring you good luck and good health in the New Year," she concludes.

I'm reminded of another New Year's Eve in this same house three years ago, when we were in Ecuador on a visit. Around midnight, as we sat quietly talking with other family members, Vicenta's husband Lautaro, who we barely knew, walked into the room and without a word blew a mouthful of alcohol all over Michael and me. At the time we were rather insulted, thinking his act was the result of too much drinking. Only later did we learn that he is a shaman, and that he was giving us an impromptu good-luck treatment for the New Year.

José Miguel returns from volleyball and the family slowly gathers, ready to film. By now it is about seven and too dark to shoot with the one dim bulb in the *sala*, so José Miguel and Pablo work to string up an electrical cord and socket from an upstairs room. This takes a while and involves much yelling back and forth and several abortive tries, but suddenly a dangling hundred-watt bulb pops on in the middle of the room, starkly illuminating the adobe walls and uneven dirt floor. In preparation for the filming, someone has covered the long table with a white cloth and brought in two bunches of flowers in jars.

Then, just as we've gathered the children to begin, Mariana worries that they are dirty and disheveled from rolling down the hillside in the yard for the last half hour. Their parents in the United States will be dismayed to see them with messy clothes and flying hair filled with straw. We all wait while clean clothes are found and the children's hair is freshly braided.

Filming gets under way at last with little Nicolás, Delfina's five-year-old, perfectly singing two songs that he has learned in kindergarten, one about a grandmother and another about the baby Jesus. Everyone is amused at his performance. Then Pacha, his seven-year-old brother, speaks gravely into the camera: *"Hola Mami, hola Papi,"* and goes on to say that he is doing well in school. With an aching heart, I imagine his parents watching this tape at some later date, four thousand miles and a world away. Six months ago, Delfina left these two beautiful boys behind to join her husband, Nicolás, who, after two years of hard work, had saved enough to pay ten thousand dollars to bring his wife to *el norte*. Delfina knew when she left her children sleeping with their grandmother that night, took the bus to the coast, and stepped onto the fishing boat that had been converted to smuggle human cargo that she could not expect to see her young sons for several years. Later, when she was in the United States and we had a chance to talk, I asked her how she had made the decision to leave. "I did it to preserve my marriage," she said

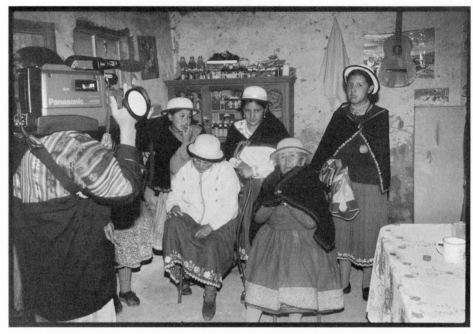

SENDING NEW YEAR'S GREETINGS TO THOSE FAR AWAY

simply. What a terrible Solomon's choice, I thought, that faces all women whose husbands emigrate. They must weigh the possibility of losing their source of support—these men who, they reason, cannot be expected to remain celibate and single for four, five, or ten years—against the sacrifice of not seeing their children grow up.

The camera moves slowly around the room as each person takes a turn sending "solemn greetings" to their Cañari family in the United States. Some, like Mama Vicenta, speak only in Quichua; some speak in Spanish, with Quichua words sprinkled in; some are shy and tongue-tied, saying only a hello, while others are verbose, giving a full report on the state of the crops and the weather. Zoila, two children on her lap and pregnant with another, talks shyly to Benedicto, her young husband who has finally reached the United States after several disastrous and expensive attempts.

"Don't forget your wife and children in Ecuador," she concludes wistfully. With Benedicto's huge debt, Zoila knows that he will have to work for years, and with three small children it will be impossible to join her husband in *el norte*.

Juan Carlos, Mariana's fourteen-year-old son, speaks to the camera and asks Nicolás to be the *padrino* of his high school graduation, three years off.

His father died when he was six, and the exodus of Cañaris has left local communities without men. Familial relations must be maintained long-distance as best they can, and it is customary that an adult relative sponsor and stand up with a young person graduating from secondary school. Nicolás will no doubt send Juan Carlos a watch or a ring for his graduation, I imagine, and some day will be surprised to meet this boy as a man.

I send greetings too, and when someone reminds me to mention Michael, I briefly explain why he isn't here tonight, trying to inject some humor: our trip to the beach, the bad ceviche, the amoebas. Everyone loves that story. And on around the room until all have spoken, the poor stark room serving as a fitting backdrop for the sentiment and sadness expressed in the messages.

But now it's time to eat. Thankfully, it's not a big meal. Just soup and a plate of chicken, rice, potatoes, and salad. No guinea pig, and not too much drinking. It makes a difference that this is the house of women, I think. If there were a man in charge, he would have to play his role of host and insist that we drink, and drink again, a mordant reminder that Serafín, Mama Michi's late husband, died of the effects of alcoholism. Another ironic effect of emigration, I think, is that the men who leave might live longer, away from the hard-drinking fiestas of Cañar. (And the women left behind get relief from repeated pregnancies.)

I am sitting next to Mama Vicenta, who is having a hard time staying awake but who still enjoys the happy turmoil of a room full of her descendants. With everyone participating, we figure out her age (eighty-two) and count her grandchildren (twenty) and great-grandchildren (eight).

"They'll all be coming to my funeral next," she says with a wry laugh. "No, no," I respond, "they'll come to celebrate your next birthday." (I didn't realize that adult Cañaris rarely celebrate their birthdays, which explains why so many older folks, when asked their age, don't really know and make a guess.) Sadly, Mama Vicenta was correct in her prediction; she would not live to see another New Year's Eve.

The hour grows late, although it's still far from midnight, but it's very cold and no one seems in the mood to stay seated around the table. Also, I remember, people need to go home and clean their houses. As we bustle around getting our wraps on, Mama Michi leaves the room for a few minutes and comes back with an armful of gifts: blankets for her sisters and son, and sweaters for her daughters. And for me, some items from Canada, which she recently visited on a "healing tour": a small chiffon scarf (which I suspect was a gift to her), a sackcloth bag with shredded tobacco, a beautiful braid of sweetgrass, and a photograph. In it, she stands stiffly in the

snow with a couple of other people, peering out at the camera from the depths of a fluff-trimmed hood. Her body is so layered with winter clothes that she resembles a perfectly spherical Russian doll.

When I thank her for the gifts, she instructs me to burn a bit of the sweetgrass around the house before midnight tonight. Meanwhile, Mariana is doling out pinches of incense for the smoke *limpieza*, which also should occur at midnight. I get a glimpse of the label: Seven Powers Incense is used to guard against jealousy, ill health, and accidents, and promotes success in work, love, and good health.

Farewell hugs. *"Feliz año nuevo,"* everyone says. I walk up the hill with Mariana and her three children. The fog has cleared, and it's now a cold, clear night—I'm chilled to the bone from sitting for so many hours. We pass a few small fires, with kids gathered around, but most people are waiting until midnight to light their bonfires, Mariana says. All I want now is to be in a warm bed next to Michael in our quiet house, but as we approach my street we hear the blaring sound system of a *disco mobile*. Following the raucous noise to an open basketball court in a little park nearby, we see hundreds of people milling around an elaborately constructed tableau of large puppet-like figures. Some wear masks that are recognizable national public figures, such as the president; others resemble local civic leaders. Mariana explains that the town of Cañar sponsors this event each year. The effigies are called *año viejos*, and all will be burned at midnight to symbolize the end of the old year and the beginning of the new.

Michael is still awake, burrowed under the covers, happily reading the last few pages of *The Comedians*. I show him our gifts and tell him about the custom of cleansing the house with smoke for the New Year. Interested in the idea, he gets up, gathers some wood chips from the odds and ends of lumber in his junk room, and lights a miniature fire on a piece of tinfoil. He doesn't want to burn the sweetgrass braid—he thinks it's too beautiful— but we throw on a pinch of the tobacco and the incense and walk around the house, banishing whatever *mala energía* is hanging around from the last year and inviting the spirits to grant us good luck and success with our work, health, and love in the coming year.

Then, shivering, we jump into bed under a pile of heavy blankets. I'm so chilled I can't bear to undress, so I keep on my sweater, gloves, hat, and a shawl wrapped around my neck. We kiss the old year good-bye at eleven thirty and fall into a sound sleep to the beat of the *disco mobile*, which is still blaring when we wake at six the next morning.

Life in Cañar at Three Months

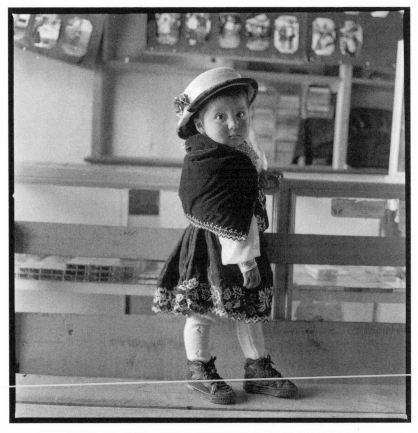

PAIWA MAYNATO, OUR GODDAUGHTER, AT THREE YEARS

THREE MONTHS IN ECUADOR. Our life on the Paseo de los Cañaris has settled into a comfortable routine, and our trips to Cuenca grow less frequent. "Things are so much more *interesting* here," one of us says to the other at least once a day. Still, every week or ten days, we make the two-hour bus ride to the city and spend a day and night in our snug apartment. Michael plays hours of chess at the Cafecito and shops for specialty foods at the SuperMaxi, the only good (i.e. expensive) supermarket in the region. This

week his list includes the makings for pizza: tomato paste, mozzarella, dried oregano, and dried mushrooms, plus fresh basil, fresh ginger, canned Spanish olives, peanut butter, anchovies, and pasta. My more prosaic routine includes taking care of thirty or forty e-mails, making the rounds of post office, photocopy place, and office supply store, going to a meeting now and then at the university (where I will teach a course later this year), and meeting my friend Lynn for lunch. Michael and I both enjoy long hot showers, a restaurant meal or two, and the least terrible of the movies playing at the three shabby local theaters.

In Cañar, as in country towns everywhere, the weather is a main player in daily life. The highland year is measured by two major seasons. The dry season, called *verano*, summer, lasts roughly from June to December; the wet season, winter, *invierno*, extends from January to May. A couple of "mini-seasons" during each period allow farmers to plant two or three times a year. After a few false starts, our overdue winter appears to have arrived. We've had rain the last few afternoons and all last night; this morning it is still raining. Michael and I lie in bed later than usual, listening to the steady drip in the back patio, not wanting to get up. The nighttime temperatures this time of year hover in the forties, and we depend on the morning sun to get us out from under our mountain of blankets. Even at this high altitude, when there is sun it doesn't take long to warm the house. But today, as I sit writing at my table by the window in the *sala*, I'm wrapped in layers of polar fleece, a sweater, and a wool shawl, with my signature black beret on my head. My hands are constantly cold; today I will go into town, buy some cheap wool gloves, and cut off the fingertips for working on the computer and in the darkroom.

On the table beside me sits a big cup of the camp-style boiled coffee we've grown addicted to in the mornings. Michael and I have an arrangement: he gets up first to brew the coffee, and in exchange I make the bed. Sometimes we catch up on the news by listening to the morning report on *La Voz de Ingapirca*, a local Lutheran missionary radio station that broadcasts in Quichua and Spanish. Every morning at eight an announcer reads directly from one of the daily papers, *El Universo*; when he pauses mid-sentence we can actually hear him turning the page. But we've forgotten to tune in lately, and the newspaper is usually sold out once I get to town, so we haven't had any news of the outside world for a week.

With the addition of two double bed frames, which Michael made last month, and the two bedside tables that he knocked together after lunch yesterday—one with a little post and reading light attached—our household furnishings are complete. In the *sala* we have three large tables, two

benches, and a variety of stools and straight-backed chairs (all unpainted). In the eating area and kitchen, there's a small fridge, a cabinet for food, three gas burners, and a countertop oven. We have curtains on all the large windows, so the house is pleasantly filled with diffused light, even on dark days. Our luxury items include a radio, a CD player with tiny speakers that we brought from home, and three small table lamps that I insisted on buying to mitigate the stark light of the dangling bulbs and provide a warmer atmosphere in the evenings. And the half-size fridge, of course, which we did not intend to buy until Michael decided he couldn't cook for a year without it. It sounds spare, compared to life in the north, but we're comfortable and have way more than most of our Cañari friends—excepting the ubiquitous TV, which even the poorest families manage to buy.

The rock-hard surface of the concrete walls in the *sala* resists any attempt at penetration with nails, so I have used masking tape to hang maps and posters. I've also painted one wall a deep red to use as a backdrop for portraits—in black-and-white photos the red will translate as a rich gray—and I like the effect of the color in the room. The adjacent south-facing windows flood that wall with natural light; I sometimes invite visitors to take a seat against my red wall for a portrait.

The floors and ceilings throughout the house are cheap wood, as are any touches of "style," like the strange plywood arches with spools and open shelves that divide the long front room into three spaces (living room, eating area, kitchen), and the hideous, semicircular bar built into one corner of the living room. Termites are busily at work everywhere and will, I fear, eventually finish off all the wood fittings in the house, leaving only the original concrete shell. One day last week I shut the door to my office and the lintel of the casing simply fell off, barely missing my head. Everything from basic construction to plumbing and electrical installation is poorly executed here; building permits, codes, inspectors, and zoning regulations are completely unknown.

Then, of course, there is our murky bathroom, which I avoid except when necessary. A small fluorescent tube on the ceiling slowly flickers to life at just about the time you're finished, which suits me because I'd rather not see my surroundings anyway: the blue toilet that leaks at the base, the broken turquoise seat, the useless tiny blue sink. For the shower, an executioner's switch on the wall heats a trickle of water that comes straight down from a high pipe. Michael used it once—I took a photo to mark the occasion—but I reserve my showers for Cuenca. It's too cold here even to think of taking off all of one's clothes at once. The Cañaris smartly wait for a sunny day to do a splash bath out in the yard.

"**I'VE DECIDED WHAT** I'm going to do," Michael solemnly announced one day last week as he gazed dreamily off at a magnificent range of saw-toothed mountains. We were on an all-day walk to Mama Zhinshona, a mountain that rises close to thirteen thousand feet and lies within a hard day's hiking distance from Cañar.

Hmmmm, I wondered . . . a new gardening project? A decision about his future when we return to the United States?

"Tell me," I said, pulling up alongside him, breathing hard.

"I'm going to make bagels instead of crepes to go with the gravlax."

Michael is the only person I know who never stops thinking about food, despite carrying on quite a normal life. He works, he reads, he dreams up and executes big projects, he socializes with people, and he plays endless chess on his electronic board. But running like a current through it all— every day, all the time—his thoughts are on lunch or dinner. (Breakfast doesn't interest him; too boring, he says.) Since the day I met him sixteen years ago, across the dinner table of the Pensión Flor y Mar in the cloud forest of Costa Rica, Michael has planned, shopped for, and cooked nearly every meal of our lives.

At home in Portland, after working a hard day, he finds nothing more relaxing than to shop for dinner—my idea of unmitigated hell at five in the afternoon. Depending on the inspiration of the day, or in some cases in search of inspiration, he makes the rounds of his favorite fish store, Italian deli, produce vendor, organic market, and other specialty shops on our side of town. Then he comes home, showers, fires up his range, and gets to work on dinner. Fortunately, I don't care much about cooking, because I don't think two food-obsessed beings could peacefully coexist in one household.

Last week, when Michael discovered frozen parve gravlax at the Super-Maxi ("parve" means it's approved for kosher diets, he informs me), he bought it on impulse. Apparently he had been thinking about how to serve it for the past several days—with crepes or with bagels—until he came to his momentous decision during our final ascent of Mama Zhinshona. So today for lunch we eat fresh-made bagels (baked to perfection in Michael's countertop oven) with gravlax, cream cheese, fresh tomatoes, and red onions. For dinner, he announces, we are having paella. The last of the saffron he brought from Portland is infusing in white wine.

HERE IN CAÑAR, people often give us generous amounts of produce, depending on what's in season: baskets of fresh corn, pounds of potatoes, and bags of *ocas*, peas, and fresh fava beans. Unfortunately, these gifts always

come in overabundance, with the harvests, but Michael has proved to be very creative. Recently we have eaten potato knishes with garam masala, potato gnocchi and basil-potato soup with scallions, grated hash browns with fresh eggs, fava bean pâté, and corn in every way imaginable: corn bread, corn crepes, corn chowder, and corn pancakes. Michael's dual discoveries in a Cañar store of an Oster blender and a cast-iron hand grinder just like the one his mother used to make mincemeat have led to a long spate of pureed pea soup and ground-sausage pizza.

One reason Michael enjoys cooking in Cañar is the ten or so little store-fronts on our street where, on a moment's notice, he can buy all the basics: flour, sugar, eggs, milk, cream, coffee, rice, spices, mineral water, beer, and Zhumir. "It's like having a big surround pantry just steps away," he says.

These stores are in people's houses, operated out of a front room that opens onto the street. A slatted wooden or metal gate across the doorway indicates that no one is attending at the moment, but from the sidewalk you can call out, *"A ver!"* (This loosely translates as "Hey!" or "Come look!") After a few minutes, a person usually appears from the depths of the house: a wide-eyed toddler who takes one look and disappears, a six-year-old girl who efficiently takes care of business for her mother, or a helpless husband who says, "She's gone; she'll be back in five minutes." Sometimes the proprietress herself appears, wiping her hands on her apron, having been interrupted cleaning the house or preparing dinner for her family.

"Cooking here is like a puzzle," Michael says. "On a typical day I might think of something we haven't had for a while — say, schnitzel — and then I have to get busy to find all the ingredients. I go into town early in the morning to visit Doña Elena, who butchers a fresh pig every day. I make small talk as I'm looking over the pig hanging beside us on a big hook. I point to where I want her to cut a piece of *lomo*, or loin. Then I make a loop around town to get the best that each store or vendor has to offer: one for fresh yeast, another for eggs, another for cheese, and so on. During the week I have to buy produce from old Doña Zoila, in Cañar's pathetic covered market, but if I'm in town shopping on Sunday I sneak by so I won't hurt her feelings."

Then there is the special inspiration of Sunday market, when all the best produce sellers and other vendors come to town. Recently Michael saw some beautiful big *moras,* or wild blackberries, and he spent the afternoon making a blackberry cordial for a pre-dinner aperitif by mixing an infusion of *moras* and imported Smirnoff vodka that he found on a dusty shelf in town. It had an old price sticker in *sucres,* and once the shopkeeper converted

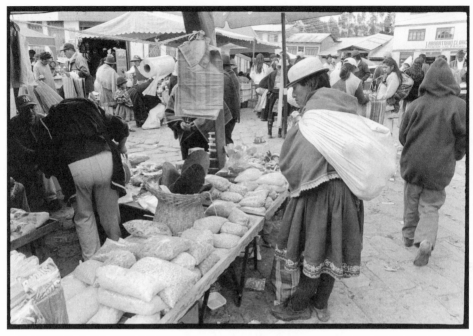

SUNDAY MARKET IN CAÑAR

to dollars it was $4.20 for the fifth. Michael was pleased with the bargain, and I with the cordial.

OUR CAÑAR WEEK IS measured by drop-in visits from friends who live in Quilloac, to the southwest, and Correucu, to the northeast. With our house at the crossroads at the edge of town, in a little *vecinidad*, or neighborhood, built in the last twenty or thirty years, everyone we know seems to come by at least once a week. (Occasionally people we don't know will knock on the door, step right in, and look around, puzzled, asking if this is where they register ownership of their property. I've grown expert at giving directions to the new office in town.) On weekdays friends usually have "business" with us. Mama Michi leaves a fifty-pound bag of potatoes inside our gate while she goes shopping. Félix needs to use the phone (which has finally been connected) to call Quito. Other acquaintances drop by with informal requests for our services: would I come to the agricultural cooperative and film a planting of quinoa, a native Andean grain that the farmers are trying to reintroduce? Would Michael sell some of the little seedlings he's growing on the patio? Would one or the other of us help a neighbor girl with her English lesson?

On Sunday, market day, we have social visits. When Antonio knocks on our door and nervously explains that he wants to introduce his "new woman," Michael invites them in and serves beer and *canelazo*. With great formality and delicacy Antonio presents Magdalena to us. She is very shy and barely speaks. Antonio says she is a neighbor he has known for a long time, but she's been away in Cuenca, working as a maid. She has a young child, he adds, which lets us know that she is an unwed mother and therefore outside the conventional marriage market for young women her age (and thus available to Antonio, a widower with four children).

Many others stop by to pick up photographs I've taken of some event. My policy of shooting color photos to give away of weddings, baptisms, or processions (as well as black-and-white for myself) has paid off beautifully this year, despite some confusion about who "owns" a photo when several people appear in it. This keeps me busy having duplicates made at Estudio Inti and making sure that no one feels slighted. But I'm getting lots of invitations to photograph, and that's what's important.

Every week or so I develop my black-and-white negatives in the kitchen sink. I hang them in the bedroom wardrobe to dry and store them in plastic sheets until I have a chance to work in José Miguel's darkroom, which is located about a block from Estudio Inti in an ancient waterless building. I have to plan ahead for my sessions in *el laboratorio*. I heat a gallon of water at home and lug it up the hill in plastic bottles to the darkroom. There, I mix the chemicals with the water and work quickly, hoping I can develop my contact sheets and photos while the chemicals stay within the acceptable temperature range. Once finished, I carry the wet prints down the hill in a plastic dish tub to the house, where I wash and hang them to dry on a clothesline that Michael has rigged in the hallway. While hardly a professional setup, I've been pleased enough with the results, although I'll wait until I get home to my Portland darkroom to make better prints. I had hoped to spend more time training José Miguel in darkroom practices this year, but he is so busy with the studio and his music group that he rarely has the time.

We also give classes at our house under the aegis of our newly formed Chaskis Foundation. Although the focus of the foundation is Cañari culture, Michael and I have been asked to "impart our knowledge" to Chaskis members through courses during the year. Michael recently held two workshops on electrical installation, using our house as an example of how *not* to do things. For the second session, he rigged a series of electrical outlets on pieces of wood, demonstrated proper procedures, and had the students practice in teams. A couple of days later, when Antonio came by to borrow

tools to install a circuit in his house and to be reminded how to identify a hot wire, Michael was so pleased.

This Saturday, I'll be giving an all-day "advanced" photography course for local people, "advanced" defined, in this case, as anyone who has had their hands on a camera and taken a few photos. Also, by special request from our Cañari friends, Michael has started teaching English classes on Tuesday and Thursday nights. I was in Cuenca when he gave the first class and had not planned to participate, but now I'm roped in as a second-string teacher and really enjoying it.

I never expect anyone to come. By seven o'clock, when the class is scheduled to start, the thick coastal clouds that roll in every afternoon during this time of year are usually at ground level, and it's dark and drizzly. I certainly wouldn't go out in this weather. But Michael puts a pot of water on the stove to make coffee and then, typically at about seven fifteen, there's a knock on the door. It's Maritza and her younger brother, Juan Carlos, shivering and complaining of the cold. *"Achaychay,"* they say, rubbing their hands, which means "cold" in Quichua but sounds to me like "chilly, chilly." Mama Michi's younger daughter, Mariana, and Benedicto, both high school students, arrive thirty minutes later. Others straggle in, up to an hour late, with muddy shoes and effusive apologies. (They know gringos appreciate promptness.) We serve big enamel cups of sweet coffee, and the room soon warms up with chatter and our collective body heat.

Eventually, a core group of six to eight students gathers around the oilcloth-covered tables, and it's time to start the lesson. We have a good time trying to explain and understand this strange language, where nothing sounds like it looks. "I sell you a chicken," says one student to another. "You buy a pig," comes the reply. Everyone finds English hilarious.

The other night, when Michael said the two hours were up, no one moved. "I don't want to leave," sighed Purificación after a couple of moments, reflecting the sentiment of all.

CHAPTER TEN

Día de San Antonio

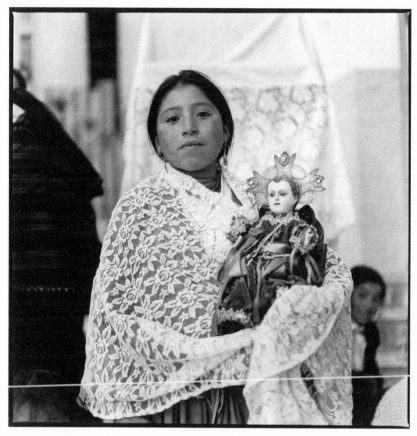

YOUNG WOMAN IN CHURCH, DÍA DE SAN ANTONIO

ONE SUNDAY MORNING AS Michael and I are having coffee, we hear the accordion music in the street that signals a religious or wedding procession. We run to the front patio and see a group of about forty men, women, and children quickly walking by, heading into town. In front, two men carry statues of saints dressed in Cañari ponchos and hats. Men and boys follow with armfuls of flowers, huge unlit candles carried crosswise, and white banners wrapped around poles. Behind them, several women and girls hold

smaller statues of *el Niño*, the Christ child, seated on tiny chairs. Near the end of the procession, three men balance small tables piled with herbs and flowers on their heads. A young girl carrying a smoking bowl of incense struggles to keep up, and bringing up the rear, the accordion player squeezes out the same three-tone tune over and over.

As the procession passes, I hear someone yell, "Juuuuddyyyyyy" (it sounds more like "Yuuuudeeeee"). Scanning the crowd, I am surprised to see Antonio Guamán, from Quilloac. With a sweep of his arm he gestures that I should join the procession. Here's my chance, I think. These processions have been passing by our house all month, but I feel I can't photograph them without being invited.

"I'm going!" I say to Michael. I put my cameras into my backpack and sprint after the procession, but by the time I cross the Pan-American it has disappeared. I know it must be headed to the church for mass, so I climb the hill into town, walking fast and panting with the weight of my gear. At the church I slide into a pew next to Antonio, and before the mass starts he tells me a little more about the Día de San Antonio, the saint's day of Cañar. He adds that it is also the day of his birth, thus his name.

Every year a different community is allowed to take the statues of San Antonio out of the church for the feast days and processions, he says. This year it's Quilloac's turn. Those who are members of what he calls the *"culto de San Antonio"* (which I take to mean a loose group of "believers") are responsible for providing food, drink, and music during the three-day fiesta, during which time the saints are "guarded" in a village house and carried back and forth to the church for several masses. Afterward, the statues are returned to the church until the next Día de San Antonio, when another community will carry on the ritual.

The honor carries an additional responsibility, Antonio continues: a young woman from Quilloac will be assigned to clean the church for a year. Good deal for the church, I think cynically as I watch the men at the front of the procession setting up the saints on a raised platform to create a tableau. Women and children arrange the lighted candles, banners, incense, and tables of flowers and herbs all around the saints. The smaller *el Niño* dolls sit in front on their miniature chairs.

I am surprised to hear this information from Antonio. Like most Cañaris we know well, he has never appeared to be tied to the rituals of the Catholic Church. As if divining my thoughts, Antonio says he is participating in the procession for the first time due to the influence of Magdalena. "In fact, this is the first time we are appearing together in public," he says, "to let the people in our community know that we are *juntos* [joined, or united]."

This is the Cañari way of announcing an impending marriage, or even an informal marriage itself, as in the case of Antonio, a widower, and Magdalena, an unwed mother. They will probably not have a church, or even a civil, wedding.

After the mass, Antonio invites me to come along with the procession back to Quilloac, but first he wants to present me to the members of the *culto*, who are starting to dismantle the tableau at the front of the church. I am pleased when he introduces me as *una amiga de confianza*, a trustworthy friend, and says that I will be happy to take some photos of anyone in the group. Antonio takes charge. First, he and Magdalena pose in front of the saints; then he lines up other family groups and they pass the saints, banners, and baby Christ from one to another for formal photos. I work very fast, as each person or group stands still for only a few seconds. One young woman spontaneously assumes a striking pose, wrapping herself and *el Niño* in a lacy shawl and looking straight into the camera. Through my lens, I can see it is a great shot, and I quickly take several color photos with a flash before switching to my big Hasselblad with black-and-white film. I have no flash on this camera, nor do I have a tripod with me (damn!), so in the dim light of the church I shoot at a slow speed and hold the camera as steady as I can, hoping for the best.

By the time the photos are done, the men have disassembled the tableau. They hoist the saint statues on their shoulders and march quickly out the double doors of the church, leading the procession around the square. I run alongside, trying to grab a few shots. Then, suddenly, a block or so down a side street, everyone seems to melt away through a small storefront door. Puzzled, I follow, looking around for Antonio. Inside the store, a woman behind the single counter seems startled to see me, but she motions for me to continue past her. I walk down a short dark hallway into a large paved courtyard, where I find Antonio and everyone else.

This is a *posada*, Antonio explains, which translates literally as resting place or shelter, although as I look around I don't think this place looks very hospitable. The courtyard, which appears to serve as a parking lot, is empty except for a couple of cars in the back and a table with four or five wooden chairs. Antonio says that they will eat and drink here for a few hours before continuing on to the village. The women are busily bringing out the food they had carried to the church in baskets and carrying cloths. Men and children run in and out of the store, buying bottles of *trago*—cheap cane alcohol—soft drinks, and sacks of hard candy. I look around for the saints, and when I don't see them in the courtyard, I peek through a window into an adjoining room where I sense something is happening. There, I see

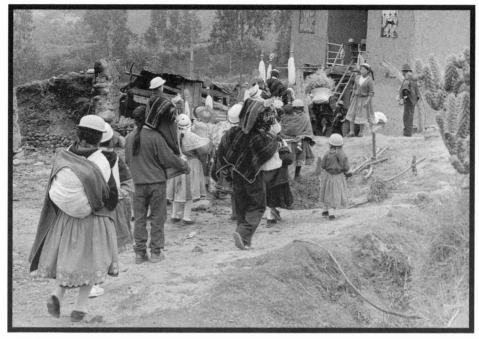

PROCESSION TO QUILLOAC WITH *SANTOS*

one of those perfect photo opportunities that will forever stay in my mind's eye, and there alone: the saints are sitting on a wooden table, with a large calendar featuring a bare-breasted woman hung on the wall directly behind them. The room is crowded with men arranging the banners, flowers, and candles; I know right away that I can't take this photo. I am a stranger to most of these people, included today only because of my friendship with Antonio. Everyone is watching me for any breach of etiquette, and pulling out a camera uninvited and crowding into the room to take a photograph would certainly qualify.

I accept a few drinks before telling Antonio that I want to go home for lunch and a rest. The procession will pass by our house later in the afternoon, so I ask if I can rejoin it then. Antonio says I am welcome to come along to Quilloac.

Michael has lunch waiting, and as we eat I excitedly describe the events of the morning. He's fascinated, but has no desire to join me for the next part of the day. I have time to read and rest for an hour or so before I hear the faint sound of the accordion, around four. This time I am ready with cameras loaded, and I run out of our house as the procession fast approaches

and try to grab some shots in the street, walking backwards, glancing over my shoulder so I won't fall, then sprinting ahead to get another vantage point. I wonder for the hundredth time why processions move so fast. The men carrying the saints look amused, but they don't slow down. They can understand posing for one photograph in the church, or maybe two, but they can't believe anyone would waste so much film trying to take this many photos, and with so many cameras.

I finally give up and fall in alongside Magdalena; we chat a bit as the procession leaves the Paseo de los Cañaris and begins to wind along the road to Quilloac. The accordionist walks in front us, endlessly pumping out the same tune, and Antonio marches beside him with a *raspadora*, a ridged metal cylinder that he plays by running a wooden stick up and down its surface. "Oh, I didn't realize Antonio was so musical," Magdalena says with a little sigh. "Yes," I reply, amused. "Antonio has many hidden talents."

Thirty minutes later, we veer off the main road and walk single file down a rough track to a simple two-story adobe house pressed up against a hillside. I see a group of women in an outdoor kitchen cutting up raw meat in preparation for the feast. The men leading the procession march right into a door of the small house and carefully set up the statues on a cleared wooden table. Others follow to arrange the candles, banners, flowers, herbs, and *los Niños* around the saints. As everyone crowds around the doorway to admire the tableau, a man inside, who I guess to be the owner of the house, removes his hat to say a prayer. I remain outside and take a couple of shots of the scene.

The saints safely stowed, people turn their attention to the business of the fiesta, and I steel myself. Etiquette dictates that as a guest, I will be expected to drink and dance and eat, and that everyone will be interested to watch. Most of the men and women are already a little tipsy from the drinks at the *posada*. One of the men pours me a small teacup of *chicha*, and once I've downed that he grins and hands me a large glass of *trago* mixed with a small amount of Coke. I sip it halfway down, but it is so strong that I turn to Antonio, who is standing beside me, to say that I simply cannot drink that much straight alcohol. Antonio comes to my rescue and downs the rest of my drink. I feel bad; he is obviously already quite drunk from the *posada* and possibly from the day before as well.

A young man has been insistently asking me to dance, so we dance to an interminable accordion song in the tiny courtyard in the front of the house. My Hasselblad swings around my neck, although I suspect my picture taking might be over for the day. No one else is dancing, but all gather

around to watch the performance, and when the song finally ends the crowd applauds. Whew! I have passed the critical drink-and-dance test, which marks an outsider as either a participant or an observer.

More dancing and drinking follow. When I am asked to stay to eat, I demur. The fiesta will last all night, and eating will mean more hours of drinking and dancing. As I try to leave, the host, who by then has had a lot to drink, insists that I have one more *trago,* and then another, and dance one more time, with him. Antonio finally intervenes, valiantly taking down my last drinks and explaining that as an *extranjera* I do not have the stamina of a Cañari. Still, the host persists, and I don't think I could have comfortably escaped if Antonio hadn't physically escorted me away from the house and down the road. As we say good-bye I thank him for the day and promise to have the photographs ready in a few days so he can distribute them.

Later that night, I awake with chills and the ominous cramping high in the stomach that I've come to know so well. I figure the *chicha* was the source of the problem, as it was probably prepared last week and given plenty of time to incubate all sorts of single-celled organisms. A visit to the clinic in Cañar the next day confirms that my old nemesis is back: amoebic dysentery. But it was well worth it—a few protozoa in my gut in exchange for photographing the Día de San Antonio.

This Camera Pleases Me

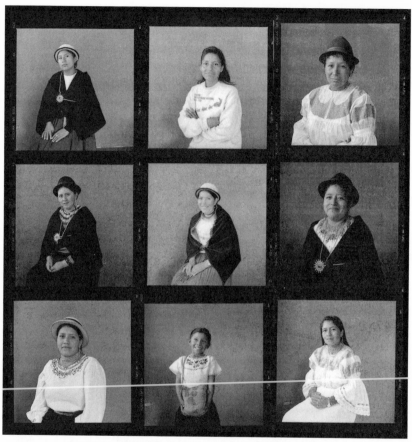

PHOTOGRAPHY WORKSHOP PARTICIPANTS, CAÑAR

AFTER MONTHS OF PLANNING, my first women's photography workshop is scheduled to begin on a Friday morning at nine in the first week of March; it will end at noon on Sunday. But when Michael and I get up at six on Friday morning, two women are already standing outside our gate, dressed in indigenous clothing that tells me they are not from Cañar. While Michael makes coffee, I invite them in and ask if they've come for the course. Yes, they have, says the one who introduces herself as Tamia. She and her friend,

Lola, have traveled all night on the bus from Quito. They arrived in Cañar at four thirty a.m. and huddled on the steps of the pedestrian bridge over the Pan-American until first light, when they were able to find our house. "We knocked once," Tamia says, "but you didn't hear."

The extra-early arrival of my first two students is a preview of what I will learn in the days to come about the degree of discomfort my students are prepared to face for the opportunity to learn something about photography. As they drink coffee at the table, Lola tells us she is from a small town near Quito, in Pichincha province; Tamia is from Imbabura, the province north of Quito. Both are active in indigenous political organizations. They appear to be in their mid-thirties, and both are impeccably dressed in the traditional *traje*, or clothing, from their region: finely pleated wool skirts and elaborately embroidered white blouses with ruffled sleeves; dark, fedora-style hats; and skimpy, cloth-and-string sandals called *alpargatas*. All of this clothing is quite distinct from the Cañari dress. After breakfast the women settle right in; Lola washes the dishes and Tamia sweeps the floor. When I protest, Tamia replies simply, "It's our way."

Cleanup done, we wait for the other participants to arrive. Tamia and Lola rest on the bed in my office and work on embroidery, while I go over my teaching materials and check my gear, impatient to get started on one of the major projects of my year in Ecuador. Will anyone else come? I have no idea. The suggestion that my first photography workshop be held for a group of indigenous women had come from Vicenta Chuma, the sister of Mama Michi's who works in Quito with ECUARUNARI. When Michael and I first arrived in Quito in October, we paid Vicenta a surprise visit at her office. After hearing that one of the projects I had proposed for this Fulbright year would be to give a series of photography workshops to indigenous groups, she suggested that my first be with women. She offered to find eight or ten students for a three-day workshop in Cañar if I would cover expenses: travel, room and board, and photo supplies. Delighted to have this opportunity drop neatly into my lap, I agreed, with no idea where I would get the funds. Vicenta said she would select women from a group participating in a three-year leadership course. They were women of few resources, she said, but much enthusiasm and dedication.

In the following two months, I planned the workshop, gathered materials and supplies, and made arrangements for a *pensión* and restaurant in town where the women would sleep and eat. I also made several anxious calls to Vicenta in Quito. Was she really finding women who had a genuine interest in photography? Were they really prepared to come to Cañar for three days? I wanted to hold the workshop here in part because I would have

José Miguel and Esthela at my side as fellow teachers. I knew that nothing I could say—or teach—would carry the weight of learning the same material from two *fotógrafos indígenas*. In our sporadic phone calls, Vicenta repeatedly assured me that the women would come; there would be about ten, she thought, but I was not able to get any other information.

So, on this morning in March, I'm set to go and two of my students have arrived. By ten two more students arrive: Delia and Rosa, from two southern provinces. They have also traveled most of the night and are tired, but cheerful and ready to go to work. Clara, a young Cañari woman I invited to participate in the workshop at the last minute, knocks on the door soon after. José Miguel, who has promised to be here first thing this morning, hasn't shown up, and I don't know about the other participants, but with five students I figure I can start the workshop.

We gather around the big table in the *sala* and do a round of formal introductions while Michael serves coffee and fresh rolls. All of the women but Tamia and Clara are married with children, and all seem to be in their thirties or early forties. Delia has four children, one of whom is grown and living in the United States as an illegal migrant. She and her family are farmers in a remote highland community near Saraguro; Rosa lives with her husband and two children on the other side of the mountains, toward the Amazon Basin, in the small town of Zamora. Both are Saraguro Indians, dressed in distinctive, finely pleated, black *polleras*, black fedoras, and elaborate beaded necklaces that fan out from their necks.

I tell them a bit about myself and begin the preliminaries of the course: "All cameras are black boxes . . ." As I say those first words I realize how nervous I have been about this long-planned workshop, and how relieved I feel to finally have it underway.

Over the course of the morning, other women arrive: Rosario, a Cañari from the neighboring town of El Tambo; then María and her six-year-old daughter Cecilia, from the central province of Bolívar. Mother and daughter are identically dressed in long skirts, woven belts, embroidered blouses, and broad-brimmed hats; they too have been on the bus most of the night. And at last, my two co-instructors—who have only to come up the hill from their house—arrive almost three hours late for reasons that I never get straight. But they are usually so responsible that I figure some sort of emergency delayed them, and I don't ask any questions. I introduce them to the women and Esthela excuses herself to hurry on up the hill and open Estudio Inti.

José Miguel makes up for his late start by working with me for the rest of the day. He shows the women how to handle a camera and load and unload

film, and he explains the parts of the camera using strange new terms like *disparador* (shutter release) and *obturador* (shutter). I talk about what makes photos "good, bad, or ugly," and the women work on an activity with clipped newspaper photos, training their eyes to see in new ways. Soon they are tossing around terms, not always correctly, such as *primer plano* (foreground), *profundidad de campo* (depth of field), and the rule of three in *composición*.

Mid-afternoon, a knock on the door. When I see a mestiza-looking woman dressed in jeans, sandals, and a skimpy T-shirt, I assume she has the wrong house, but she steps right in without hesitation. "Señora Judy? Is this the photography course?"

She introduces herself as Kathy Bueno from Esmeraldas, a coastal province in the far northwest of Ecuador. She had started out by canoe the day before from her village in the jungle, and it had taken her all day just to reach the provincial capital. From there, she traveled the length of the country, all night and most of today, via three different bus lines. When the bus finally passed through Cañar, she was sound asleep, she said, and only awoke in the next town, Azogues, where she got off and caught another bus in the opposite direction back to Cañar. "I'm very tired," she said, "but so happy to be here and ready to work. May I take a shower first?"

Late in the afternoon, the moment they've been waiting for arrives: an outdoor photo shoot. The cameras I have brought from Portland for teaching—six small automatics and two "professional" 35 mms—have been laid out all morning on a table. Now, it seems that each woman had been eyeing her favorite. Rosa immediately picks up the little Canon with the pretty case; Tamia is drawn to the small automatic Fuji, with its flashy silver body; and Delia grasps the tiny black Olympus to her chest and says, *"Esta cámara a mí me gusta,"* which I first hear as, "This camera loves me," but actually translates as, "This camera pleases me." I realize that most of the women have never had their hands on a camera before, which makes this a significant moment. Only one woman, Rosario, has brought her own camera, a semi-automatic Canon sent by a relative in the United States. She says she has no idea how to use it. No one, I notice, picks up the larger, more professional-looking cameras.

For the photo shoot, the women are instructed to work in pairs, one camera between them, with twelve shots each on a roll of twenty-four. I give them a sheet with directions for each shot (close-up, head-and-shoulders portrait, landscape with a figure in the foreground, action shot, and so on) and ask them to keep a written record identifying each photo. As we walk to a nearby park, the afternoon clouds are just beginning to descend. I pray it won't rain, as I haven't planned an alternative activity.

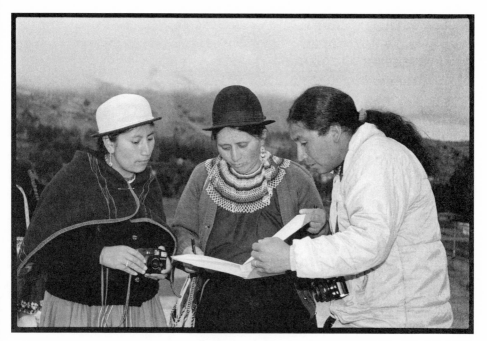

JOSÉ MIGUEL TEACHING

The women shoot their rolls very slowly. Kathy can't figure out how to put the camera to her eye, or which eye to use. Lola jolts the camera each time as she jams down on the shutter release, reminding me that these are women more accustomed to handling farm tools than cameras. Delia takes a "close-up" portrait of Rosa from twenty feet away. José Miguel and I circulate from one pair to another saying, *"Suave, suave,"* gently, gently, and, "Move a little closer to your subject." The women treat each photo as an infinitely precious work of art.

By the time we finish, it is spitting rain and nearly dark. We walk back to the house, unload the film, and I am about to wrap up for the day when Tamia timidly raises her hand to ask, "Please *compañera* Judy, can we come back after dinner? We have talked it over and we all agree that we want to work longer because we started late and two *compañeras* didn't arrive until afternoon."

What can I say? *"Sí, mis compañeras, trabajarémos dos horas más."* Yes, my colleagues, we will work two hours more.

We take a break and the women, now numbering seven plus Cecilia, the little girl, walk into town to rest in the *pensión* and have dinner, while I scramble to prepare an evening activity. Everyone returns after dinner ready

to work as they had promised, but long before the two hours are up most are yawning or nodding off.

On the second day of the workshop José Miguel arrives right on time, to my relief. I have asked him to begin by telling his life story, ending with how he became a professional photographer. I think it will be inspiring and take some mystery out of the process, in a culture where so few make the transition from the fields to a profession.

José Miguel describes his teenage years, when his father spent several months in jail for a minor infraction and José was forced to drop out of high school to help support his five younger siblings. Like so many other young Cañari men at that time, he cut off his long braid and went searching for work at the coast, where he found a job on a rice plantation. He eloquently describes the hard life of the *indígena* migrant from the Sierra working in the unhealthily hot coastal climate. José Miguel was only a teenager, and lonely, trying to maintain cultural and familial ties by coming home for fiestas and family events. On one of these trips home he met Esthela, a young woman who had been forced by the death of her father to also leave school. They married, had a son who died in infancy, and the hard life continued.

The job at the coast lasted for several years, José Miguel says, until he dropped a hundred-pound rice sack and broke his leg. He came back to Cañar, regrew his braid, began to wear traditional clothes again, and he and Esthela tried to scratch out an existence from the land that surrounded her mother's compound, where they live.

He goes on to tell about meeting me in 1991, when he was in his early twenties, and how, after he learned the basics of photography, he felt the possibility of a vocation stirring in his heart. He had always hated farming, and with five siblings he would never have enough land of his own to make a living.

From this point, his story becomes a minor epic. After Michael and I left Ecuador in 1993, José Miguel began to take photos of family and sport-ing events—graduations, baptisms, marriages, and soccer games—using the small point-and-shoot camera we had sold him. When clients asked where they could pick up their photos, José Miguel could only think to say, "In the park on Sunday." That odd arrangement worked for a while, he says, until a particularly exciting soccer championship when he took more than a hundred photos. He knew he couldn't have everyone looking for him in the park, so he and Esthela decided to rent a little storefront space in town for about ten dollars a month, where people could come to pick up their photos. With nothing but a built-in shelf on which to set the photos and a chair to sit on while waiting for the customers, they were in business.

While José Miguel talks, I remember the long silence between us in those years. Cañar has no postal box system (it was only recently that I discovered the post office, an unmarked storefront that is open sporadically), and Michael and I heard nothing from José Miguel for several years. Then, in 1997, we received the letter announcing that he and Esthela were now the proprietors of Foto Estudio Inti, on one of the main streets of Cañar. But he saved the most amazing news for last. After many childless years following the death of their son, he and Esthela had produced a daughter, Paiwa Pacha. She would be two years old in December, and they would wait to baptize her until we could come back to Ecuador and be there for the ceremony, as her godparents. He closed by saying he hoped that would be soon.

Michael and I did come back to Ecuador for Christmas that year, our first visit in four years. How could we not respond to a weighty invitation like that? We were amazed to find that Estudio Inti was a thriving business. An uncle of José Miguel's had loaned them the money to buy a professional Canon camera, a flash, and a tripod, and with the first profits they purchased a large Polaroid so the studio could offer passport and identification photos. Both Cañaris and people from town flocked to the studio, even though three other older, mestizo-run photography studios were well established. When I asked José Miguel how he had captured the mestizo customers, he said they came to Estudio Inti because their photos were of good quality and delivered on time. The Cañaris came for the same reasons, of course, but also because the proprietors spoke Quichua and they had made the studio a comfortable place to "hang out." During our Christmas visit that year, Michael built a darkroom for the studio, and we became godparents to little Paiwa.

The women listen with rapt attention to José Miguel's story, which lasts a couple of hours. They are inspired, I can tell, even though their own ambitions do not include establishing a photo studio. The important thing is that an *indígena* has become a professional photographer starting with nothing but a point-and-shoot camera like the ones they used the day before.

In the afternoon, we walk into town to meet Esthela and observe Estudio Inti in operation. As we stand around, two mestiza teenage girls step in off the street and shyly ask to pose together for a photo. Next, a woman arrives carrying a little boy in new clothes and slicked-down hair; she wants a photo to send to the boy's father, an illegal migrant in Queens, New York. An old Cañari man slowly labors in after that. He needs an identification photo in order to collect his state old-age pension of five dollars a month. Esthela handles all her customers with respect and patience, speaking Quichua to those who are *indígena*, allowing everyone to take as long they need

to wet and comb their hair in front of the mirror at the entrance to the back room.

After closing time, Esthela takes a portrait of our workshop group, posing us against the new Switzerland-themed backdrop. Then we sit on stools in the back room and Esthela tells *her* story, beginning with her husband's insistence that she sit in the first little storefront and hand out photos so he could go out photographing. When times were particularly busy, she says, she had to learn how to take photos herself. José Miguel showed her how to use the automatic Canon camera, but one day when she was eight months pregnant, the Canon broke down while she was photographing a high-school graduation. She was forced to switch to a manual camera, which she had never properly learned to use, and that was the day she became a "real" photographer. "It's good to learn the basics of photography from the bottom up," she tells the women, "not the hard way like I did."

Esthela talks about how the other photographers in town gave them a hard time when they first opened their studio, claiming they were not "legitimate" because they had no diplomas. At first, José Miguel had hung up a framed copy of the little diploma with the gold seal I had made for him when he was my student and pointed to his "international credentials." But eventually he and Esthela were forced to take a "professional guild" course offered by the municipality to be certified as photographers, although the course had nothing to do with photography; it taught accounting and other business practices. Now the owners of the four studios get along fine, Esthela concludes with an air of satisfaction, because there is plenty of work to go around. They even agree on prices.

That night Michael and I host a social event for the workshop participants and other Cañari friends, with the live music of Los Chaskis, dancing, *canelazo*, and, of course, Michael's famous banana cake. At midnight, as the women are leaving for their *pensión*, they shout back that they'll be here at eight in the morning for the last day of the course. They are tireless, it seems, but I am exhausted.

Sunday. Peals of laughter as the women look over the photos they had taken on Friday. "Her head is missing, poor thing," laughs Rosa at the portrait she's taken of Clara. "Too far from subject," says Tamia critically as she squints at a team of oxen barely discernible on the horizon. "Out of focus," says Lola, throwing her photo down in disgust. At least they are learning to recognize their mistakes, I think, as we carefully analyze the results of each woman's twelve photos.

We spend the remaining time planning for the future. Although I had not anticipated a second women's workshop, my students insist: three days,

here in Cañar, and with Michael's banana cake, please. (Several are busily copying his recipe.) I agree, gratified that the women are so motivated. We set the date for three months ahead, while I make a mental note to look for funding (I didn't have time to find funding for this one, and decided to use my Fulbright pay to cover the costs).

And by the way, Tamia asks as an afterthought, can they borrow the cameras for the Semana Santa (Easter week) fiestas coming up? Several women have already spoken to me privately to ask if they can take the particular camera that is "pleasing" to them and bring it back to the next workshop. It isn't a good idea, as I have other workshops scheduled in other parts of the country, but I promise to sell each of them the camera of their dreams for twenty dollars when they come back in three month's time. You can't ask fledgling photographers to go too long without their own equipment. (I make a second mental note to figure out how to get another stock of automatic cameras. In this case Kodak comes through, donating more than thirty cameras specifically for my teaching work in Ecuador.)

Some women leave Sunday afternoon to start the long journey back to their provinces, but Tamia, Lola, and María and her little daughter want to wait to catch the night bus and reach home in the morning. Ever good-natured about unexpected guests, Michael cooks a chicken dinner with corn on the cob. As we sit around the table the women have a chance to talk more about their own lives, their dedication to improving the lot of indigenous women, and what it meant to them to come to this remote corner of the country for a three-day photography workshop.

The New Economy

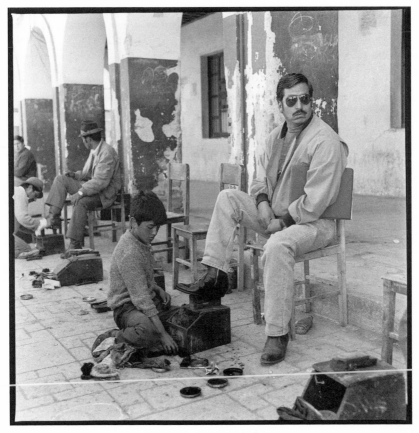

ON THE SQUARE, CAÑAR

OUR NEIGHBOR ACROSS the street, a sweet old woman we call Doña Teresa in public and Mother Theresa in private, has been a storekeeper for something like thirty years. She minds her meager stock of candy, soft drinks, matches, rice, flour, and fresh-killed chickens in a tiny space at the front of her house, with a low wooden gate across the doorway to keep out kids and dogs. Customers too, as the store is so small I can stand outside the gate and request a liter of milk.

"How much?" I ask.

"Let me see," Teresa mutters slowly to herself, "that's 8,500 in *sucres,* which in dollars is . . ." she stands transfixed as the old calculator in her head clicks away. "Thirty-four *centavos!*" she concludes triumphantly. I give her an American dollar bill and she makes change out of a small box filled with a mixture of United States and Ecuadorian coins. It takes her a long time, as she studies each coin and mutters its value to herself. On the wall next to her hangs a government-issued chart with photographs of each unit of U.S. currency and its equivalent value in *sucres,* which was Ecuador's monetary unit until September 2000. The photos are also supposed to help identify counterfeit twenty-dollar bills, which flooded areas like Cañar immediately on the heels of the new currency laws and are easy to pass off to someone like Doña Teresa.

To understand what has happened in the last couple of years to this small country of twelve and a half million people, imagine something like the Great Depression. Ecuador's economy had been stagnant for years, but it had a stolid constancy that its people had come to depend on, even with its high rates of poverty and unemployment. When Michael and I lived here in 1991–1993, the base monthly salary was equivalent to forty dollars a month, and a person could actually survive on that, though barely. Then, the *sucre* was relatively stable at 1250 to the dollar. Subsistence farming, combined with bartering and labor exchange, was a traditional way of life that the indigenous people had survived on for centuries. Eight years ago, our Cañari acquaintances were able to grow enough produce to feed their families and sell the excess at the weekly market to generate a bit of cash. Today, it is no longer possible to support a family from the land, and tens of thousands of young people in the southern region of Cuenca and Cañar have fled the country as illegal immigrants, seeking work in Spain, Italy, and Israel, but mostly in the eastern United States. (Queens, New York, is a favorite destination where, we are told, on a Sunday afternoon you can watch an Ecuadorian soccer game while eating roasted *cuy* and *mote* bought from Ecuadorian sidewalk vendors.)

The *sucre* began its precipitous descent in the late 1990s, and by early 1999, when the exchange rate fell to 25,000 *sucres* to the dollar, the country was on the edge of economic collapse. The government, the fourth in four years and thoroughly corrupt, defaulted on its foreign debt, and none of the emergency measures of the World Bank or International Monetary Fund (IMF) were able to help the country avoid the crash. On March 19, 1999, a "bank holiday" was declared and all forty national banks closed their doors. When the dust settled several days later, only twenty-six reopened,

and the others were declared *quebrado*—bankrupt. Millions and millions of dollars—or *sucres*—simply disappeared overnight, and all those Ecuadorians who earned enough to have bank accounts, in *sucres* or dollars, woke up to find their money gone. Simply evaporated! Those banks that did reopen froze all accounts for one year.

Two years later the fallout is a continuing drama in the daily papers. Most depositors still have not recovered their savings from those banks that survived the crash, although occasionally one or another bank will announce with great fanfare that it is "giving back" a token amount—equal to about four hundred dollars around Christmastime, for example. As investigations and revelations continue, many a banker has fled the country to take up luxurious exile, Latin American style, in Europe or the United States. The national press delights in uncovering an ex-banker's million-dollar hideaway home in Spain, detailing his luxurious lifestyle and his new marriage to a beautiful young Spanish heiress (without having divorced his first wife, as it turns out). But that seems to be the extent of it.

To add to the scandal, a couple of months ago a list was made public of the bankers and their high-up political friends who had withdrawn their own funds when they saw the crash coming. The list, shamefully, includes Ecuador's current president, Gustavo Noboa.

In late 1999, with inflation at 60 percent and the economy imploding, Ecuador's president Jamil Mahuad, with the blessing—or the spur—of the IMF, announced a drastic measure that he promised would stop inflation, stabilize the economy, and encourage foreign investment: Ecuador would adopt the dollar as its currency. Many saw this as an expansion of U.S. influence in Ecuador, and within a week a massive indigenous uprising and protest march on Quito literally chased President Mahuad from his office, with the help, surprisingly, of junior military officers. These strange bedfellows soon parted company when the new military junta squeezed out the Indian leaders. The United States expressed its displeasure at what it saw as a near-coup d'état by closing its embassy doors in Quito for a few days, and the military junta chief was pressured to step down. Vice-president Gustavo Noboa assumed the presidency, and a shaky democracy that began in 1978 continues on its rocky road. (Today, one of those junior military officers, Lucio Gutiérrez, is the civilian president.)

But the dollarization plan remained and went into effect last September, a month before we arrived. Accustomed to carrying thick wads of the practically worthless *sucres* and thinking in terms of millions, vendors in the Cañar market, I notice, now carry huge rolls of dollar bills. Last week, we bought some tapes from a friend who sells music cassettes at a street stall,

and he pulled out a wad of dollars with a fifty-dollar bill wrapped around twenties, tens, and ones. No one trusts the banks now, so most of the people we know keep their money in their pockets or, in the case of the women, hidden in their skirts or in some mysterious place deep in their bosoms.

ALONE IN CUENCA FOR a couple of days, I go out one evening to a special screening of a Buñuel film that I'd seen advertised in the paper. When I arrive at the theater, it is dark. A young man stands leaning against the open doorway, a scarf muffling his neck and lower face. He shrugs at my inquiring look, and says the film has not come from Guayaquil. "It often happens," he adds, without the least show of emotion or customer-service concern. It is early, so in the waning light I stroll down the street toward the main plaza, or Parque Calderón, a formal park with benches and fountains dominated on the west side by the huge "new" cathedral, begun in 1880 and built to hold ten thousand people. On the opposite side of the square, the smaller Catedral Vieja (Old Cathedral), built in 1557 by the Spanish founders of the city and closed for many years, sits inconspicuously. Municipal offices, shops, and businesses run along the other two sides of the square.

It is strangely quiet. I look around and am startled to see two knots of police standing at the far corners of the square, holding large clear plastic shields as though they expect an imminent attack. Then I remember there had been a protest march today. And isn't that tear gas I feel stinging my eyes and throat? Yes, definitely. That's why the young man at the theater had his scarf wrapped across his face. Curious now, I leave the square and take a longer walk through the adjacent streets. At this time of the evening, the commercial center of Cuenca is usually full of life with shoppers, strollers, and friends meeting for coffee. But tonight the stores are closed and shuttered on all but one street, and even there the crowds are light.

When I read the newspaper tomorrow, I'll learn that five thousand campesinos, trade unionists, teachers, and students marched in Cuenca today as part of a national protest against the price hikes, or *alzas,* that were mandated by the government at the end of December and went into effect this week. The cost of a tank of cooking gas, which even the poorest could previously afford, doubled from one dollar to two, bus fares went up by 75 percent, and gasoline prices jumped, which affected the cost of all basic goods. These were cruel blows to most Ecuadorians, coming on top of the end-of-year announcement that the country's inflation in 2000 was 91 percent, the highest in the Western Hemisphere.

Protests against government hikes, especially by high school and university students, are a proud tradition in Ecuador. The students serve as a

kind of political barometer, and middle-class Ecuadorians feel almost sentimental about the annual uprisings of their young people. Bus fares are a particularly sensitive issue and can always be counted on to cause organized protests. In a country where cars are horrendously expensive and only the well-to-do can own them, 90 percent of the population depends on public transport to get around.

As I walk through Cuenca in the aftermath of the march, students still mill about, many with kerchiefs over their faces and rocks in their hands. Smoking tires and trash piles burn at a few intersections—burning tires is a favorite form of protest here—and the police have blocked off many streets with barricades. Two World War II–vintage tanks sit ominously on side streets. Black, squat, ugly, and utterly out of place in Cuenca's lovely colonial center, I've seen these relics before. They always make an appearance at student protests, but usually they sit with doors and hatches open, the young policemen on duty leaning against the tank and drinking soft drinks or talking to young women. Tonight, however, I watch in horror as a tank careens around a corner and heads straight for a group of students gathered at the end of the street. With a great boom a canister of tear gas shoots out. Students scatter, the air fills with acrid smoke, and the tank scuttles around a corner and disappears.

Amazingly, no one ever seems to get killed in these local protests, although minor injuries are common. In fact, non-violence is a point of pride all around for those who live in Cuenca: the police are usually restrained and stay in the background, and the students arm themselves with only rocks. But these most recent price increases have galvanized the country. They are the latest in a series of crippling economic measures dictated by the IMF and World Bank as part of a tough recovery plan designed to bring Ecuador back from the brink of economic collapse. For poor Ecuadorians, the doubling of the price of cooking gas represents a real disaster. And let's not forget the bank crash when tens of thousands lost their savings, the military overthrow of the government, a present minimum monthly wage stuck at $117 (for those who have jobs), and a national poverty rate of 79 percent (which puts Ecuador just above Haiti and Nicaragua on a list of the poorest nations in the Americas).

A WEEK LATER, Michael and I are in Cuenca when we hear that an indigenous uprising is paralyzing the country by blocking the Pan-American Highway at intervals along its route; a national strike is imminent. We rush to the bus station, agreeing that we would rather be trapped in Cañar, where we will be with friends and closer to the action, than in the eighth-floor

apartment in Cuenca. About an hour into the trip, as the bus begins the climb up the mountain just out of Azogues, it is forced to stop by a barricade of rocks and earth across the road. Peering out the window and up the steep slope, we can barely see a knot of men and boys high on the hill. Every few minutes they lob several small stones in our direction, but they don't seem intent on any serious damage. The driver's helper orders the passengers off the bus and we watch as it inches over the barricade, precariously tipped to one side. After that we get to Cañar without incident. We later heard that ours was indeed the last bus to make it to Cañar from the south. No doubt the men and boys on the hill outside Azogues made sure of that by building up the barricade once we passed.

The national strike begins, and we hear on the radio that the government has declared a state of emergency. The next morning, hundreds of people from indigenous and campesino groups, plus organized labor, young Communists, and, surprisingly, the mayor and other city officials, gather in Cañar for a march in support of the strike. Michael films and I take photos; I suppose we look like a regular press couple. Gregorio, a reporter we know from the local radio station, circulates with his tape recorder and stops to ask us for the "international perspective." We both stand tongue-tied for a moment before Michael says something along the lines of, "We are here to show that people outside Cañar and Ecuador support the strike"; I say something lame about the importance of peaceful protest in a democratic country.

The sun has appeared in the midst of a cold spell, so the mood of the marchers is upbeat and relaxed. After circling the streets in the center of town chanting and waving banners, the marchers head north on the Pan-American. I ask people around me where we we're going, and no one seems to know. Within about thirty minutes we come to a straight stretch in the road that is obviously our destination. A huge pile of rocks on the roadside, originally destined for a construction project, are to be the instruments for the local *bloqueo*, or blockade, of the highway. Everyone — including women and children — gets to work lugging large rocks from the pile into the road; Michael and I join in. A few trucks and buses appear around a curve in the distance, coming from the north, but when the drivers see the protesters and the blockade they skid to a stop and quickly turn tail. They know from experience that if they come any closer they are in danger of having their tires punctured by knives, a traditional part of a *bloqueo*. Once the road is blocked, the marchers sit down on the grassy bank, or on the rocks themselves, to listen to speeches.

First to speak is the director of the indigenous political organization in

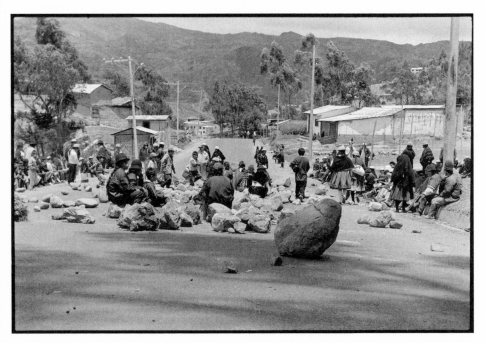

BLOCKADING THE PAN-AMERICAN HIGHWAY

Cañar that encompasses all the agricultural cooperatives in the province. Then the mayor speaks. He looks *indígena* but has no other obvious signs of indigenous identity; otherwise, I doubt he could be mayor in this community. A passionate speech by a member of the Communist youth group follows (de rigueur red-and-black bandanna around neck). His is the group responsible for the only graffiti I see in town. Finally, the director of bilingual education in Cañar, who is a community leader from Quilloac, speaks. As a photographer I am very happy. Only in public events such as this am I able to freely take photos, although a few women still duck their heads or turn their backs when they see my camera trained in their direction. A tense moment occurs halfway through the last speech when a military jeep pulls up about fifty yards down the Pan-American and several armed policemen get out and march in our direction. The crowd grows quiet and watchful, but as the men reach the edge of the gathering they raise their arms to wave, smiling and nodding to acquaintances and relatives as they pick their way through the rocks and continue up the road. Michael and I laugh, recognizing this as typical of small towns everywhere, where the local policeman might be your husband, brother, or cousin.

Speeches over, the mayor and his minions leave, and Mama Michi and

others build a cooking fire in the middle of the highway, preparing to fix a meal for the several hundred people that remain. Huge pots appear, but no food is yet in evidence. Michael and I decide to go home for lunch.

Later that day we hear on *La Voz de Ingapirca* that the government has signed an agreement with the national indigenous leaders and the strike is over. The price of cooking gas is to be immediately rolled back from its doubled price of $2.00 to $1.60; gasoline prices will be frozen for a year; bus fares will be cut back, though not to their previous levels; and fares for students, elderly, and the disabled will stay at 50 percent of full fare. A few other issues are to be taken under discussion.

In some ways, I think, it seems a meager victory after three weeks of protests and roadblocks, three deaths (during an encounter between police and protesters in a jungle community), and scores of injuries. This country is between a rock and a hard place economically, and I suppose the indigenous leaders know that there is no going back to the way things were before and that a compromise agreement is better than none at all. But in Quito, for the six thousand Indians who have come from all over the country for a two-week sit-in, it is an unqualified victory, and time to go home.

A Death in Cañar

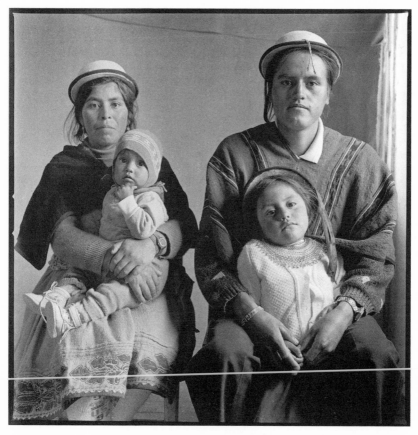

JULIANA QUINDE AND DOMINGO ALVAREZ

WE FIRST HEAR THE news on the local radio station that broadcasts death notices. A lead-in of the first strains of "Ave María" lets listeners know that sad news is coming and reminds us of the inevitability of death. Juliana Quinde Pichisaca, from the village of Quilloac, has died; her funeral will be on Monday. Michael and I pay little attention, although we know someone named Juliana Quinde. So many people share names here, and the details are in Quichua. But later that evening Esthela drops in, and the announcement

is played again. She listens carefully and says this is the Juliana we know, the daughter of Isidoro Quinde, wife of Domingo. "No!" I blurt out. "It can't be! I saw her just last week in town. She looked fine. And she has four or five young children," I add, as though it is an impossibility that a young mother could die. "Six," corrects Esthela. "One is still a baby."

The next morning, when Anastasio Pichisaca comes by, he confirms that it is true. Juliana was a relative who lived in his village. "From what I hear," he says, "she fell off a wall near her house. That's all I know." This sounds unlikely. Cañaris are the most sure-footed people I know. From an early age they walk everywhere in these precipitous mountains—atop rock walls, up and down the steepest slopes, along the edges of deep ravines—and the women almost always have babies on their backs or carry heavy loads. How could Juliana have simply fallen off a wall and died?

Anastasio, a man from Quilloac I've recently met, is helping me do interviews with old folks who speak only Quichua, and we have scheduled some work together today. Because it's a nice day and our work will involve a lot of walking, Michael is coming along. As we strike out for the countryside, Anastasio says that we will be near Juliana's house after our first interview, so we should stop and pay our respects to the family.

Michael and I knew Juliana and her husband, Domingo, when we lived here eight years ago. The couple were in their mid-twenties then, with two children. Domingo, who is from a village across the valley, farmed with his father-in-law, Taita Isidoro, a respected leader in the Quilloac community. At the time, we knew Domingo better than Juliana because Michael worked with him and a few other young men on a project building terraces on Taita Isidoro's land. Also, when Domingo built an adobe house just down the hill from Juliana's parents, Michael helped him wire it.

The few times I was around Juliana she was so shy she would not talk to me, and I knew almost nothing about her. With her hair unkempt—highly unusual for a Cañari woman—her fierce face burned dark by the sun, a baby on her back, and another in her belly, she invariably seemed distracted and unhappy. I assumed she spoke only Quichua, so I didn't press her beyond a passing greeting, to which she barely responded. This year, I occasionally saw her on the streets in Cañar, and she always watched warily to see if I would recognize her before she nodded at me. Her hair was still wild, and she still had a baby on her back.

As we walk with Anastasio toward the village of Quilloac, I recall a terrible chapter in Juliana's life I came to know about accidentally. Two years ago, when I was back in Cañar for a brief visit, I ran into Juliana's older brother Isidoro at Mama Michi's house. I knew him well from our original

stay in Ecuador, when Michael and I volunteered for the organization he created, INTI. I asked what had brought him to Cañar, and he told me a chilling story in a flat, even tone. His father had called him home to handle a serious family problem, he said, that had required him, as the oldest, to administer a ritual beating to his youngest sister in front of the members of the *comuna.*

A couple of years before, Isidoro continued, Domingo, already married to Juliana, had impregnated Juliana's middle sister Patricia, then a teenager living with her parents in a nearby house. A hasty marriage had been arranged between Patricia and Domingo's brother, and they were dispatched to live with his family on the other side of the valley. Juliana and Domingo then had a third child, and then a fourth.

But now, Isidoro continued, Domingo had fathered yet another child with Juliana's youngest sister, Elena, who was left a single mother with no prospects of a husband. In the Cañari culture, while an unwed daughter with a child brings shame to a family, it is not terribly uncommon; the child is usually incorporated into the family and cared for by the grandmother. But adultery committed within the family is extremely serious, tantamount to incest.

"I had to beat her hard with a *chicote* [a leather riding whip]," Isidoro said with distaste, obviously unhappy with his responsibility. He gazed around the countryside as though this place also was distasteful to him.

I was horrified and could hardly absorb what I was hearing. It seemed so uncharacteristic of the gentle people I know. "But what about Domingo?" I asked, incredulous. "Isn't he the one who should be whipped?"

"If we could find him I'd beat him even harder," Isidoro said vehemently. "But he's disappeared."

We parted, and that was all I knew of the story until we returned to Cañar this year, when I heard another chapter from Esthela. After the Elena's public beating and Domingo's disappearance, Juliana and her four children went to live with Isidoro and his family in Quito. Domingo eventually reappeared in Cañar, Juliana eventually came back from Quito, and the family was reunited. Elena, along with the child, continued to live with her parents just up the hill. Two more children were born to Juliana and Domingo, making a total of eight children that Domingo had fathered with the three sisters.

About a month ago, Michael ran into Domingo and Taita Isidoro, Juliana's father, on the street. Both dressed in their best and smiling broadly, they greeted Michael warmly: why hadn't we been to see them? We must come visit on Monday to celebrate the baptism of Domingo's second-youngest child. When Michael relayed the invitation, I said I didn't want to

go to Domingo's house; I was disgusted by his behavior and had no interest in being friends. But Michael reminded me of our friendship with, and respect for, Taita Isidoro, Juliana's father, who had extended the invitation.

So we went, and, sitting in the *sala* of Domingo's house with Taita Isidoro, we caught up on Domingo's life. He had left farming, he said, and is working in construction in Guayaquil. He comes home every few weeks for a few days. Two of his brothers have emigrated to the United States and he talks to them regularly by cell phone. He gestured proudly to the magic instrument itself, resting incongruously on the crude adobe sill of the plastic-covered window. Juliana stayed out of sight the entire visit, sending one of her children with food to the big table where we sat. It was the second day of the baptism festival, Domingo said, and both he and his father-in-law were in high spirits from drinking. They insisted we join them in repeated *canelazos*, although it was early.

Children of all sizes ran in and out the front door, hair flying, faces dirty. "And who is this one?" I asked Domingo several times, referring to a particular child. He would screw up his eyes and think a minute before coming up with a name. They were all his children. I asked about the youngest one, and he said she was about a year old and hadn't been named yet.

NOW JULIANA IS DEAD. As Michael, Anastasio, and I approach the road that runs along the steep hill below Domingo's house, we see him and others climbing down from the back of a truck. All are dressed for mourning, in black or deep purple clothing and black fedora hats. Domingo introduces us to his father and other relatives from his village across the valley. I embrace him, and Michael embraces him, and no words are exchanged but we all choke up. We begin climbing the steep path to the house, Michael, Domingo, and I in front, Anastasio and the family members trailing behind. After a few minutes, Domingo turns to me and says, simply, *"Mala suerte."* Bad luck. Nothing else. After a respectful pause, I ask what happened. "She fell off a wall right next to the house," he says, "and her head was injured . . ." He makes a motion with his hand along his cheek.

On the outer adobe wall of Domingo's house, facing the path, a sign has been crookedly hung, announcing that death has come to this house. Three dim bulbs illuminate the tragic, painted face of Jesus with a crown of thorns, and the words "Funeraria Alvarado."

"I have my cameras with me," I say to Domingo. "May I take a few photos? What do you think?" He nods assent, but I don't take a camera out; I know I must wait for an unobtrusive moment.

We walk around the edge of the house, which is built into a deep cut in

the hillside, and through a small dirt patio to reach the entrance. At the doorway, I stand stunned. An elaborate casket, faceted with strips of mirror, dominates the earth-floored room. Each corner of the casket has glass-covered insets that display paper flowers and saints and the Virgin Mary. Three-foot candlesticks with guttering candles stand on either side of the coffin, along with several wooden columns about five feet tall, topped with bulbous electric lights. Sprays of artificial red roses sit in baskets on the floor. A beautiful, embossed metal cross about six feet tall and decorated with glowing lightbulbs stands at the head of the casket. The mud walls of the room are draped with a metallic-threaded cloth which has been rolled up over the single window to let in light and also over the doorway to allow access to the other room of the house. Chairs and wooden benches line three walls of the *sala*. I can't help but wonder how far in debt this funeral will take the family.

Taita Isidoro, sitting beside the coffin, stands up to greet us. "Mikito," he says, tears streaming down his cheeks as Michael embraces him. Michael has been a favorite of Taita Isidoro's since he gave him an electric razor for his sparse whiskers a few years back. He looks Michael in the eyes, shakes his head, and says with resignation, *"Fue destino."* It was destiny. I think how much this dignified old man has suffered: his oldest son an intellectual in Quito who rarely comes home, another son seriously handicapped with childhood polio, his two unmarried daughters made pregnant by his son-in-law, and now this, the death of his eldest daughter.

Taita Isidoro's wife, also named Juliana, bustles in and speaks to him in Quichua. He explains apologetically that he must leave to help with preparations for the *velación*, the all-night vigil before the funeral.

We sit on chairs, joining Domingo and a few other neighbors and family members. After a few minutes, Anastasio initiates a conversation with Domingo about the circumstances of Juliana's death. It is all in Quichua, so I understood almost nothing, but suddenly everyone in the room stands up and walks out the front door into the patio, an earth-floored space cut into the hillside. Domingo tells the story in Quichua, and Anastasio translates it into Spanish for Michael and me: yesterday morning Juliana went out to collect some straw for tinder to start the fire to cook *mote* (we are to hear this particular detail many times, whenever the story of her death is told). She was alone and returning to the house when she fell, Domingo said, apparently while trying to cross over a stone wall on the edge of the embankment that stands directly over the patio. Domingo gestures and we all look up, trying to imagine the last moments of Juliana's life. The drop is fifteen feet at least. No one saw her fall, but someone—who? one of the children?—

found her lying in the patio. Domingo was called from the house. "She didn't speak," he says, "but she moved her arm onto her chest, and then she was dead." Perhaps she hit her head on one of the rocks in the patio, he concludes, because the side of her face was bloody.

We will never know. In the Cañar countryside, doctors are not called when someone dies, so no official cause of death exists. I try to imagine the rest of the scene. Had Juliana's children gathered around their mother on the patio as she lay dying? Had one of them run up the hill to tell her parents the terrible news? Who had moved her into the house? How had they arranged for the casket?

Putting together what Esthela had told us the day before, Michael and I speculate later about the course of events. When Esthela saw Taita Isidoro and other family members walking past the studio dressed in black, they must have been going to buy the casket and make arrangements for the funeral. Funeraria Alvarado, then, must have delivered the casket up that steep hill, put their lighted sign on the outer wall, arranged Juliana in her casket, and placed the candles, flowers, cross, and metallic cloth around the room. And it was probably the funeral home that called *La Voz de Ingapirca* to place the death announcement and give details of the funeral. In this land without telephones, country people get all their local news from the radio.

We are back in the *sala*, sitting around Juliana's casket on straight-backed chairs and benches. Domingo makes the rounds as host, serving us shots of hot, sugary *canelazo.* Children run in and out the open door, sucking on hard candies that one of the visitors is giving out. I see Juliana's oldest child, who must be about ten, and I wonder if it has hit her yet that her mother is gone, leaving her the oldest of six brothers and sisters, the youngest still without a name.

At one point Anastasio stands, takes off his hat, and says a prayer. He then walks over to the casket, removes the crucifix, and opens a small hinged door at the upper end, near where Juliana's head would be. He motions for me to come over, and I peer over his shoulder. Juliana's face and upper body are completely covered in a shimmery black cloth that Cañari women sometimes wear as fancy shawls. Only a bit of her hair is showing, escaped from her braid and flying, as it always was when I saw her in life.

As people begin to leave the room, Anastasio turns to explain to Michael and me that the family and neighbors will keep a second night's vigil with the body. An *orador*, a sort of lay preacher, has been hired by the family to pray and sing through the night to help keep people awake, he says, and the family will provide food and drink.

When the moment seems appropriate and no family members are pres-

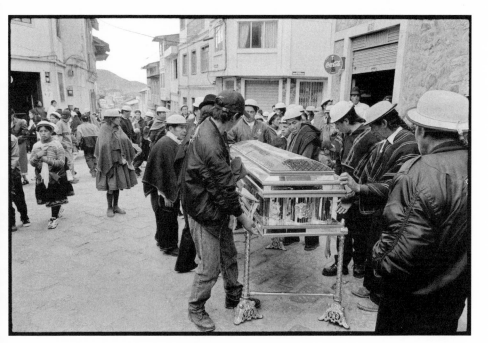

FUNERAL PROCESSION

ent, I pull my camera out of my backpack and, using the low light of the open doorway and partially covered window, take several photos of the casket. We leave soon after, promising Domingo that we will join the family the following day for the funeral procession to the church and internment in the cemetery.

THE NEXT DAY, just after noon, Michael and I strike out for Quilloac, and within minutes meet the funeral procession. Strung out along the road, a hundred or more people walk slowly toward town, the men in front, the women behind. Taita Isidoro, taller than most Cañari men, leads the procession in his black wool poncho, black fedora, and sandals made of rubber tire. Michael embraces him in greeting and asks if we might walk along. He nods and says, *"Más soldados."* More soldiers.

A group of five or six children walk directly behind Taita Isidoro (most are Domingo's, I realize by their distinctive features), each carrying small sprays of artificial flowers. Following them, four men carry the mirrored casket. They have already walked about three kilometers in the midday sun, I figure, beginning with the steep, rutted hill in front of Domingo's house. They are all sweating profusely with the weight of the coffin. Two men fol-

low, carrying the elaborate worked-metal legs and crossbars that the casket rested on at the house.

Within a few minutes, the procession halts and the four pallbearers and two men carrying the legs and crossbars carefully set up the casket in the road, where it glitters in the afternoon sun. An old man stands at the head of the casket and prays in Quichua; this must be the *orador*. As he prays, a few people cover their eyes and cry, as if on cue, but the majority of the mourners sit on the grassy verges or stand in the road, chatting. The tone is somber, but not tragic. Michael and I circulate among the few people we know: Isidoro and María Juana from Quito, Mama Michi and others from the Chuma family, people from the Quilloac community. Any references to Juliana's death carry the same sense of implacable fate that we have heard from Domingo and Taita Isidoro: "It was her time to die." "Bad luck." "Destiny." "Such is life."

María Juana and another woman move among the crowd, serving small plastic cups of Zhumir mixed with Sprite. The pallbearers drink first, then the family members, the men, and finally the rest of us. After about thirty minutes, the pallbearers hoist the casket onto their shoulders and the procession sets off again.

We stop twice more before reaching the church. Each time the casket is carefully set up in the road, and the mourners stand or sit patiently for a half hour while drinks are served and hard candy is passed around. It appears that at each stop a different member of Juliana's family serves the drinks. At our last stop, on a cobbled street in the center of Cañar, we pick up two "village fools" who stay with us the rest of the day, through the mass at the church and on to the graveyard. One is simply drunk, and the other is a mute, wild-eyed, barefoot beggar we've seen around town since we got here. With typical Cañari generosity, they are tolerated and given drinks and sweets.

I am a little uncertain about my role as photographer, as I've not been to a funeral in Cañar before. At first, I only photograph the casket and the family gathered around it at the rest stops, and not the other mourners, who might object to a stranger taking their photo. But I get bolder as the procession goes on, and eventually I have three cameras hanging around my neck. No one objects, though I could see people commenting and gesturing at my cameras, and several ask me who I am and where I am from. It helps that Michael is in the crowd and obviously a friend of Taita Isidoro's. At the last stop, in the cobblestone street leading to the main square, I motion for Domingo to stand beside the casket and he poses for me, looking im-

passive, with his arm resting possessively on top of the casket. What could he be thinking?

As we approach the church the procession quickly breaks apart. Father Jesús, waiting on the steps in front of the massive double doors, hastily throws some holy water on the casket and everyone quickly moves inside to take their places for the mass. Domingo, his children, and Taita Isidoro stand at the front of the church, facing the rest of us. The church is packed; others who were not in the procession have joined us from communities that were not along the route, such as Correucu. Domingo has asked me to take some photos of the mass, but I will have to use the flash and I quake at the thought of the stern priest turning his censorious eyes on me. I wait until the end, then sneak behind a column and take a couple of shots.

The mass over, the mourners file out of the church and walk fast through the town, down the hill, and across the Pan-American to the graveyard. I try to run ahead of the procession to get some shots, but I barely get a focus before the crowd is upon me. Why so fast? I wonder for the hundredth time.

I am near the front of the procession as it passes through the front gates of the cemetery. Just after the pallbearers climb the first set of stairs and make a quick left turn between two walls of burial niches, I see a man standing beside an empty niche, a wheelbarrow filled with wet mortar by his side and a trowel in his hand, watching the casket approach. "It won't fit," I hear him say flatly just before the crowd surges around me.

From the sidelines, I can see nothing beyond a sea of round white hats and black fedoras. I look up at the next level of niches to discover a long line of men, women, and children leaning over a concrete railing. They obviously know the routine and have rushed up to the next tier to get a good overhead view. José Guamán, a friendly man from Quilloac whom I've recently come to know, motions that I should come up to where he is standing, so I climb up to the next level, but I still can't get near the railing, as the spectators are two or three deep. José sees my camera and says that he will take a photo for me, as he has a prime spot directly above Juliana's niche. I make a guess at the exposure, hand my Hasselblad over, and watch in horror as José leans dangerously far over the railing, both feet slowly rising in the air. I grab a foot, anxious both for him and for my expensive camera. "Got it!" he says triumphantly as he turns to hand the camera back to me, pleased with himself.

Taller than most everyone, I am able to stand uncomfortably on tiptoes, peer over heads, and get a general sense of what is going on below. At first, thinking that Juliana's casket is going directly into the niche, the mourners

closest in begin to keen and cry in a ritualistic way, touching the casket or laying their heads and arms on it. Then, as it becomes clear that the casket will not fit, people grow quiet. Within a few minutes I see drinks in small paper cups circulating throughout the crowd. From above I can easily spot Michael by his orange cap, standing far back in the crowd.

Another glimpse over the heads and I am horrified to see that the upper hinged lid of the casket is open and the mason—the man with the wheelbarrow and mortar—is prizing off the hinges with his trowel. Someone holds a blue shawl over the glass top so that Juliana's body will not be visible, and Domingo and Taita Isidoro busily help to get the hinges off. But one of Juliana's brothers, Santiago, stands by crying inconsolably. After maybe ten minutes, the upper part of the casket lid, or "viewing door," comes off, and I catch a glimpse of the tufted white satin interior as it is handed over the heads of the crowd to rest against a wall.

The lower part of the casket lid is not so easy to remove, as it is fastened without hinges and was never meant to be raised. After the trowel proves useless, a young man comes running with a hacksaw. The crowd settles down to wait while the mason and his helpers attack the casket top, hinge by hinge. I see women sitting on the steps of the niche wall bringing out food that has been wrapped in carrying cloths and baskets. Other mourners are quickly and obviously getting drunk. Children run around on the edges of the crowd, up and down the steps, enjoying the warmth of the late afternoon sun and the excitement of the day. I circle and try to get some unobtrusive shots of the mourners; by now I am pretty well ignored.

Soon I notice money quite literally changing hands in the crowd, but very discreetly, almost like a sleight-of-hand exchange. I can't discern any reason or pattern, but a friend standing nearby says that it is the custom for the mourners to pay the family of the deceased "to help with their pain." I take another look and see that, of course, people are handing money up through the crowd to Taita Isidoro, Domingo, and Juliana's brothers. I haven't brought a single dime, but Michael has a pocketful of change.

During the forty-five minutes it takes to get the lower part of the casket lid off, I catch occasional glimpses of the proceedings, like fast cuts in a film: someone firmly holding the shawl over the glass as the mason saws at the lid; the final wrenching off of the metal piece, its underside industrial-looking gray metal definitely not meant for public viewing. I can't see the casket in its altered form, but as the pallbearers prepare to move Juliana into her final resting place, I see them light up cigarettes, as do other men standing nearby. Normally, the Cañari smoke only at fiestas, but tobacco is considered to have shamanistic powers and is also smoked on ritual occa-

sions. I recall an incident Michael described years ago, when he was working with Domingo and others, digging to build the terrace on Taita Isidoro's land. When they came upon a big slab of rock, the Cañaris thought it might be a tomb, so they stopped work and sent someone to buy cigarettes before continuing to dig.

As the casket slides into place, the keening and crying begin again, but quickly subside as the mason gets to work filling the opening of the niche with bricks and mortar. The crowd rapidly melts away from the tomb, and I am finally able to get up close. Juliana's mother, who is very shy and has been in the background all day, is kneeling alone in front of her daughter's niche, her face impassive. One of the pallbearers is also crouched down in front of the niche, scratching in the wet concrete: Juliana Quinde Pichisaca, February 9, 2001. Later, a glass-fronted display case will be set into place with her name and dates, and with room for paper flowers, small saints, and other offerings, like those in niches all over the cemetery.

I turn to see the last of the mourners streaming out the cemetery gates. Beyond, at the first house in the curve of the road leading away from the cemetery, the crowd is settling down on the ground and along the grassy edges of the yard. I trail out the gates toward the house, wondering what is happening—maybe it's time to eat and drink again. As I draw close, I am surprised to see Michael sitting on the ground in a line of men, tightly packed back to front as though preparing for a toboggan ride. I join Mama Michi and her sisters and ask, "What on earth is Michael doing?" They laugh, and Mama Michi says simply, "Leave him." Later I find out that Michael didn't know what he was doing either; he was sitting on the ground with the other men when Domingo's father suddenly commanded, *"Join up, Michael!"* and he found himself tightly packed in a line of men. The next day Esthela explains that this is the traditional way men sit when they are being served a meal in the fields, each one providing support for the others.

Within minutes, the women lay out a long piece of white cloth on the ground alongside the men and spread potatoes, *mote*, and roasted chicken along its length. The lineup of men eat first, then the rest of us, while several men and women circulate serving small cups of *trago* and soft drinks. Baskets of food continue to appear from the crowd for about an hour, when everything is gathered up and we walk in procession down the Pan-American and along the Paseo de los Cañaris, heading toward the country.

By now it is late afternoon, and I am definitely starting to flag. It has been an emotional day, and hard work besides, and I yearn to put down my heavy backpack of cameras, escape the crowd, and have a cup of tea. The mood of the mourners is lighter now that the *entierro*, the internment, is

over, but I know what will follow. This is the third and final night the family is obliged to stay awake, and the first that they will really be able to let go, without the somberness and heavy responsibilities of the first two nights. Tonight will be the equivalent of a wake—eating, drinking, and dancing all night long in a time-honored expression of grief to help reconcile the pain of losing a loved one.

Michael and I walk along with Mama Michi and her sisters, Mariana and María Juana. They insist we accompany them to the next *posada,* a tavern across from our house where the mourners will stop for last drinks before walking the few kilometers to Domingo's house. Michael finally agrees, under pressure, but I beg off and slip into our house, where the afternoon sun slants through the windows, all is warm and quiet, and I can sit and think about all that I've seen.

Carnaval

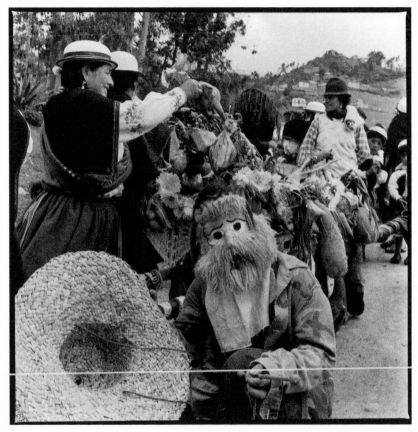

CARNAVAL PROCESSION

ONE RECENT SUNDAY MORNING, Michael was on his way to the village of Correucu when he ran into José María, the president of Correucu, wrestling with a huge pig on a rope lead. The pig was squealing in distress, spinning and lunging, hauling José María this way and that as he stopped to chat. He explained that he had just bought the pig at the animal market to help feed the great crowds of people coming to Correucu to celebrate the *fiesta de carnaval,* or Carnaval.

Carnaval marks the beginning of Lent on the Catholic calendar and is one of the most important fiestas of the year in Latin America. In the highland communities of Ecuador and almost everywhere else, however, Carnaval has little to do with the church and is in fact more closely tied to a pre-Christian European tradition of a pagan festival. As far as our Cañari friends are concerned, however, Carnaval is a movable feast that falls on a Monday in late February or early March; that day and the following Tuesday are national holidays. But in Cañari homes, elaborate preparations begin days or weeks before, when the women dye handwoven cloth for skirts and shawls, prepare *chicha,* and buy animals to fatten up for the fiesta. Cañari men working at the coast start traveling home on Friday, as do young women working as maids in Cuenca. Actual holiday activities begin on Carnaval *sabado,* Saturday, with a visit to the market to buy food, and continue through Carnaval *domingo,* Sunday, when animals are killed in preparation for the feast on Monday. Men and older boys construct small drums stretched with animal skins that are played only during Carnaval. Monday is the big day, with processions, drinking, eating, singing, and dancing, and for many the fiesta continues nonstop into Tuesday. On Ash Wednesday, some people go to church, perhaps to repent for recent behavior and settle back to their regular routines. But for many, as near as I can tell, the celebrating, visiting, and traveling consume the entire Carnaval week.

Each year, one *comuna* among the twenty or so villages around Cañar that are members of TUCAYTA, an umbrella organization of local agricultural cooperatives, plays host to all the others for the Carnaval fiesta; this year it is Correucu. Being host is a complicated and expensive responsibility, and controversy has broken out almost immediately in the community. Correucu is one of the smallest and poorest of the villages, with undersized family plots backing onto the river ravine or running up steep, eroded hillsides. Putting together a large event such as this presents a lot of headaches, lack of money being the main one. The host community must arrange an outdoor space big enough to accommodate a couple thousand people, build a stage and presentation area for music and dance groups, provide drink and food, and manage a myriad of other details, from presenting formal invitations to community leaders to soliciting Zhumir, the distillery of the alcohol that contributes to so much alcoholism here, to provide banners announcing the event.

All this is why Michael is on his way to Correucu this early Sunday morning. He has agreed to be the "official electrician" for the event, which in this case means running some electrical cables from a nearby house to the stage

being constructed on the soccer field, arranging lighting on the stage, and hooking up the rented sound system.

Struggling with the agitated pig all the while, José María invites Michael to come to the *casa comunal,* the community center, after he finishes his electrical work. The elders will be "skinning a cow," and Michael might find it interesting. José María goes on to say that a party of men from Correucu have gone to "hunt" a cow in Azogues and should be back soon. Michael finds his use of words strange, but doesn't say anything. José María then mentions that Judy, the "official photographer," is also expected at the *casa comunal* to photograph and film the occasion. Michael explains that I've already gone to Quilloac to record old Mama Juana Guamán singing traditional Carnaval songs, but that I'll be along after that.

(Later that day, our friend Mercedes explains José María's expressions and gives us some background on the ritual slaughter of an animal for Carnaval. Traditionally, she says, a group of men went to the mountains to hunt a deer, but for as long as she can remember the men have simply gone to the animal market to buy a cow. This helps explain why José María used the expression "hunt a cow." The "skinning" simply refers to the butchering, Mercedes says.)

Michael arrives at the soccer field to find a group of men puzzling over a pile of adobe blocks, several thick short logs, and two saggy wooden platforms—the components of the stage. He offers to help them construct the stage, since it's obviously too early to do anything about the electrical hookups. Santiago, Mama Michi's brother, who appears to be in charge, gratefully accepts. The men are especially pleased that Michael has brought along the only tools: a measuring tape and Swiss Army knife.

After working an hour or so and promising to return later to hook up the lights and sound, Michael walks over to the *casa comunal* just as the "hunters" come up the road with the cow. With one horn broken and bloody, the poor creature twitches and pulls on her rope like the pig, seeming to sense her unfortunate destiny. Among the escort party of about five men, one is carrying a bundle of rockets. Every few minutes he shoots one off. (These rockets are used all over the countryside on holidays, and I hate them because they are deadly silent until they explode in the air with a loud, cannon-like boom. I also hate them because last week I saw a man in Mariana's clinic who had blown off his thumb and two joints of his index finger with such a rocket, a not-uncommon accident in these parts.)

As the men prepare to slaughter the cow, a group of women and children gather in front of the *casa comunal.* Mama Michi, whose house is nearby,

appears with a bucket of water, as if on cue. She sits on the ground beside the cow, washes its udder, and milks it before turning her over to two older men who, Michael surmises, are the official butchers. These men are dressed with care in traditional handwoven clothes and woolly sheepskin chaps called *zamarros*. The members of the hunting party help the elders tie the cow's feet front and back, and then with a shove they tip her over onto the ground. An older child is sent off for a plastic tub, water, and knives; nothing seems to be arranged ahead of time. Meanwhile, one of the women serves shots of *trago* and *chicha* to everyone present; drinks continue to be served every few minutes throughout the process.

When the water and tub arrive, the elders ritually wash their hands, take off their chaps, and put on rubber boots. With the hunting party standing by to assist, one of the old men stretches the neck of the cow over a log while the other reaches around and gropes to find the artery. Michael cringes as he watches the man saw through the neck of the cow with a dull knife. Blood flows copiously into the plastic tub positioned under the cow's head. As the life pours out of her—which takes an agonizing ten minutes or so—Antonio, a young man of about eighteen, appears with a plastic cup and a jug of *aguardiente*.

He dips the cup into the blood for a generous serving, adds a shot of liquor, and serves it around the circle, offering it first to the elders and hunters, then to the community leaders, and finally to the bystanders. At some point Antonio takes a big drink for himself. Most of the men and a few women drink, although some, including Michael, decline. "Things were starting to get a little surreal," he tells me later. "The men were pretty drunk by then and beginning to get more boisterous, reminding me of *Lord of the Flies*, when the boys kill the pig. Words like 'pagan' and 'sacrifice' were popping into my head." (Later, slightly embarrassed at not having participated, Michael mentions to José María that he was not able to drink the blood, and José María replies in a whisper, "I couldn't either.")

After the completion of the "blood toast"—we later learn that its purpose is to acquire the strength of the animal—a woman carries the basin of blood in the direction of the outdoor kitchen, and Michael follows to see her dump it into a big cooking pot. Nothing is wasted here. He spots the unfortunate pig over in a corner, still tethered to a post and calmly watching the proceedings.

The cow is now quiet and lying on her side. Antonio sits down on the ground and begins to milk her a little more when Cesario, a man we know from Quilloac, suddenly appears; he has obviously already been celebrating

Carnaval. He lurches over to the cow, gets down on his hands and knees, and—clowning—clamps his mouth over one teat and pretends to drink. Everyone laughs, and the mood turns from serious to festive.

The butchering begins, but the men have only a few dull knives. Cesario turns expectantly to Michael, who reluctantly pulls his Swiss Army knife out of his pocket and then watches in dismay as someone begins to sharpen it on a rock. (Michael hates to loan his tools.) Several men work around the cow, quickly removing the four hooves, severing the head, and opening the hide from neck to tail. Beneath the black hide, the inner membrane is white. A man picks up an axe and whacks the breastbone into two pieces. Two dogs that have been hanging on the edges of the crowd come close and lap blood off the ground.

In the outdoor kitchen across the road, several women bustle around huge pots boiling over a large wood fire, tending to the blood and other offal from the cow. The pig still stands in the corner, but it is about to meet its fate. Several women gather around and hold it down while one pushes a skewer into its heart. Like the cow, it struggles, screams, grows weaker, and seems to take a painfully long time to die.

At this point I arrive from Quilloac. The recording session with Mama Juana has taken longer than I expected, but Michael tells me I am lucky to have missed the slaughter. It's a good thing I'm here now because José Miguel, who has been shooting in video, needs to leave. I take the camera and watch through the lens as the cow is quickly cut up into parts, which are then laid out on two small tables that have been brought out of the *casa comunal.* Mama Michi stands at one of the tables, holding a knife, ready to handle the meat. Michael, coming close to observe with a cook's eye, asks for identification of some strange-looking organs. "Pancreas," Mama Michi explains when he points to long grainy thing. "Can anyone possibly use it?" he asks. "No!" she laughs as she takes another largish organ to one side and begins to clean out fine green stuff that she says is recently ingested grass. Michael asks about this part of the cow and Mama Michi says *guatita*—cow's stomach. Michael and I look at one another with mock horror; we had seen this item on the menu in a restaurant last week and wondered what it was.

Meanwhile, the old men quickly reduce the cow to hide and head, leaving the head sitting on the ground at approximately the same spot it would be if it were still attached. I drift over to the outdoor kitchen to film the preparation of the pig. White, scalded, and gutted, it lies on its back on a short bench, its little front legs sticking up in supplication. Looking at it, I think of the popular expression for death: *patas arriba,* feet in the air.

Michael calls me back to the *casa comunal*. The men want me to film the ritual of the *entrega de la carne*. This translates literally as the presentation, or delivery, of the meat, but Michael and I have no idea what it means in this context.

We wait and wait; nothing happens. It's about six thirty by now, dusky and dark; I'm cold and tired and hungry and anxious to get away from all this carnage and go home (I was a vegetarian for many years and today has been unsettling, to say the least).

Finally, the *entrega de la carne* begins. One of the elders takes a cut of meat from the table, holds it up, speaks in Quichua, and then ceremoniously hands it to a second man who hauls it over his shoulder into the *casa comunal*. I follow, trying to film in the darkness as the second man uses a rope to hang the meat from a ceiling beam. This routine continues until only the head and skin of the cow are left outside.

Just as I've caught Michael's eye to signal that we should leave, Cesario comes roaring out of the *casa comunal* with a large piece of meat on his head. He is singing in a coarse voice and twirling madly, one part of the meat balanced on top of his head, and two other attached pieces flapping out along his arms. I get the video camera up and focused, backing out of the way so as not to be hit with the swinging meat. I'm a little horrified, but at the same time I regret that the light is nearly gone and I can barely see. What on earth is he doing? Is this just Cesario drunk, or is this a ritual? Later, Mercedes explains that this was the *baile del condor*, the symbolic dance of the condor, and that the particular piece of meat that Cesario has on his head, taken off the breast and ribs, represents the condor, a bird of almost mystical significance throughout the Andes.

As Cesario dances down the road, twirling and flapping his bloody "wings," two of the old men follow, one staggering under the weight of the head, still with its bloody horn, and the other carrying an unrecognizable part of the cow. I follow along uncertainly, still trying to film.

I wait in the road as Cesario disappears into Mama Michi's compound. He emerges a few minutes later and dances around us, this time with a live chicken on top of his head, stuffed under the meat. At this point it is virtually dark. Turning to pack up my camera, I receive a great whack on the back of my head from one of the flailing pieces of meat. I don't know whether to be angry that I've been slapped with a piece of bloody meat or honored to have been touched by a condor's wing. In any case, I'm glad it's all over.

As we walk home, Michael muses that today's experience certainly gives new meaning to the word *carne*—meat—the root derivation of the word "Carnaval." I can't agree enough.

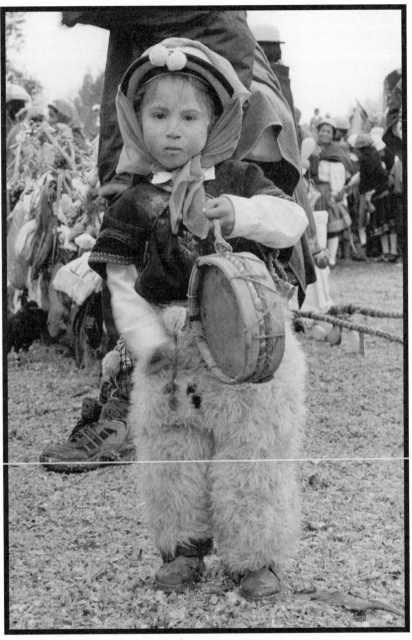

NICOLÁS GUAMÁN WITH CARNAVAL DRUM

THE BIG DAY: Carnaval Monday. Up early, we eat a hearty breakfast—not knowing when or where lunch will fall—and take off under cloudy skies for Correucu; we've been instructed by Mama Michi to join her at her compound at eight thirty. She has told us only that a procession will wind through the countryside into Cañar, march around the main square and streets, and then finally head back down to Correucu, where the festival will take place on the grassy soccer field.

We arrive at the scheduled time, but the procession doesn't begin until ten thirty, and in another place altogether, Quilloac, which is several kilometers away. But it's fun to watch the preparations at Mama Michi's house. Her grandchildren run around, messing up the special clothing they've been dressed in for the day. The little boys wear costumes of traditional men's clothing: black pants and handwoven *cushmas*, with finely woven belts wound around the waist. The older boys wear headgear used only for Carnaval: flat, wide, cowskin hats balanced on their heads like giant saucers and held on with straps under their chins. Each one carries a miniature drum made especially for Carnaval, which he will beat ceaselessly all day.

Mama Michi and her daughters Zoila and Mariana wear the best and newest of their clothes: multiple, bright red or yellow or fuchsia wool *polleras*, black wool shoulder wraps made especially for today, embroidered blouses, lots of jewelry, and new white felt hats.

As we prepare to leave, Mama Michi arranges a huge bouquet of flowers in her shawl and slings it on her back. José María carries a beautiful live rooster in his arms with two one-dollar bills tied around its neck. Michael had contributed one of the dollars, although we never learn the significance of the rooster or the dollars.

Our small procession finally gets under way, Mama Michi and José María leading. In thirty minutes or so we see hundreds, perhaps thousands, of people from surrounding communities gathered along a side road, waiting for the contingent from Correucu to arrive to lead the procession into town. And a grand parade it is. Behind Mama Michi and José María, a large group of men and boys fall in, banging their drums or playing tunelessly on bamboo flutes. Their faces are smeared with cornstarch, a custom of Carnaval. Most of the men wear sheepskin *zamarros*, and all sorts of extras hang from around their necks or belts: gourds, bags with candy and cigarettes, blocks of *panela* (raw cane sugar). It's all about abundance, I suppose. Some marchers, mostly men, wear large saucer-like hats with elaborate tassels of yarn or small balloons hanging in front of their faces. The most impressive hats I see have animals laid out on top: a cooked guinea pig, a small, desiccated deer's head, and, incredibly, a condor, badly stuffed but recognizable.

Groups of musicians follow, walking or riding in tractor-drawn carts displaying their names on banners or cardboard signs—my favorite is Grupo Musical Imigración 2000. Teenage girls, also with the huge fringed hats, walk sedately in small groups, banging delicately on small drums. I see Luz María among them, and she stops so I can take a few photographs. A sort of clown-devil dances around me beating on a drum, his face completely covered with a scary homemade sheepskin mask. He is crazily dressed in an army fatigue jacket, athletic shorts pulled over long pants, and an oversize straw hat. He gestures at me in a slightly threatening way, so I offer him a dollar, thinking he is asking for money (a custom of masked clown figures at other festivals). He takes it and speaks to me in a low voice, saying he only wanted to see my photographer's badge, before he dances away waving the dollar in the air, to the delight of the crowd.

The most impressive sight I see is a group of six or eight women, among them Mama Michi's sister Mariana, carrying a fringed platform that might be used to display a saint, with an artfully arranged tableau of fruits, vegetables, flowers, cooked guinea pigs, and other foods appropriate for a harvest festival. It takes me a minute to realize that the "fringe" hanging around the edges is a line of live guinea pigs, tied and dangling by their hind legs. At the four corners live chickens hang. All are frantically pawing the air or flapping their wings; some are bloody, others appear dead. (This is certainly not a holiday for animal rights advocates, I think, remembering yesterday's slaughter.)

When the women stop to rest, I frantically try to grab some shots. As with all processions, this one is moving fast and it's hard to get a clear view. As I juggle my cameras—color shots for the participants, black-and-white for me—I'm reminded how difficult it is to photograph these huge events.

Taking serious my responsibility as official photographer, however, I started the day also juggling the video camera, but it was too much, so I assigned it to Félix. But then a man I know handed me *his* 35 mm Pentax and begged me to take photos for him, and I'm in a constant sweat trying to manage the cameras, change film, and keep up with the fast-paced procession. The television media are here from out of town and one big cameraman always seems to be in the way of my best shots.

Every once in a while, the procession passes by a thatched hut, or *choza*, constructed just for today as a refreshment stand for the *carnavaleros*. Each is prettily decorated with flowers and sheaves of grains. Women pour free drinks and hand out food tidbits on pretty ceramic dishes that are used only for Carnaval. I later learn that each community the procession passed

through was responsible for constructing a *choza* and offering food and drink to the revelers.

All this takes hours. Overhead, roiling clouds threaten to open up and spill their contents; our friends have told us that it always rains on Carnaval Monday. As the procession moves along the Paseo de los Cañaris and heads into town, I slip into our house for a rest and a bite to eat, knowing there's a lot more of the day ahead. I have long ago lost Michael in the crowd.

An hour or so later, I arrive at the soccer field in Correucu to see Michael just finishing hanging the lights on the rickety stage—a row of dangling bulbs and a couple of halogen work lights on tripods. So this is where he's been. As the crowd surges onto the field, I see women carrying the cornucopia platform into a cordoned off space in front of the stage. By now the guinea pigs and chickens show only feeble signs of life. A row of empty chairs sits behind the platform, presumably for visiting dignitaries. Community leaders, among them the directors of TUCAYTA, Mama Michi, and José María, who still holds the rooster, stand around onstage. As usual in events such as this, nothing happens for a long, long time, but everyone simply stands and chats. A few clumps of people sit on the outskirts of the crowd, on the banks of an irrigation canal, passing drinks and food.

Suddenly, before the opening ceremony can get underway, the heavy skies open and a downpour soaks us all in minutes. I huddle under the plastic tarp at the edge of the stage, my backpack and equipment already wet. A few minutes later, I'm aware of a hubbub beyond the stage and I watch in amazement as everyone around me rushes out into the rain to gather around . . . something. "What's happening?" I yell at the person standing next to me, over the sound of the drumming rain. *"Un pleito,"* he says with a satisfied shake of his head. A fight. Well, what's a fiesta without a good fight?

Mercedes says that Carnaval was traditionally a time to settle any conflicts that had sprung up in the past year, either between individuals or communities. Ritual battles or fights often ended in injuries and, on occasion, deaths. This practice was outlawed years ago, she says, but some people persist in thinking that it's best to settle accounts in the old way, at Carnaval, because otherwise people would fight all year long.

I suspect the present fight is not a case of settling a long-simmering account, but rather is a spontaneous outburst, because it's over as fast as it begins. More likely it's a case of too many drinks during the hours-long procession.

The rain lessens, and I wander around looking for good shots, holding my camera under my wet rain jacket. I run into José Miguel, who is also filming and photographing the event. I see Mercedes and her niece and

nephew, and she allows me to take their photos. Little Nicolás is dressed in miniature finery, with a scarf holding his hat on, banging on a tiny drum.

I pursue the man with the condor on his hat, a magnificent looking Cañari man I've been trying to get a clear shot of all day. He finally turns to me and says very politely, "I'm very drunk now and I don't want you to take my photo. I'll pose for you some other time." He holds out his hand for a friendly shake. Fair enough. I turn around and see a beautiful young man standing alongside the crowd, wearing a big, fringed hat and banging his drum. I approach and ask if I may take his photo. "No," he responds with a sharp shake of his head. When I take a wide-angled shot of the crowd and see a mother tip her son's hat down over his face with a quick flick of her hand, I realize that it's time to head home. The rain has started again, the clouds have come down to house-top level, and *carnavaleros* are streaming out of the grassy field, by now a muddy quagmire, on their way home.

I run into Michael, his shoulders hunched under his rain gear, waiting for the program to begin. "I didn't have any lunch," he says plaintively, "and I'm cold and tired. Why don't we go home and I'll fix a big plate of pasta with tomato sauce?"

"Yes," I say, "that sounds perfect."

We begin a slow walk up the hill, threading a friendly gauntlet of men and women from Correucu who are lined up along the muddy road beside the soccer field, acting as hosts and generously offering *chicha* or *trago* to anyone who passes. Despite the weather, the mood is festive and sociable. Clumps of people stand in the road, talking and drinking as though at a cocktail party. As we reach the *casa comunal* I can see that meals are being offered, the end result of yesterday's butchering. We run into many people we know. Just about everyone, by now, is quite inebriated, and we can't drink with one and not another. Sometimes, when yet another "host" stops us, I walk ahead and sacrifice Michael to the protocol.

Ah, home at last. Wet gear off. Dry clothes on. Inspection of equipment. All okay. Salted water bubbling on the stove, tomato sauce heating. We sit at the table eating our pasta, gazing out the window in the waning light and watching the *carnavaleros* pass by on their way home: tired little boys still beating their drums but without much enthusiasm; tipsy men weaving zig-zag in the street, their wives guiding or pushing them along; pretty teenage girls in their best clothes, strolling slowly, arm-in-arm despite the rain and cold, still excited and not yet ready for this special day to be over.



CHAPTER FIFTEEN

Betrothal, Cañari Style

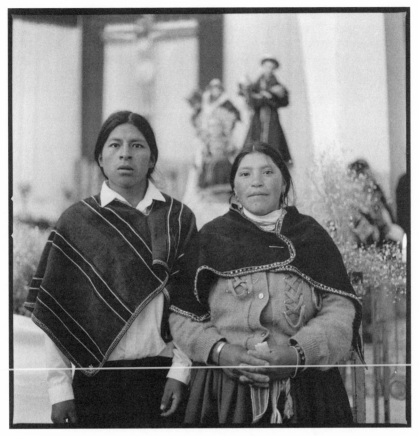

YOUNG COUPLE IN CHURCH

MICHAEL CAN'T STOP TALKING about it the next day, or the next, and together we spend hours trying to figure out what really happened on the night of Pablo's betrothal, or *la entrada*. Mostly, we speculate about why Michael had been so deeply involved in the engagement ritual of a young man we barely know, although the fact that Pablo is Mama Michi's second son makes Michael "near" family. But to start from the beginning . . .

At around nine on a Saturday night, Michael answered a knock on our

door and disappeared outside. I was busy with a photography workshop, and my students and I had just sat down to a small feast of potatoes and *cuy* when Michael came back into the house and announced—rather dramatically—"I must go to *la entrada!*" I had never heard the word used this way before, but whatever it meant I didn't seem to be invited, so I ran outside to see what was going on. Mama Michi, her brother Santiago, her sister Mariana, and several other family members including her youngest son, Serafín, were gathered outside the gate. The women had heavy loads on their backs, which meant they were on their way to some event that required eating and drinking. I spied Pablo, Mama Michi's second son, half-hidden around the corner of the house with a very pretty young woman at his side. Mama Michi greeted me warmly but didn't divulge any information.

Just then a truck pulled up and everyone loaded their baskets and bundles and climbed into the back. Michael ran back in the house, saying (correctly, as it turned out) that it might be a long cold night; he was going for his down vest. The truck took off down the road towards Quilloac, a couple of kilometers away, and that was the last I saw of Michael until four the next morning.

Actually, Michael had gotten an inkling of something brewing earlier in the day when he was at Ingapirca, the archeological site about an hour from Cañar, with Mama Michi and her nephew, Félix. A farmer plowing had recently discovered a burial site, and Mama Michi had been called as a *yachaj* to do a cleansing and other rituals before excavations began. Michael was summoned by Félix to film the ceremony, as I was busy with my women's workshop. Arriving back in Cañar on a late afternoon bus, Michael was starting down the hill toward home when Mama Michi called him back and insisted that he go shopping with her and Félix. He thought this odd, but went along as a friendly gesture. First they bought two big bottles of beer, because, Félix said pointedly, "Michael likes beer." This was a peculiar comment in the context of the moment, but Michael thought little of it. Later, he realized it was the first "buttering-up" gesture in anticipation of the night to come.

Then there was the strange shopping list: one hundred and thirty fresh rolls, a case of Zhumir, several bottles of wine, numerous bags of hard candies and animal crackers, and four packs of cigarettes. All this indicated to Michael that an important event was in the offing, but no one was bothering to enlighten him. About that time, however, Mama Michi used the term *la entrada*—meaning, literally, the entrance or entry—in relation to Pablo and his girlfriend, Narcisa. Michael was intrigued. We knew nothing of a girlfriend, but remembered that the previous week, José Miguel

had said to Michael, "Pablo has a woman in the house." Putting two and two together, Michael assumed that the food and drink were to celebrate Narcisa's entry into Mama Michi's household. But why had Mama Michi insisted he come along?

As well as we know Mama Michi, José Miguel, and the daughters in the family, we had never really been friends with José Miguel's two brothers, Pablo and Serafín. Pablo must be about twenty-five now, and Serafín a couple of years younger. Always in the background of a family dominated by two "stars"—Mama Michi the *yachaj* and community leader and José Miguel the photographer—the brothers seemed to me lacking in charm and drive, but perhaps I judged them unfairly. In any case, I could imagine that Mama Michi is eager to have them married.

Michael stayed with the group until the purchases were loaded on a truck and heading down the rough road to Mama Michi's house. He jumped out at the crossroads and yelled good-bye, assuming the day was over, and was surprised to hear Félix yelling back, "We'll be back later to pick you up." Huh? It was yet another atypical moment, as there had still been no mention of an event, or an invitation.

Around nine that night, Michael found himself in the back of yet another hired truck, heading into the country with a group including Mama Michi's brother and sister, Santiago and Mariana; the eight-months-pregnant Zoila; Félix and his wife, Alegría, with a baby on her back; and Pablo and Narcisa. A few kilometers down the road, the truck pulled off into the darkness; Mama Michi instructed Michael and Santiago to come with her and the rest to wait beside the road. She was clearly directing the show. As they followed a rough trail toward a darkened cluster of buildings, Mama Michi stopped and told Michael to put on his green rain jacket. Presumably she thought it would make him look more important, or formal. It wasn't until this moment that Michael realized he was to play a role in some unfathomable ritual about which he knew nothing.

They stopped behind an outbuilding from which they could see a small adobe house about thirty feet away. Santiago whispered to Michael that this was Narcisa's parents' house. Peeking around the corner, Mama Michi called out, *"Wasiiiiiiiooooo, wasiiiiiiiiooooo,"* in a shrill voice, which in Quichua means figuratively, "Anyone home?" Nothing. The three advanced into the courtyard, and Mama Michi called again. Dogs began to bark. Finally a woman appeared—Narcisa's mother—and Mama Michi went forward alone to meet her. The discussion between the two women went on and on, and it seemed to Michael, who was standing with Santiago a short distance away, that the mother was insisting she could not give up her daughter. But,

finally, she turned back into the small house and began talking to a man lying on a bed. Santiago whispered that Narcisa's father, José, was already *chumado*, drunk (perhaps he had an inkling that he was to lose his daughter this night), and motioned for Michael to follow him into the courtyard.

The father gradually rustled out of bed, staggered out into the courtyard, and began to urinate in front of the "guests." His wife grabbed him in the brusque way of Cañari women handling inebriated husbands, and with harsh words pulled him around the corner of the house. He came back buttoning his pants and without formalities launched into a harangue that was soon followed by tears, saying he would *never, never* give up his daughter. Everyone stood in the courtyard for a long while, watching the father crying and protesting and Mama Michi placating, until Santiago abruptly interrupted with a businesslike, *"¡Entramos!"* Let's go in.

Voilà! Michael suddenly realized that *la entrada*, used in this context, must refer to the groom's family gaining entry into the bride's house to negotiate the union, as opposed to the bride entering the groom's house. We later learned that it is customary for the bride's parents to resist giving up their daughter.

The group moved into the one-room house. A double bed, a couple of chairs, and a small table were the only furniture. A crude wooden ladder along one wall led to a loft. Mama Michi pulled a bottle of Zhumir and a small glass from the bundle on her back and insisted that Rosita and José, Narcisa's parents, take three drinks each in quick succession. Michael overheard some discussion in Quichua about his presence; no doubt Narcisa's parents were questioning why this gringo was here. Santiago said that Michael was "like family" and used the Quichua word *"hueracocha,"* meaning "gentleman" or "person of confidence."

Thus began what Michael calls "bottle diplomacy." Mama Michi and Santiago alternated serving shots. After several rounds, Rosita formally asked the guests to *descansar*, or rest, which is a polite way of saying, "Sit down and stay a while." This appeared to be a critical moment, when proper negotiations could begin. Mama Michi yelled to the rest of the group, still waiting somewhere in the yard, to come in and everyone, including Pablo and Narcisa, crowded into the small room and found a place to sit, the women on the floor all around the edge of the room, the men on the few chairs and benches.

Mariana brought forth a cardboard box she had been carrying on her back and presented it to Mama Rosita; Michael saw that the items of the afternoon's shopping trip—including the one hundred and thirty rolls—constituted an offering to the bride's parents. After that, drinks arrived in

fast succession. Mama Michi and Santiago worked on the father, who was obviously the main obstacle in negotiations. Crying one moment and laughing the next, hysteria and sadness melded as he groaned continuously in Quichua, *"Mana, mana,"* no, no.

At one moment the father, José, turned to Pablo, who was sitting quietly with Narcisa, and called him a Mexican in an insulting tone. Then he changed it to a Guatemalan, and finally settled on a Chinaman. Then the father turned his attention for the first time to Michael, and for some unfathomable reason decided *he* was Mexican. "Let's you and I go away to Mexico," he said affectionately. Apparently Narcisa's father was beginning to warm to the proceedings.

Perhaps seeing an opportunity, Pablo sat down next to José and promptly burst into tears, saying he knew he had "committed errors" and wanted to be forgiven. Michael thought the tears were rather dramatic, but figured Pablo was apologizing for having stolen José's daughter earlier in the week. After a few more drinks, when things seemed to be going well, Santiago told Pablo and Narcisa they could leave. Without a word the young couple slipped out of the house accompanied by Serafín, who had arrived earlier out of the darkness.

Soon Mama Michi and Santiago also made motions to leave. Mama Michi pulled a fresh bottle of Zhumir out of her basket and set it on the table, while Santiago turned to Michael and said, "You're in charge, keep serving the drinks." Then they both headed out the door without another word. It dawned on Michael that as the senior man left on Pablo's team, it was up to him to keep the ball rolling. He measured out a shot glass of *trago* for Narcisa's father, and then one for her mother, and on around the room. Mariana, watching Michael from across the room, would periodically catch his eye and indicate with her chin or glance which person he should serve next, or when it was time to start another round. Soon Narcisa's father had his arm around Michael's shoulders.

It was well after midnight when Mama Michi and Santiago returned with Pablo and Narcisa and others. They had been out rounding up Narcisa's relatives: an older sister, an uncle and aunt, and another very old uncle. The younger uncle, Segundo, was already in tears when he walked through the door, ranting, *"¡Nunca, mana! ¡Nunca, mana!"* a mix of Quichua and Spanish meaning, "Never, no! Never, no!" This did not seem to be a ritual performance; Segundo seemed genuinely distressed. Mama Michi and Santiago turned their attention directly to him, giving him multiple quick drinks, but he wouldn't stop yelling and he wouldn't sit down. It seemed to Michael that Segundo was repeating some serious complaints about Pablo, but Michael

couldn't understand the language. And by then, Pablo was cozily sitting tucked under the arm of his future father-in-law.

Uncle Segundo, it turned out, was the hardest nut to crack, requiring hours of coaxing and many drinks. *"¡Mana! ¡Mana!"* he kept chanting. Finally, Segundo calmed down and grew quiet, only to leap to his feet and bolt for the open door a few minutes later when the discussion turned to who would be *padrinos de la boda*, or godparents of the couple's wedding. Apparently he and his wife had been mentioned as the likely candidates. In a flash, Mama Michi ran across the room, slammed the door, and sat down on the floor with her short legs extended straight out, blocking the exit. She crossed her arms and threw a smug look at Michael as if to say, "Now watch this!"

Segundo sagged down to the floor and Santiago went back to work on him, plying him with more drinks. Poor man! His was an economic protest as much as anything. The godparents to a marriage must contribute to the considerable costs of the wedding, including buying the wedding clothes for the bride and groom, and accompany the couple for the three days and sleepless nights of the marriage ceremony. (In traditional weddings, the godparents also stand by in an adjoining room while the young couple consummates their union.) Then, in custom if not in practice, the godparents must watch over the couple all their married lives. If there is trouble, they are expected to intervene; if there is economic need, they are expected to help. So it is no wonder that Narcisa's Uncle Segundo, vehemently against the marriage in the first place, would bolt for the door when he was suggested as the godfather.

At about three in the morning, things had settled down. Segundo was still there, slumped in the corner, which signaled acquiescence if not defeat. Narcisa's parents were sitting quietly, half-asleep. Mama Michi and Mariana cleared a space in the center of the room, where they covered a small table with a white cloth. Mama Michi laid out a ring and a large wooden cross and called Pablo and Narcisa to sit in front of the table. She offered prayers to the Cañari and Christian gods and saints, and then Mariana offered a prayer. As soon as there was a pause, Michael bolted into the courtyard to pee, and finding Félix doing the same, Michael asked how much longer the affair would last. Félix said it was almost over.

Back in the house, Pablo and Narcisa were embracing, and she had the ring on her finger. Everyone seemed happy and calm, or maybe just exhausted. Michael figured the engagement was settled, so he told Félix he was leaving, slipped out the door, and walked home.

The next day Michael ran into Zoila, who told him that the gathering had lasted until six a.m. Michael worried that he might have violated proto-

col by leaving early, but Zoila, looking amused, said it was alright that he had left, even though he *was* the second candidate for godfather of the wedding. This, of course, was news to Michael, but at least now we understood Mama Michi's insistence that he be involved.

Days later, we hear some of Pablo and Narcisa's backstory from José Miguel. Three years ago, when she was sixteen and he twenty-two, they dated briefly. She became pregnant and had a son. Pablo wanted nothing to do with the child or with Narcisa, and Narcisa's family actually brought a legal complaint against Pablo for child support, using one of the storefront lawyers in town. For three years, José Miguel said, Pablo has been paying four dollars a month, but he still has no relationship with his son. Somehow, the young couple got reacquainted, and a few weeks ago Pablo "stole" Narcisa and took her to Mama Michi's house.

This led to the famous *entrada*, where Michael played a part he has yet to fully understand. Did Mama Michi think Michael would give weight to her family's bid for Narcisa because he is a big tall *gringo* in a green rain jacket? Was Michael really a candidate for *padrino*, an outsider who would not be around to fulfill his responsibility beyond the wedding? Or was the family group simply missing an adult male to help with the negotiations? Perhaps other male members of Pablo's family disapproved of the marriage, as did Narcisa's uncle, and declined to participate? And where was José Miguel, Pablo's older brother, in all this? We didn't ask.

THREE DAYS LATER, Mama Michi comes to the house in the morning and insists that Michael accompany her to witness the marriage of Pablo and Narcisa. "By the way," she adds as an afterthought, "have you seen Pablo?" Michael and Mama Michi hurry up to the civil registry office and find Pablo, Narcisa, the recalcitrant Uncle Segundo and his wife, and another relative sitting on a bench in the waiting area of the Registro Civil, where civil marriages and other legal business take place. A brusque woman clerk, smoking a cigarette and typing at the same time, quickly makes it clear that a foreigner like Michael will not do as a witness. "*¿No valgo?*" I have no value? Michael retorts jokingly, which the waiting group finds hilarious. Another witness must be found, and Pablo runs off to a nearby seed store to find one of the few Cañaris who work in town. When Pablo and Narcisa approach the clerk again with their new witness and the papers, they are told they need three copies of each document. Pablo runs off to a photocopy place and the wedding group goes back to the waiting bench. Meanwhile, other family members, including Narcisa's parents, arrive, until about ten people are waiting.

Finally, everything in order, the wedding party crowds into the clerk's office and gathers around her desk. Automaton-like, she takes forms from various cubbyholes, stacks them in triplicate with carbon paper, snaps them into her typewriter, and types and puffs furiously while the group stands patiently by. Lawyers occasionally rush in and interrupt the proceedings to have their legal papers stamped by the clerk, who finally gets around to reading the brief marriage document to Narcisa and Pablo. "Now you're married!" she says, with a perfunctory glance at the couple.

Out on the street, Mama Michi invites everyone over for a wedding feast, and Michael spends the rest of the day at her house, dancing and drinking and toasting the newly married couple. He comes home at seven in the evening, more than a little *chumado*, and goes straight to bed, complaining that he is exhausted by Pablo's engagement and marriage activities.

He is noticeably pleased, however, to hear through the grapevine a few days later that "Mama Michi is very satisfied with Michael."

Life in Cañar at Six Months

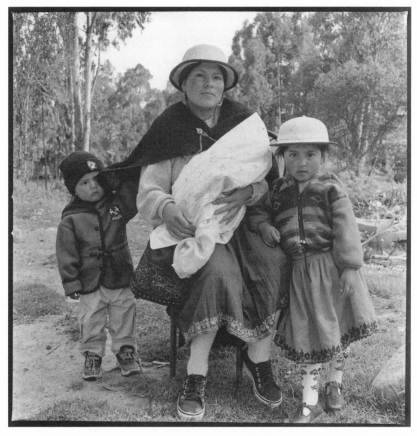

ZOILA CHUMA WITH HER CHILDREN RANTIN, COYA, AND PACARI

WE ARE AT THE halfway point of our year in Cañar, and on this particular morning the thought of returning to our cozy, centrally heated house in Portland could not be more appealing. Rain beats down in gusts, the temperature inside the house must be in the fifties, and the curtains over our ill-fitting windows flutter with the whistling wind. Dressed in several layers of clothing, I sit at the table in the *sala* writing on my laptop, trying out my

new wool gloves with the fingertips cut off. Every couple of hours, when I get really chilled, I go outside and take a brisk walk.

Michael, on the other hand, happily bustles around the warm kitchen, with the gas burners and oven going full blast. He announces he's preparing a special lunch of hand-ground, German-style pork sausage from the loin of a fresh-killed pig, made with his own mixture of spices and herbs from our little patio garden. All this is really just an excuse to use his new cast-iron hand grinder with interchangeable grinding discs.

This past weekend we finally became *padrinos*, godparents, to Rantin, Zoila's fifteen-month-old son. I feel a special affection for Zoila, and I'm very happy that we are *comadres*. We have known her since she was a teenager, when she was bright and full of hopeful plans and determined not to fall into poverty. I made a portrait of her then and recorded an interview in which she said, "I am seventeen years old and going toward my future. I want to do something useful, to have experiences, to help people." She concluded with, "I think I would like to marry when I am twenty-two or twenty-three and have two or three children, no more. You have to plan your family size well so that the children can have a better future."

Not so long after this, Zoila was thrust prematurely into that future with her first pregnancy and consequent marriage to Benedicto. Now barely twenty-two, she has two small children and a third about to be born. Her young husband is an illegal immigrant in the United States and she does not expect to see him again for years. Without any means of support— Benedicto must pay off his huge debt to the *coyote* who arranged his trip before he can send Zoila money—she lives with Mama Michi in the crowded compound of sons and daughters, daughter-in-law, grandkids, and animals. The only thing that cheers me about Zoila's situation is that with Benedicto away for several years she will have a rest from successive pregnancies. I referred to this in front of Mama Michi and Zoila the other day as *planificación natural*—natural birth control—and they found it very funny. That's about as close as I can come to the subject of contraception here.

On Easter Sunday we arrive at the church at two for the scheduled baptism to find a scene of chaos. Children of all ages run up and down the main aisle, while families of all stripes—indigenous and mestizo, from the town and country—gather in clusters in the interior of the church. Babies and toddlers are crying and older kids are having a ball. Some parents are busy changing their children into special baptism outfits. The little mestizo girls are mostly dressed like brides, all white ruffles and tulle, with veils and silk flower bouquets, while the few Cañari children are in traditional

dress or sports clothes. Ages range from babes in arms to children ten or twelve.

In one corner of the church we find our group: Mama Michi and the eight-months-pregnant Zoila, Serafín, Pablo and Narcisa, and Mama Michi's sister, Mariana, with her three teenagers. And then there is Rantin, the guest of honor, a sullen, feisty little fifteen-month-old who refuses to have anything to do with Michael and me. As godparents we are theoretically supposed to hold him during the ceremony but there is no way he will allow that, so Maritza, one of Mariana's daughters, will be our proxy. Rantin is dressed improbably in a white sailor suit, complete with white tennis shoes and a little sailor hat. We probably should have bought this outfit for him, I think miserably when I see him squirming in Maritza's arms. Michael and I knew we should buy baptism clothes for Zoila and Rantin, so earlier today we went shopping at the market and bought Zoila a pretty sweater and Rantin little jeans and a jacket. Zoila was wearing the sweater, I notice, but we'd obviously missed the boat with Rantin's outfit. (Mariana bought the sailor suit, and she allows us to repay her.)

Mama Michi, taking charge of our group, directs us to sit on the steps to one side of the altar, as though she knows that something important might happen there. Minutes later, a priest enters hurriedly; it is Father Gregorio, the handsome young *padre* I sometimes see walking by our house with a gaggle of teenage boys. I think he teaches at the Catholic high school down the road. I am initially pleased that it is not the stern Father Jesús, but then disappointed a moment later when Father Gregorio looks out over the noisy sanctuary and announces sternly that the church is not a soccer field—would parents please control their children!

He adds with a touch of annoyance that too many families have shown up for baptisms today, so half the group will be sent to a nearby "church salon" for their ceremony. I miss the full import of this announcement, but suddenly Mama Michi pushes a paper into my hand and urges me to get up to the altar, where Father Gregorio is being mobbed with people, all waving papers. I rush up without knowing what's going on, but perhaps because I'm an *extranjera* here, a stranger, the crowd gives way and I simply hand Father Gregorio my paper. "That's all," he says, adding it to the sheaf in his hand. "Those left must go to the salon," he gestures dismissively to the group of disappointed parents and godparents.

A few minutes later, Michael and I join a group of about fifty people being herded by the old man who assists the priest into a half circle around the altar. "Children and godparents only, children and godparents only," he

mumbles unsmilingly as he arranges us. Parents hand over their children, some crying and grasping, and fall back behind our half circle. In our case, Maritza stands in the circle with Rantin and we stand behind her.

Once we are all in place, Father Gregorio begins an abbreviated baptism service, running through the litany of the responsibilities and obligations of the godparents, foremost among them, of course, to oversee the child's spiritual life as a Catholic. He mentions buying shoes and clothes for school, providing food if it is lacking, paying for schooling if the parents fail to educate their child, and so on. Every few minutes he pauses to ask if we accept these responsibilities, and we answer in unison like school children, "*Sí, las aceptamos.*"

In Latin culture, becoming *padrinos* carries great social weight, not only in designating a second set of parents for a child, but in creating kinship alliances that suggest all sorts of mutual obligations and benefits. Of all the families we know in Cañar, we are closest to the Chumas, and I am pleased to have that connection strengthened. Zoila is now my *comadre*, or co-mother, and Benedicto, whom I hardly know, my *compadre*. They will greet Michael and me as such, rather than using our given names. And Michael and I will be expected to take a special interest in Rantin, theoretically for the rest of his life, although we will be living thousands of miles away, and for the moment he won't even look at us.

Father Gregorio makes three quick rounds of the children—first pouring water over their heads from a pitcher into a silver basin (Rantin kicks and screams); then anointing their foreheads with holy oil (Rantin yelps and swats away the priest's hand); then passing around a candle from which we each light our own tapers (which Mariana had the foresight to buy).

Ceremony over, the priest makes a rapid exit with a flap of his robes, and the day immediately turns into a media event. Family groups take over the altar area to pose for photos and long video shots. With emigration from this area so high, and dollars pouring in from the United States, every family now seems to own a small automatic camera or camcorder. Our group finally takes its turn in front of the altar and Pablo duly documents the moment with one of the cameras from Estudio Inti.

In the indigenous culture, the church baptism is only the beginning of a two-day celebration that marks a child's entry into the social world. After the photo session, we walk as a group of about twenty people down to Mama Michi's house. There, we have to climb over a huge eucalyptus tree that was felled a few days ago for firewood and lumber. It narrowly missed the house and now totally blocks the entrance to the compound. The tree

is so thick in circumference that it effectively serves as a fence, keeping kids and dogs out or in. (It will stay in place for several months, until Mama Michi returns from her next trip to Canada with some cash. Right now, she says with a rueful laugh, she doesn't have the money to hire someone to saw the tree into lengths.)

After a few rounds of *tragos* have been served, Michael and I learn some lessons about the rituals of becoming godparents in indigenous culture. Mariana—who, it has become clear, is our coach for today—hands me Rantin and instructs Michael and me to "give" him to Zoila. We attempt to do this while Rantin furiously resists, with pinwheeling legs and stiffened back. We then exchange embraces with Zoila and formally hand over a basket of food and small gifts for her and the children. (Mama Michi had clued us in about the basket the day before.) Then we drink, in succession, *chicha*, champagne, and *canelazo* while waiting for dinner to be served.

After the meal, the table is cleared and pushed aside as a tape is put in the cassette player. It's time for dancing . . . and dancing and dancing. Michael and I have mastered the two-step-shuffle-in-one-spot this year, and he dutifully invites each woman to dance while the men ask me. Mama Michi and Mariana continue to serve drinks, and the hours pass in a succession of endless songs, brief rests, and more drinks and dancing. The mood shifts from celebratory to melancholy, a frequent development in fiestas as the night grows late. Normally, on occasions such as this, Michael and I would excuse ourselves and go home around midnight, but since we are the *padrinos* we hold on as long as we can. By about one in the morning, I can see Michael nodding off in the corner, head down, arms crossed on chest (he tells me later that he was feigning sleep to avoid accepting more drinks). I am exhausted from dancing with the few men who are still able to stand. Several people are already sleeping on mats laid down around the edges of the room.

I explain to Mama Michi that as *gringos debiles*, weak gringos, we need our sleep, in our own house, even during a fiesta. She's heard it before and knows it isn't true—the part about us being weak—but she accepts our excuse with good humor, insisting that we return the next morning to continue celebrating.

We do go back at nine the next morning, refreshed and ready to party, but find the action mostly over. No one is in evidence but Mama Michi and an old aunt, Mama Juana, just waking where they have slept on mats in the *sala*. The two rumpled women, still a little drunk, clear their heads with a few shots of *trago*. They are in great spirits, making jokes in Quichua and

laughing uproariously. Every few minutes Mama Juana breaks into song, and I regret that I haven't brought my tape recorder. They insist that we sit down to join them for a drink. Yes of course, we say. We are, after all, the *padrinos*.

MY FAVORITE PHOTOGRAPHY students these days are four nuns at the Monastery of the Immaculate Conception, a four-hundred-year-old cloister only a couple of blocks from our apartment in Cuenca. Back in December, my friend Alexandra Kennedy invited me along with her to take the nuns a Christmas cake. An Ecuadorian art historian, Alexandra spent years cataloging the convent's archive and has a special affection for the twenty or so "Conceptas" who remain in the cloister. For my part, I was thrilled to have a peek behind the massive double doors of the cloister wall that I walk by nearly every week.

Alexandra had made previous arrangements for our visit, so Sister Rosa, the nun designated by the Mother Superior as the official greeter and guide, welcomed us. When Alexandra introduced me and mentioned that I am a photographer, Rosa clasped her hands under her chin like a child and said dramatically, "Oh, I would so *love* to know how to take pictures." This was my cue. I immediately offered to teach her, but Sister Rosa put on a sad face as dramatic as the happy one and said, "But we have no camera. We are a very poor convent." I told her that when I had a camera to donate I would come back to give her lessons. Delighted, she clapped her hands again and said she would ask the Mother Superior's permission.

A couple of months later, when Kodak contributed fifteen cameras for my teaching activities, I called Rosa (at a certain hour on a certain day, the only time one can call into the convent and get an answer), and she gained permission for me to enter the cloister. Three other nuns were chosen to take lessons with Sister Rosa, and we have met weekly for the last month or so.

Here is the routine: at three o'clock sharp on Thursdays, I wait outside the ancient double doors of the entrance to the convent, which has occupied this same site in the center of Cuenca since 1599. A wealthy Cuenca widow bequeathed her house and properties to the Church, with the proviso that her three daughters enter as the first Conceptionist nuns (how I would love to hear the rest of that story!).

Over the centuries, the cloister has grown to encompass an entire city block, all of which is enclosed by a twenty-foot wall, except for the beautiful church on one corner. Small shops and stalls set into the outer wall open onto the streets around the convent, and the old infirmary has been

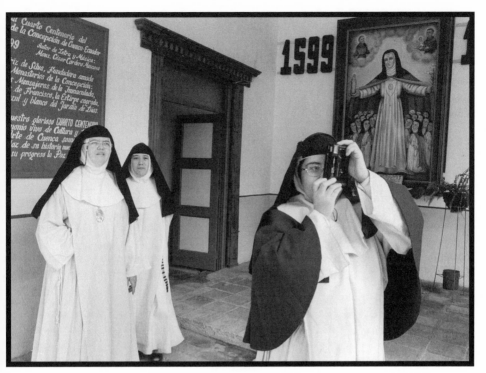

NUNS LEARNING PHOTOGRAPHY

converted into an exquisite little museum. As I stand waiting, an ancient woman who works in a stall nearby selling the herbal drinks and pastries made by the nuns hobbles down the street toward me, holding an enormous key on a metal ring. How old is that key? It is her job to open the outer doors of the convent twice a week, on Tuesday and Thursday at three, for one hour, when outsiders can have limited contact with the cloister.

Inside the dark, stone-floored anteroom, I pull the thick rope hanging from the ceiling that rings a brass bell announcing a visitor. I have a few delicious minutes to sit quietly on the stone bench built into one wall, and I try to imagine what it would be like to pass through this entry as a young novice, knowing you will never see the outside world again. A rap on wood signals that a nun is on the other side of the *torno*, a revolving three-tiered shelf in a cabinet set into one wall of the anteroom. There a visitor can talk with the nun, but have no visual or physical contact—the faithful come here to buy special prayers (for an ill family member, for example) or contribute money to the convent. I stand close to the *torno* and say loudly, *"Soy la fotógrafa."* I'm the photographer. Footsteps disappear and I hear the interior

bell ring ten times, a signal to Sister Rosa, who, a few minutes later, cracks opens the inner door. I slip into the cloister.

Sister Rosa always looks delighted to see me. We normally stand for a few minutes in a plain little room that opens onto an interior patio; sometimes the Mother Superior chats with us. Friendly but guarded, she's the one who attends to the *torno* and monitors outsiders coming in; I'm very aware that she's checking me out. As Rosa quickly escorts me along one side of a colonnade running around the lovely patio garden, my eyes busily try to take it all in—the flowers, a fountain, a patch of corn—before I'm ushered into a small room that serves as parlor for visitors. That's as far as I usually get into the cloister. I can see nothing from the room, as the one window has been covered with translucent paper. The nuns enter one by one, coming from various parts of the convent, and here most of the lesson takes place, for one hour exactly. At four, when the cloister again closes its doors to the outside world, Sister Rosa escorts me back along the colonnade to the interior door, and the old woman with the key waits outside for the last supplicant or visitor to leave.

My four students, Sisters Beatriz, Patricia, Mariella, and Rosa, are in their twenties and thirties, I would guess, but in social interaction they strike me as naive adolescents (the point when they would have entered as novices). They are playful and curious, but not very good students. Sister Rosa, the oldest, can't seem to remember to rewind the film before she opens the camera, so several rolls have been lost. Sister Beatriz continually cuts the heads off her subjects, which lets me know she hasn't yet learned to look through the framing window. *"Qué vergüenza,"* what a shame, she always says with a laugh, looking at a photo of yet another headless subject.

The younger nuns come to the class only sporadically. They often rush in breathlessly, with blue-checked pinafores over their habits, to report that they can't attend that day because they are baking, or cleaning, or washing clothes for the priests at the monastery in Azogues, a nearby town. "We have to earn our keep, you know, because we are a very poor convent," Sister Rosa reminds me frequently.

Naturally, I am fascinated to see what the nuns choose to photograph within their restricted environment. As an outsider I might be allowed, under special conditions, to visit certain areas of the convent—with Alexandra, for example, I have seen the dining room, with its fabulously frescoed walls, and the nun's private chapel. But I would never be allowed to see what I see in my students' photos: two novices making a meal in the ancient smoke-blackened kitchen; the nuns adorning a saint's statue for a religious festival; an inner patio with a kitchen garden and a clothesline strung with

laundry. Uninteresting as photos, perhaps, with the missing heads and crazy angles, but exciting to me as images of an absolutely hidden world.

One day I broach the idea to Sister Rosa of a photo lesson that will take us around the cloister to the chapel, say, or the crafts room. She thinks for a long moment and says she will talk to Mother Superior, and I understand that this is probably a no. Our picture-taking activities during the lessons are confined to the colonnade and the central patio.

This past week all the nuns were there, and after a good lesson, when we were chatting, they discovered that I am not a Catholic. With exclamations of surprise, and then giggles and wide-eyed looks, they suggested that I might experience a conversion and go back to the United States to start a convent of the Immaculate Conception. Perhaps in Miami, Sister Rosa suggested. "Aren't there lots of Latinos there?" she asked. (So she *does* know something about the outside world.) I laughed and said, "That would indeed take a certifiable miracle."

MEANWHILE, IN CAÑAR, Michael was pleased to be asked to teach a beginner chess class at the Club de Deportes, the local sports club. The classes begin next week. A couple of days ago we heard the awful racket of a sound truck driving through the streets, cheap speakers blaring. Usually the message is so loud and fuzzy that you can't understand anything but *"¡Atención! ¡Atención!"* But this time Michael thought he heard the word *ajedrez*, chess, and we went outside to listen. Sure enough, the truck was cruising the streets of the town and the countryside, announcing Michael's class.

People around here are crazy about chess, much to Michael's delight. A month or so ago he put a hand-painted sign on our gate that said, "If you play chess, inquire here." For a while it generated a flurry of drop-in visitors: two young giggly town girls who only wanted to see the inside of the house, I think; four teenage boys who asked if they could play together against Michael as a team; and the local high-school English teacher, who barely speaks any English and wanted to practice both English and chess with Michael. Others came simply because they were curious about the *gringos* in the corner house. The most interesting opponent so far has been the local chess champion, a nervous boy of twelve or thirteen who was brought to the house by his mother. The kid never smiled and compulsively wrote every move on a little pad. He gave Michael a good run for his money, winning one out of the three games. Like the others, he promised to come back. A few did return a couple of times—though not the little champion—but the visits soon trickled off. The other day Michael mentioned disconsolately that no one comes around to play chess anymore. I reminded him

that most people don't like to get beat every time, and joked that to keep people coming he needed to compromise a few games. Never! he replied. Perhaps the classes will generate new interest.

ONE OF OUR GREAT pleasures this year has been getting to know Paiwa, our little goddaughter who is five and a half. She goes to kindergarten at the Catholic school just down the road, and a couple of afternoons a week she stops by our house for a visit. Michael has made her a miniature table and benches, which sit in one corner of the *sala*. To keep her occupied, I bought crayons, colored pencils, paper, scissors, and glue—all items that Cañari children become familiar with in school but rarely have at home.

Now that Paiwa has grown accustomed to us, she is no longer shy. In her school uniform, she marches right in the door, puts down her satchel (even kindergartners have homework), and works busily at her little table for thirty minutes or so before she looks up and asks for a snack. "Peanut butter and jam," Michael offers gravely, "or crackers and cheese?" We try to discourage her requests for *monedas*, coins, to buy sweets and soft drinks in neighborhood stores. Her perfect almond-shaped eyes study Michael as she contemplates her choice.

If I have the time and Paiwa is in the mood to read, we select a book and go into the bedroom, following a routine that she has come to love: we take off our shoes, climb onto the wide bed with the red-and-white-striped cover, pile the pillows against the wall, and—Paiwa's favorite moment— reach up to turn on Michael's bedside reading lamp. She loves the switch on the post and the shade that throws a soft yellow light over us and sets the atmosphere for checking in on Franklin, the turtle. I've had the good luck to find in Cuenca a trove of Franklin books in Spanish that are just right for her age: *Franklin's Bad Day, Franklin is Lost, Franklin's New Friend*, etc. With Franklin's help, Paiwa has become a perfect "pre-reader" this year, and I'm proud of my role in this. She knows the stories, she can guess key words when I pause to prompt her, and she loves to talk about the illustrations.

No one reads books for pleasure here, I notice, which is understandable in a culture where the older folks are illiterate or barely functionally literate. For most, reading is a tool you use to navigate the outside world: to understand legal documents, road signs, and instructions, and to complete your lessons. For leisure, you turn on the TV—virtually everyone, no matter how poor, has a TV in Cañar. To encourage Paiwa to keep reading after we leave in two months, Michael has promised that he will make her a reading lamp exactly like his, but painted blue to match her table and benches.

A Wedding

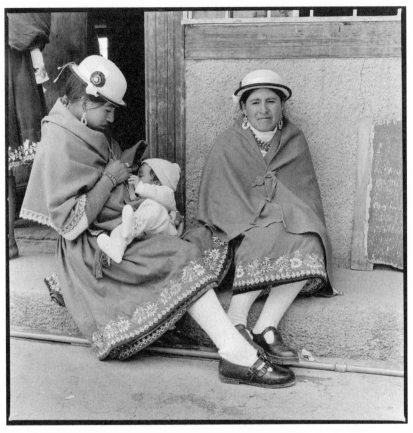

THE BRIDE WITH HER BABY AND THE GODMOTHER OF HER WEDDING

ANTONIO COMES BY THE house on a Saturday afternoon with Magdalena and Juanito, a small older man he introduces as a friend of the family. After Michael serves drinks and pleasantries are exchanged, Antonio reveals the reason for the visit. "Are you free to come to a wedding this evening?" he asks solemnly. Magdalena's younger sister, Beatriz, is marrying Nicolás, a neighbor. The wedding party will be at the church for the six-thirty mass,

and afterward we'll walk to Beatriz's mother's house for *"algunas copitas,"* a few small drinks. The family would be so pleased if I could take some photos. We're happy to come, but because we know that no Cañari event is carried out with only a few small drinks, and because we know Antonio and his family well, I feel free to add that we can't stay all night. We'd like to be home by midnight. "No problem," Antonio replies, "I'm sure you'll be on your way home by nine, *máximo!*"

This formal invitation, so simply delivered, reveals none of the complexities of a traditional three-day wedding, the negotiations between the families that must have preceded the event, or the mix of Andean rituals with Catholic Church customs that make a union legitimate by Cañari customs and legal by the state. Nor did our casual, qualified acceptance to Antonio's invitation reveal how excited I would have been, until recently, to be included in such an occasion. Just months ago I might have gladly stayed the night, or perhaps participated in all three days. Now, however, with invitations to photograph and film weddings, baptisms, and graduations coming regularly, along with plantings and harvests (even tree cuttings—"Do you want to come photograph me cut down a tree?" Santiago asked last week), my overriding concern these days is getting enough sleep, or at least not losing entire nights.

Around six that evening, Michael and I take a leisurely stroll up the hill into town. A welcome spate of warm days has arrived in the midst of the cold rainy season, and everyone is out on the streets. We walk around the town square, which has been boarded up since we arrived six months ago ("Improving Your Park," the sign on the painted fence still says), listening to the automated bells ringing in the tower of the homely Catholic Church. Cañar's old adobe church was torn down about fifty years ago, like so many others during a crazed "modern" phase of church architecture, and rebuilt with concrete block and plaster. The result is an awkward, undistinguished building with a sharp-angled exterior and a cold, stark interior. Inside, we spot Antonio and Magdalena and take our place in the pew beside them. As the church fills to capacity, I realize that this is not a wedding mass, but an ordinary Saturday night mass. I see several sets of *novios,* or engaged couples, sitting in the front pews, and just before the service begins they get up as a group and disappear through a small door behind the altar. Antonio leans over to explain that there the priest will marry the *novios* in a quick ceremony. Previously, he says, the priest married *indígena* couples during the Sunday mass with more ceremony, but no longer. (Mestizo couples, however, have wedding masses on Sunday; I once saw one in preparation, with flowers and ribboned-off pews and the bride in a long white dress. My

guess is that the costs involved with that kind of wedding are prohibitive for indigenous couples, whereas what we are witnessing tonight is free.)

Tomorrow, Beatriz and Nicolás and the other *novios* will return for the Sunday mass, where the priest will read their names to the congregation. And that, Antonio says, will complete their union "in the eyes of God." For the *novios* and their families, however, the Christian ceremony is only one small part of an elaborate series of rituals and celebrations managed by the bride and groom's families that will seal a couple's commitment to one another and secure their social and economic place within the community.

The mass begins, given by Padre Jesús in his usual patronizing manner. Each time a child talks or a baby cries he stops abruptly and glowers in the direction of the disturbance until quiet reigns again. It gives me secret pleasure to see, halfway through the mass, a scruffy dog run down the outside aisle near where we sit. He settles down beside an old Cañari woman and proceeds to do what only dogs can do in public: lick his private parts. If Padre Jesús notices, he makes no sign; the dog lies on the tile floor at the end of the pew throughout the mass, which winds up, as always, with the congregation singing "The Sound of Silence," accompanied by a guitar. Someone who thought Simon & Garfunkel's tune would make a fitting conclusion to a Catholic mass has written new lyrics in Spanish. I hum along.

After everyone leaves the church, Antonio says, the *novios* and their godparents will change their clothes at the back of the sanctuary before walking in a procession through the streets. As the lights go down in the church, Michael and I walk into the foyer where, in near darkness, we see the bride and groom and their godparents in a niche behind the main door. Others are gathered around. Without actually showing any flesh, the two couples are slowly accomplishing a complete change of clothes. A group of women helps the bride slip a bright new *pollera* over her head, then an even fancier *pollera*, and finally an embroidered blouse and short shawl held in place over the shoulders with an elaborate *tupo*, or pin. The godmother is changing into an identical set of clothes. Everything is brand spanking new, right down to the white kneesocks and black plastic shoes. A group of men help the groom and godfather change into beautiful new ponchos with *ikat*-weave red and black stripes, white embroidered shirts, and black *cushmas*.

As we stand watching I ask Antonio about this practice of changing clothes in the church. "In the past we borrowed good clothes for a three-day wedding and gave them back when it was over," he says. "Now, it's the custom that the godparents buy new clothes for the bride and groom and for themselves, and present them to the *novios* in the church after Saturday night mass. These are the clothes they'll wear for the mass on Sunday,

when everyone can see them dressed in their best. It's very expensive to be godparents for a wedding."

Once the two couples have changed and put on new white hats, the *novios* and their godparents—who Antonio explains are the groom's aunt and uncle—pose stiffly for photographs in the church foyer. I'm ready with my cameras and flash, but two pesky kids run in front of the couples and mug, their silly faces and fake Nike jackets spoiling the effect of the traditionally dressed Cañari wedding party. Someone shoos them away, and I'm able to get a few acceptable shots.

The rest of the wedding party has been waiting on the steps of the church, and as the two couples emerge a man with an accordion begins pumping out a tune. We take off walking at a fast clip through town. I follow along or run ahead of the procession, trying to both shoot photos and film with the video camera, but the kids—who turn out to be the sons of the godparents—seem to be in front of every shot.

We walk around the boarded-up square and down a dark cobblestone street, stopping at a small store where light spills out the open door. This is our *posada*, in the small paved parking lot behind a store. I've been here before, during the Día de San Antonio celebration, and it is one of my least favorite places. Tonight, in the dark, it is especially dreary, the space nearly filled with cars and trucks—the storekeeper's son runs out to caution us not to lean against or touch the vehicles—and unlit other than a single bulb hanging from the back balcony. And no bathroom, I note with annoyance, reminded again that the storekeepers in town are happy to take money from the *indigenás* and sell them alcohol and sweets, but provide few services in return.

Nevertheless, within a few minutes the men have brought out chairs and wooden benches to fill the narrow space between the cars and store, and a small table is set up for the men. Bottles of *puro* appear in front of Nicolás and the godfather as the other men crowd around the table. Most of the women stand or sit on the ground, their heavy skirts gathered under them for warmth. Drinks are passed around, first by one family member and then another, always in the same small glass. When the server asks if I want my *puro* straight or with a little cola, I say with cola, but he pours a huge shot with a tiny bit of cola, and then stands by and watches with amusement as I drink. I'm trying to learn to shoot it down with one gulp rather than sip and hold up the proceedings, and this time I manage with two gulps. As is custom, I shake the last few drops on the ground as a symbolic offering to Pachamama, Mother Earth, and hand the glass back with the standard refrain, *"Dios se lo pague."* The server moves on to the next guest.

Women begin to pass around potatoes and *mote,* and the effects of the food, drink, and the music of the accordion soon dispel the dreariness of the place. Children play quietly around the edges of the adults. The old woman with the dog from mass sits chatting with other old women, the dog curled contentedly at her feet.

I am sitting on the bench next to the young bride, Beatriz, whom I've never met, and I sneak a look at her. She seems shy, her eyes on the ground, but when I speak to her she looks up at me and replies softly. She has a long narrow face uncharacteristic of Cañari people, and her eyes, like those of her mother and sister, are large and slant oddly downward at the outside. A fresh scar along one eyelid, still swollen, exaggerates her sleepy look. There is absolutely no interaction or even eye contact between her and her handsome groom, Nicolás, who sits across from us at the men's table.

Earlier, I had noticed a teenage girl who seemed too young to be the mother of the baby she was carrying on her back. Now she comes over to Beatriz, swings the baby around in its sling, and deposits it on the bride's lap. Beatriz opens her cape and blouse and begins to nurse. I ask the baby's name. It is a girl, María Beatriz, and she is five months old. Finished nursing, the bride gives the swaddled baby back to the young girl and assumes her passive position, eyes on the ground, hands folded in her lap.

I take a look around at the crowd. Most are from Quilloac, Antonio's village, and I recognize people by their faces if not by name. I photographed many of them at the Día de San Antonio fiesta a few months ago. There's José Guamán, the friendly man who took the photo for me in the cemetery at Juliana's funeral; that must be his wife beside him. I lean over to look down the length of my bench and see the accordionist, or *maestro* as he's called, talking animatedly to Michael. The *maestro* has probably been hired by the godparents to play his few monotonous tunes for the three days (and nights) of the wedding celebration, and he is treated like an honored guest and regularly takes breaks to eat and drink. In fact, he already seems a little tipsy. He and Michael laugh uproariously at some joke.

After a short while, maybe an hour, the *posada* is over. The table is cleared, food and bottles of *trago* are tucked into women's baskets and shawls, and within minutes we are walking out the double doors of the parking lot and down a street that crosses the Pan-American. When we reach the highway and everyone stops to look for speeding cars, an old man I hadn't noticed, dressed in knee-high rubber boots, scampers across the road ahead of us. "That's Taita Manuel," someone says. "He's eighty-five years old." I'm impressed. He's lived way beyond the life expectancy for a Cañari man, and is still spry, too.

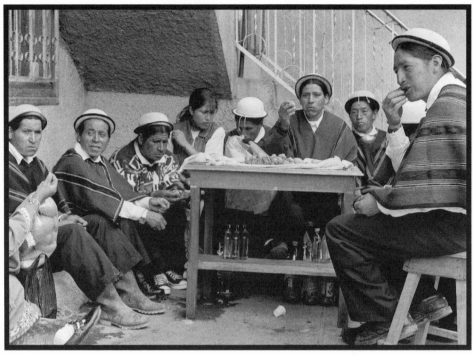

THE GROOM WITH THE GODFATHER AND MALE GUESTS

Soon we are walking single file on a rough trail. A shrouded half moon is our only light, and within minutes I'm stumbling and lurching. Everyone else steps fast and sure-footed; the trail is well known to them. I glance behind and see Michael, steadily putting one size-twelve boot in front of the other. He smiles at me, looking happy. The young woman in front of me, the groom's sister, keeps turning around to politely point out rocks or a muddy stream crossing. We start up a steep hill and I begin to pant with the altitude and the heavy load of cameras in my backpack. The young woman spontaneously turns around and grabs my hand, and I feel her incredible strength as she pulls me up the hill with hardly a pause or a glance at the path. I finally have to stop, gasping for breath. "How much farther?" I ask her. *"Allá, no más,"* she says, a favorite phrase in these parts that means literally, "There, no farther," but in fact can refer to distances from fifty meters to several kilometers. She points to a single light atop the hill that looms above us in the darkness. It seems far away, but in a few minutes we are there.

Those in the lead, including Taita Manuel and the *maestro,* have stopped at the crest of the hill to wait for the rest of us. We gather in front of an ancient

adobe compound, and as is the custom when approaching a Cañari house someone calls out *"wassssiiiiioooooo"* before we pass single file through a gate and into a walled courtyard. Antonio has told me that Magdalena's mother is a recent widow who lives in this hilltop compound with her daughters and their children and various other relatives.

In the dim light cast by a lamp rigged up in the courtyard, I notice that additions have been made haphazardly to the main structure, an old adobe house. I see what looks like a small sleeping room on one side, a lean-to kitchen on the other, and various outbuildings, all adobe with thatched roofs. To get into the main house, we step up on a huge stone, maybe eighteen inches high — an unusual entrance to a house. Inside the single large room, the tilt of the rough dirt floor indicates that the house has shifted with the hillside. This is an area of active geological faults. Antonio, who lives just down the hill, is building a new house because last year a landslide came so close to his old one that it covered the stable, killing several animals.

We file into a room where benches and crudely made wooden chairs line the back wall, facing the door. Two small wooden tables with chairs sit against each end wall, facing one another across a space of about fifteen feet. A single bulb dangles from the ceiling, casting a soft, dim light. I drop into a chair along the back wall and have just shucked off my heavy backpack with a sigh when Antonio comes over to tell me that I've taken the place of the *maestro.* I quickly move to the bench farther along.

Once everyone is settled, I realize that all the women are gathered on one side of the room, where the bride and godmother sit behind one table, while the men are on the other side with the groom and godfather. Without realizing, I've ended up sitting on the border of the men's side, though not exactly among them. The men sit on benches or chairs, and the women fill the space on the floor, their legs tucked under their skirts. Many have young children and babies in various stages of drowsiness or sleep.

The man nearest me wants to talk. "Does everyone in the United States own a car?" he asks as an opener. By custom rather than prohibition, men and women don't usually talk to one another at these events, but I've noticed that when it comes to male-female relations in Cañar I seem to fall into some androgynous category. Perhaps because of my different shape — tall and thin in a culture of short, round people — and my unfeminine clothes — pants, hiking boots, muted colors, and no jewelry — I'm not considered a "real" woman in the Cañari sense, and therefore, I suppose, also not a threat to common protocol or a cause of petty jealousies.

With Michael, on the other hand, there's no question. He's unequivocally

a man, and an instantly popular guest, with his easy manner, good laugh, and few words of Quichua. He's already sitting in the middle of the group gathered around the groom; the men are calling him "Mikito" and offering him drink after drink. (I, on the other hand, never get called anything because no one can pronounce my name. In Spanish the word "Judy" comes out sounding like "Yudy" or "Hury"—not very attractive to anyone's ears.)

It is about ten by now, and the room gradually quiets, with only the plaintive notes of the accordion to keep us company. Antonio and Juanito circulate among the guests, serving *canelazo* to each person in a shot glass. The sweet hot tea mixed with liquor goes down well, and I am soon relaxed, warm, and happy. It's too dark to take photos, and I don't want to use a flash, so I am officially an off-duty photographer—I'm so relaxed, in fact, that I completely forget about the video camera in my backpack that films in low light. (Later I'll regret this.) Newspapers line the upper part of the adobe walls, and as the evening wears on I amuse myself by reading city headlines that are as remote from the reality of life in Cañar as the moon: "Taxes Sure to Go Up," "Banks Declare a Holiday," and—my favorite on the unreality scale—"Holland Legalizes Euthanasia."

I hear a few murmured conversations around the room, but I'm struck by how subdued everyone is considering that this is a wedding fiesta. The Cañari are naturally quiet. Women tend to talk in coarse whispers, men speak softly, and even the children play quietly. A child is hardly ever allowed to cry; a baby gets a breast stuck in its mouth, and a fussy toddler is quickly picked up. Older children are customarily not allowed to fight, talk loudly, or interrupt adult activities.

After sitting awhile longer—we are waiting for the meal, I assume—I go out for a walk around the compound. I peek into a low adobe building nearby and see a group of people gathered on the ground around a large candle. *"Buenas noches, señorita,"* someone greets me from the darkness. This group doesn't seem to be attached to the wedding party, but Antonio had mentioned that an old uncle died that morning, so perhaps this group is sitting *de luto*, in mourning, for the uncle. In another outbuilding I see Magdalena and her mother sitting on the floor cutting a pile of roasted guinea pigs into pieces. Good! That must mean dinner is on its way. A bit earlier, Michael had asked Antonio if we could make our farewells now—just to remind him we are not planning to stay the night—and he had replied, *"Ya, mismo,"* another favorite expression referring to time that can mean anything from fifteen minutes to hours.

I know from experience that it would be unforgivably rude to leave before eating. Rituals of hospitality forbid it, so we simply must stay. I wander

back into the main room, where several of the women, the bride among them, appear to be napping. The women on the floor sleep sitting up, their round white hats lowered over their eyes. The bride leans her head against the adobe wall, her hat over her face. The men too appear to be half-asleep. From my sleep-loving, routine-bound perspective, this is sheer torture. The family members of the wedding party and their related guests not only have to stay awake all night tonight, but tomorrow night as well, when they go to the groom's house for a repeat ritual. Only after the third night will they be allowed to sleep. Traditionally, the bride and groom formally consummate their marriage on the third night, in a room of the groom's family house, while the guests continue the fiesta.

Finally, dinner arrives. Antonio, as the newly anointed head man in the family, is in charge of serving the guests. The godfather receives an enamel basin loaded with rice, corn, potatoes, and mutton, topped with three huge guinea pigs roasted a rich brown; he looks enormously pleased with his king-sized offering. Then the godmother is served, next the groom and bride, all equally large portions, and then smaller portions go to everyone around the room. The process takes a long time, and those who have been served first begin to eat delicately with their hands while the rest of us sit quietly, waiting. I'm finally given a small enamel bowl with bits of guinea pig and mutton and a few potatoes. I eat everything but the mutton with great relish. This year I've learned to like guinea pig, but the mutton will not go down after the first bite.

The room grows quiet. Even the accordion player stops playing to eat. I watch the old woman slip a piece of meat to her dog, curled up around her feet. It is unusual to see affection between human and dog in the Cañari culture. Generally, dogs are simply watchdogs, workers who must look out for their own survival.

A few minutes later, the godfather gets up, walks across the room, and hands his basin of food to his wife, and she in turn hands hers over to him. This is a ritual I've not seen before. Then the bride and groom formally exchange plates. Soon, husbands and wives and others are exchanging plates; the person next to me offers me a handful of *mote* with a gentle nod that says, "Now, we all share." As people grow sated, women discreetly dump the excess food from their plates into their shawls and skirts to take home later. Michael asks Antonio for a plastic bag, and we fill it with our leftovers.

Slowly, the room comes back to life, in a subdued way. The accordion music starts up; people begin to chat and move around. I'd like to go home before the drinks start to make the rounds again. Michael thanks Antonio, who invites us to come again tomorrow night to the groom's parents' house.

Outside we stop, stunned at the brilliant, star-filled night. The entire Cañar valley lies below us, lights blinking across the far hillsides like fireflies. We start down the rough trail to the main road and I switch on my Maglite to see the path, something I would have been embarrassed to do on the way up. Michael refuses to use his, as always, claiming he is saving the batteries for an emergency. In the quiet of the night, without seeing another soul, we come to our little corner house with the red roof, and within minutes we are in our bed, reading lights on and books in hand.

Mama Michi Goes to Canada

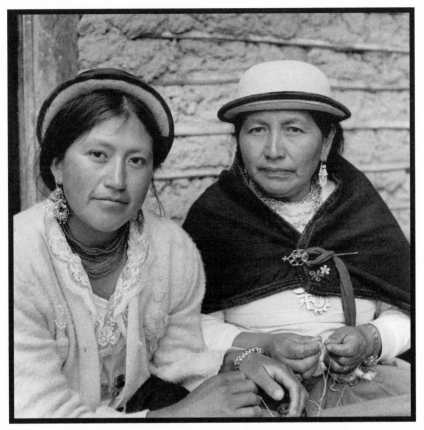

MAMA MICHI WITH HER OLDEST DAUGHTER, DELFINA

WHEN I WAS LAST in Cañar three years ago, Mama Michi was training to be a native midwife, a *partera,* and this year I had planned to document her work tending home births. Once here, however, I discovered that rather than becoming a midwife, Mama Michi is now a *yachaj.* Her sister Mariana, a community nurse and midwife, explained that Mama Michi found delivering babies too frightening. She was alone with Delfina, her oldest daughter, for a prolonged breech birth during which the baby died and Delfina nearly lost her life. Mama Michi was so traumatized by the experience that

she declared she could not be a midwife. Instead she began to do cleansing ceremonies and hands-on healings and discovered that not only does she have healing powers, but she also has the strength to resist contracting the maladies that others bring to her. Mama Michi had found her calling.

"I'LL BANG ON YOUR gate at four thirty tomorrow morning," Mama Michi said one day last week, "and we'll get to the flower market in Cuenca at a good hour to buy the plants I need for Canada." When I groaned and replied, "Oh no, do we really have to go *that* early?" she gave me an affectionate oh-you-soft-*gringa* look, and said okay, she would bang on the gate at five.

This is Mama Michi's big buying trip for the flowers, herbs, and other plants she uses in her healing rituals and *aguas medicinales*—medicinal waters, or teas. She needs time to dry and prepare them before she leaves for Canada in a couple of weeks. I've come along to film and photograph as she shops, and to ask her about the properties and functions of the plants. I'm feeling conflicted about her leaving for two months, not just because I'll miss her, but because I received a grant to document her work this year, and I still have a lot to do from the time she gets back in August until we leave in November.

Last year, Mama Michi was invited to Canada to attend the first International Medicine and Healing Gathering in Saskatchewan. It was her first trip away from Ecuador. Of the 4,500 shamans, native elders, and traditional healers from across the Americas, Mama Michi made such an impression that she was featured in a *National Post* article, in which she was quoted as saying, "The spirits told me when I was a young girl that I would come to Canada to help heal other indigenous peoples. The spirits showed me what would happen here, that there would be a tremendous number of people wanting help, and so I came."

Now, I know for a fact that when Mama Michi was a young girl growing up in a tiny village in the Andes, she had no notion that Canada or Saskatchewan or even other indigenous groups existed, but there's no question of her success once she got there. The photo that accompanies the article shows her sitting on a hill above the Nekaneet Valley, legs tucked under her skirt Cañari-style, arm raised in a proclaiming-to-the-multitudes manner and, I imagine, a visionary look in her eye. Dressed in her homespun wool skirt, embroidered blouse, black wool cape, and round white hat, she looks right at home in the landscape, if it weren't for the teepees in the background.

Mama Michi has a commanding presence despite her four-feet-ten-inch height—about average for a Cañari woman of her generation—and her

compactly rotund body, which has not the slightest bit of fat. (Until, that is, she returns from her second visit to Canada complaining about the extra ten pounds around her middle; too much food and too little walking, she declares). Her direct gaze conveys ironic humor most of the time, and her generous smile is sometimes missing its front tooth, when she forgets to put it in. Strong, girlish legs do not show a sign of the thousands of mountain miles she has walked in her lifetime, usually with heavy loads or babies on her back. Mama Michi says she is fifty-two, but her face shows the wear and worry of her life, and she sometimes looks older. Best of all is her laugh, an unmistakable high-pitched cackle.

She was invited back to Canada a second time last year for a month, to a series of classes and healings at a native university in Saskatchewan. Or maybe it was Alberta, she's not sure. Mama Michi, with her third-grade education, is illiterate, so her sister, María Juana, who works with CONAIE, the national indigenous organization in Quito, takes care of the correspondence and travel details related to these trips. María Juana will also accompany her sister on this trip, because Mama Michi cannot make her way through airports and change planes alone.

Mama Michi was very pleased with her Canadian reception, and she returned with beautiful quilts, beaded moccasins, a fluff-trimmed hooded jacket, and a couple hundred dollars—all gifts or payments from people she had healed. (When I recently visited Zoila, who gave birth to her third child a couple of weeks ago, *she* was wearing the fluffy hood, but detached from the jacket. Months later, when we finally take our Inca Trail trip, the hood will turn up again on Mama Michi's nephew Ranti.)

And now Mama Michi has been invited back to Canada for the third time. "To heal people," she says with a shrug when I ask her why. She doesn't really want to go, she adds. She has a new grandchild in the house, and animals and crops to attend to as well as her many patients. "But they've asked me to come, and I can't refuse," she says with another shrug. It's a mystery to me exactly who "they" are, and who her patients will be once she's there, but Mama Michi can't help me out with any of this information. "I just go where they take me," she says.

On the morning of our market trip, I'm reading a book by candlelight in our *sala* when Mama Michi appears at the gate at five fifteen, looking sleepy. Without speaking, we walk to the Pan-American and wait in the darkness for the first bus. On the bus, I continue reading by the light of my flashlight while Mama Michi sleeps, her black shawl pulled up over her face. Since her fame has grown, she always seems tired and sleepy. At her twice-weekly clinics at the indigenous center in Cañar, clients overflow from morning

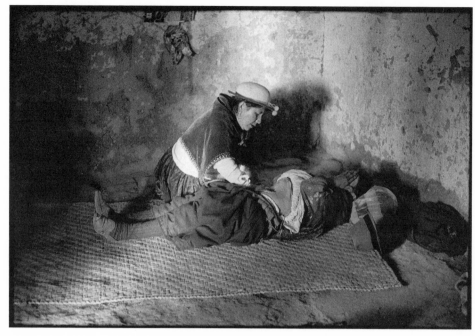

MAMA MICHI DOING A HEALING

until night. After clinic hours, they come to her house, especially at night when they believe her healing powers are more effective. Mestizos, *indígenas*, old folks, mothers with babies, young men ready to emigrate—they come or are carried to Mama Michi to be cured of everything from *espanto* (a fright) and *mal aire* (literally "bad air" but encompassing various spells and possessions), to heart problems, kidney complaints, love sickness, or bad luck.

At her house, Mama Michi sometimes works all night, her main room filled with patients sitting or lying on rush mats. Many simply stay the night once their healing is done and travel home in the morning. They pay with everything from cash to potatoes to live guinea pigs. "I'm going to die before my hour," Mama Michi said one day with a rueful laugh, referring to her sleepless nights and long days.

Mama Michi has not always had a vocation. When we first knew her ten years ago, she and her family were struggling to survive on the few pitiful plots of land, mostly on steep mountainsides a two- or three-hour walk away, that had been allotted to them during the agrarian reform of 1964. She was married to Serafín, then a sad, defeated alcoholic who was sometimes abusive, with whom she had six children.

Despite her lack of education and personal travails, Mama Michi has always been a community leader. In the early nineties, she was president of the agricultural cooperative in place of Serafín because he was too sick with alcoholism and disabled with old injuries to take the job when it was his turn (then, a woman was not allowed to be an "official" president). Unlike other Cañaris we met at the time, Mama Michi was curious about Michael and me, and immediately friendly, in part, I suppose, because I was teaching her oldest son, José Miguel, photography.

In fact, my first "breakthrough" photo in Cañar was by invitation of Mama Michi. I had been hanging around on weekends for months and had taken no significant shots. On May 1, 1992, the agricultural cooperative members posed for me after the International Workers' Day annual march through Cañar. In one photo everyone is seated casually on the ground enjoying a picnic; in a second they are stiffly lined up in a formal pose, holding the group's flag. I was pleased with the result, and so was Mama Michi—so much so that she asked me to make a copy for each family in the cooperative.

By the time Michael and I came back to Ecuador for a visit in 1997, Serafín had died. He was only in his forties. We had known him mainly as a sweet-faced presence at fiestas who always drank too much, but his hard, sad life was illuminated by a story José Miguel told us just last week. Around 1978, when José Miguel was ten or eleven, a local law was passed in Cañar that any "inebriated Indian" could not cross the Pan-American and come into town. (The highway still marks the socioeconomic and ethnic boundary between the *indígena* countryside and the town, where the population is almost exclusively mestizo and white.) Serafín was arrested one Sunday as he crossed the highway. When Mama Michi heard, she sent José Miguel and his young cousin Lazaro to the jail with clothes and food. While they were talking to Serafín through the bars, a policeman entered the cell and Serafín, still drunk, tried to fight him. José Miguel and Lazaro watched in horror as the policeman knocked Serafín down and kicked him repeatedly in the stomach.

The internal injuries were so severe, José Miguel said, that his father spent three months in the hospital in Azogues, where he had several surgeries. Serafín came out of the hospital a broken man, nearly an invalid, and he never fully recovered. (The fact that he had gotten from the jail to a hospital alive was miraculous; it was more likely, at the time, that an Indian with injuries caused by the police would simply have died in jail.)

A second miracle occurred when a Catholic nun in Azogues heard the story and helped the family lodge a legal complaint against the Cañar police that eventually led to a trial. José Miguel remembers testifying with Lazaro

from behind a screen because they were still children. Against all odds, the case was decided in favor of Serafín, and he won a small cash settlement. More importantly, the law was struck down, the Cañar police force shaken up, and new local laws were created to protect *indígenas* from abuse at the hands of police. According to José Miguel, nothing like this had ever been seen in Cañar, a town that had always been controlled by mestizos.

But it was too late for the Chuma family, whose already precarious economic state was devastated by Serafín's months in the hospital and his invalid condition afterward. José Miguel and Delfina were forced to leave school after grade six, and soon after that José Miguel, at fifteen or sixteen, went to the coast to work on a rice plantation. Mama Michi had another child and continued to survive as best she could under marginal conditions. Fifteen years later, drink and the lingering effects of the injuries finally finished off Serafín.

Only then was Mama Michi free to take a few short courses in community nursing, with the help of her sisters Mariana and María Juana. While her husband was alive, Mama Michi was not allowed to leave the house or the fields for more than a day, she told me once when we were talking about Serafín. When I asked why, she answered, *"Celos,"* with a short bitter laugh. Jealousy. "He thought I might go with another man." This is a common belief among Cañari men, that any wife allowed the freedom to travel alone or continue her education will automatically have adultery on her mind.

TWO HOURS ON THE bus and we're in Cuenca. It's seven o'clock by now, and the morning is dull, gray, and chilly. We take a taxi across to the Feria Libre, or free market, that occupies several acres on the west edge of town. There, we enter a vast world of colorful, cacophonous anarchy. Two days a week, anyone with any sellable item to offer can set up a temporary stall or simply lay their goods out on the pavement, where narrow spaces are marked with yellow strips. There are also huge, covered sheds with permanent stalls. Mama Michi quickly threads her way through the market to the flowers and plants section at the far end. I trip along behind, keeping her bobbing white hat in view, stumbling on the goods that are piled up in rows with barely eighteen inches between.

"We're late," she shakes her head. "The medicinal plants will be gone." But there are still plenty of flowers, and she immediately picks two bunches of violets and begins to bargain hard with the vendor, then carnations, amaranth, chamomile, and others. She pays out of a wad of bills she has in her pocket, stuffs all the plants into a huge plastic grain sack she pulls out of the sling on her back, and moves quickly on.

Meanwhile, I'm trying to take some color photos and struggling to pull the camcorder out of my backpack. I drop the cassette case on the ground, and a flower vendor who is watching me with interest picks it up and hands it to me, saying, "You'd better zip up that pack, *patrona,* or you'll lose something else." With all the equipment straps tangled around my neck and the chaos of the market, I feel totally disorganized and out of my element. I bring the video camera up to my eye to discover that Mama Michi, once again, has disappeared in the mash of shoppers and vendors. But since I'm taller than everyone else by a head it takes only a minute to survey the crowd and find her.

And so it goes for the next two hours. Mama Michi buys flowers, herbs, grasses, and other bushy plants, and I follow along, photographing and filming, stumbling, knocking into shoppers or being jostled by vendors carrying loads. Sometimes I get a chance to ask her how a plant is used before she stuffs it into the grain bag, but mostly I just manage to keep up. "Who is she?" curious flower sellers ask me every few minutes. "A famous healer," I say. Mama Michi looks pleased at the serious nods of the vendors.

Finally, when the huge bag is so full that it cannot be dragged any further, Mama Michi trusses it up with rope and leaves it for safekeeping with the last vendor she dealt with. She turns to me. "Let's have some breakfast!" These are indeed sweet words, as I feel I'm about to faint, not being accustomed to working so hard so early in the morning without eating. I gratefully follow her to the food stalls along the outside wall of the market, where we sit on stools gulping down hot sweet coffee and eating fresh rolls. Delicious!

"Now," Mama Michi says, brushing crumbs off her skirt, "let's go look at clothes." I laugh, delighted. Just like all women on a shopping trip, we took care of the essentials first and then we got a little reward. We thread our way back through the flower and plant sections to a more open area of the market, where women have laid out their wares on tarps spread on the ground. Mama Michi is looking for something special to wear to Canada, she says. She spots some acrylic sweaters she likes, and holds one up for me. "What do you think?"

"Good bargain at seven dollars," I say noncommittally. She buys three in different colors—dark green, creamy beige, and dusty rose—and announces it's time to get back to Cañar.

The Way Things Work

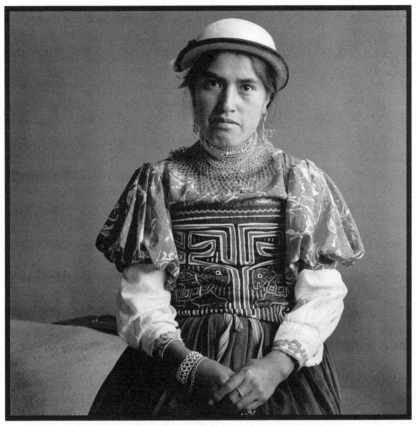

MERCEDES GUAMÁN, WEARING A CUNA INDIAN BLOUSE
MADE WITH A *MOLA*, FROM PANAMA

IT'S BEEN A TERRIBLE WEEK. Thursday, Mama Purificación, sister-in-law of Mama Michi and wife of Taita Shanto, was badly burned by a gas explosion. Her daughter Puri, a woman in her twenties who still lives at home, came to our house to make a desperate call to her Aunt Vicenta in Quito. Her mother was preparing to fix lunch on their old gas range, Puri said, which she had turned on before fumbling with a match. By the time she struck the match, the room had filled with gas, and the explosion blew out

the window and burned Mama Purificación's face, hands, and feet. "She's in the hospital," Puri said tearfully, "and we need money to pay for her medications and food. Can you send us something?" Puri went on to explain that times were particularly tough because the local indigenous organization she works for was having a financial crisis, and she had not been paid for several weeks.

As I listened, I recalled what little I know about Mama Purificación. When we first met her ten years ago, it was obvious something was terribly wrong. The few times I glimpsed her coming in from the fields, carrying wood for the fire or sheaves of grass to feed her guinea pigs, she walked bent over, very slowly, with a short-stepped shuffle. Her gaze, when she tipped her head in my direction to make eye contact, was kindly and intelligent, but when she talked in her small breathy voice, it sounded like gibberish. "What happened to Mama Purificación?" I asked Mama Michi back then. "She was burned, and was never the same afterward," was all she would say.

When I occasionally saw Mama Purificación at Mama Michi's house or at family gatherings, her interaction with her family seemed minimal. She seemed to live silently in their midst, doing what jobs she could, but largely ignored by everyone. Earlier this year, we heard from Esthela a more detailed version of what was rumored to have happened years back that, if true, has horrible implications. Esthela said Mama Purificación was suffering from rheumatism—a common complaint in this cold climate, where women wash clothes in ice-cold springs, streams, or irrigation canals—and the doctor, or someone, recommended treatment with a hot vapor bath. Purificación's two daughters, Mariana and Puri, who must have been teenagers then, decided to cure her themselves, according to Esthela's story. They boiled water, heated stones on a wood fire, and sat their mother under a tent of blankets. No one knows for sure what happened next, but whatever it was caused severe burns to Mama Purificación's legs and lower torso. She spent months in the hospital, Esthela said, and "went sort of crazy." When she came home she was practically an invalid, nearly mute, and has been that way ever since.

"And that's why her daughters have never married," concluded Esthela, her voice lowered dramatically. "Maybe for shame, they know they have to stay at home and take care of their mother."

Puri hung up the phone, wiping tears from her cheeks. Vicenta didn't have any money at the moment. I asked how much she needed; she said twenty dollars would cover the hospital costs for the bed, medications, and food. (That's what counts as socialized medicine in a poor country, I

thought cynically.) Puri said she would sell a sheep on the next market day and pay us back.

Later that day, Michael and I went to the hospital, a small one-story building on the edge of town. Michael took a piece of his famous banana cake, made that morning, in case Mama Purificación could eat. We found her in the women's ward, a light-filled room with only four beds. She greeted us unintelligibly in her tiny voice, and her gaze, through eyes nearly swollen shut, was sweet and thankful. Her face was blistered and swollen, the skin red and weeping, and her eyebrows were completely gone, but these were not deep burns. We asked about her hands and she showed us minor burns on the insides of her wrists. We didn't see her feet, but there was a framework under the sheet that prevented contact. Later her son, Ranti, told us that her feet were the most severely burned, and I shuddered to imagine her cheap plastic shoes melting into her skin.

We asked Mama Purificación if she was alone in the house when it happened, and in her breathy, garbled reply I heard the words "kitchen . . . lunch . . . daughter-in-law." Michael and I stood at the edge of the bed, not sure what else to say. We were Mama Purificación's only visitors at the time, but family members of other patients in the room and from out in the hall came to look her over—in part, possibly, because they were curious to see who the *gringo* visitors were. When they asked her what had happened, she whispered, "Gas," and everyone nodded knowingly. I wondered if this is a common accident in this part of the world; domestic cooking gas is cheap enough that nearly everyone has at least one tank hooked up to a hot plate or an old range.

We said goodbye and were about to leave when a nurse came in with a prescription slip and asked Michael and me if we would go to the hospital pharmacy and buy the syringe and medicine for the injection. Mama Purificación did not seem to be in pain, but I wondered: if she were, would the nurse still wait until visitors came to give her an alleviating shot? Just then Puri arrived. She took the slip and went looking for the pharmacy, while Michael and I headed for the exit. I saw the pharmacy on our way out; it was closed for lunch.

TWO DAYS LATER, on a Sunday morning, we were anxiously awaiting the arrival of Stuart and Patricia, friends from Cuenca who were coming for breakfast. Michael had prepped the banana pancake batter and made fresh butter from cream (strangely, although we are in a dairy region, butter is not available; it's too expensive). The coffee was hot. Stuart is a North American

geographer and alpaca rancher who has lived in southern Ecuador for more than twenty years, and Patricia is his youngish second wife — a pretty, dark-eyed Cuencana he married a year or so ago. Stuart was coming to talk to Michael about a crazy idea: he wanted to transport several hundred alpacas from Peru to his hacienda in a remote corner of Cañar province, and he wanted Michael to design the cages.

About the time they were due to arrive, Patricia appeared at the door, shaking. "We've had an accident," she said in a quavering voice. Ten kilometers outside of Cañar, a small pickup came straight at them in their lane at about sixty kilometers an hour. Stuart was able to turn the wheel at the last moment to avoid a head-on collision, and the pickup hit them just behind the driver's door. The back end of their truck was destroyed, Patricia said, but she and Stuart were unhurt. The other driver was not so lucky. After the collision his truck careened down the road, hit a ditch, and tipped onto its side; Stuart and Patricia found him unconscious and bleeding from the head. He was dressed in police pants and reeked of liquor. "We found this," Patricia said, pulling a half-empty bottle of Zhumir out of her bag with shaking hands. She asked us to keep it as evidence. Stuart had stayed at the scene to make sure the driver got to the hospital, while Patricia had hitched a ride into Cañar to our house.

While Patricia made several calls to her family in Cuenca, Michael hired a truck and driver to take us to the scene of the accident and ran down the street to ask our neighbor, Jorge Molina, a lawyer, if he would come. Jorge promised to be there in half an hour, after he had dressed and shaved. With Michael and Patricia jammed in the front of the truck and me riding in the open bed, we climbed out of Cañar onto the Pan-American, heading south. It was a beautiful sunny day, and as I clung to the side of the truck I felt how flimsy our existence is here, in this world where no one wears seat belts, gas stoves blow up, men regularly drink and drive, and people are transported at high speed in the backs of open trucks. How easily I could be flung out of this truck if the driver, distracted for a moment, drove off the road. It was a banal but revelatory moment.

At one of the highest points on the divide, just before the Pan-American begins its drop into the Cañar valley, we found Stuart's truck sitting at a right angle to the road, across one lane, its rear end virtually detached from the front. A Greek chorus of neighbors and passersby were perched along the road verge, watching and commenting on the scene. One of them told us that Stuart had gone to the hospital with the injured policeman. After Patricia, Michael, and I engaged in one of those confusing let's-do-this-no-let's-do-that conversations, we decided that the two of them would wait for

the lawyer while I went back into town with the hired truck and driver to look for Stuart.

Thus I found myself at the hospital for the second time in a week, this time in the emergency ward, really just a small plain room at the end of one wing. A woman standing in the hall said that the injured man, Sergeant Rivera, was there, but the *norteamericano* had gone to a laboratory in town to buy vials for a blood test. A hospital without test tubes? Then I remembered our earlier visit and Mama Purificación's syringe and medication. I peeked through the open door of the emergency room to see the policeman on a gurney with several nurses gathered round; one was mopping blood off the floor. Emboldened, I went in to take a look; no one objected. The policeman was semiconscious, moving his head from side to side, and I could see several scalp wounds that had just been stitched. Below his bare chest his uniform pants were spotted with blood. I asked the nurse swabbing the floor if he was going to be okay; she nodded yes distractedly.

Stuart arrived with the test tubes his usual cheerful, analytical self, as though nothing unusual had happened. The purpose of the vials was to gather hard evidence that the man was drunk, he said, as Ecuador's police are notorious for hiding their crimes. Stuart asked the nurse to take two blood samples and then, with full vials in hand, quickly left for the laboratory again, asking me to request a written document from the doctor certifying that the man was inebriated.

A few minutes later, as I stood in the hallway, four policemen strode in like visiting dignitaries. They warmly greeted the nurses and attendants, shook hands all around (except for me, whom they ignored), and walked into the emergency room as though they owned the place. I watched as the X-ray technician asked one of the policemen to help him guide the gurney down the hall to the X-ray room. They passed me in the hallway, joking and smiling. The patient was now half-awake and mumbling, but obviously still drunk.

When the lone doctor on duty that day finally appeared, I was surprised to see that he was a young *indígena*. A Cañari physician! Dressed in a white coat, he was slight, young, and handsome, with a long braid down his back. I was so surprised and touched, I felt a sudden lump in my throat. No paperwork that day, he answered wearily, in response to my request. It was Sunday; I would have to come back tomorrow. (Later, Mercedes Guamán tells me that his name is Alfredo Pinguil; he is from the nearby village of El Tambo and is indeed the only Cañari doctor. But a young woman from Quilloac has just finished medical school and is doing a year of national service in a remote community. She will be the second Cañari doctor.)

Hours later, after rounds of the police headquarters, lawyer's office, laboratory, hospital, and finally the wrecking yard where the truck had been towed, we met back at our house for a belated breakfast. By then Patricia's father and brother had arrived from Cuenca. Michael reheated the coffee and resurrected his pancake batter, and we finally sat down to eat. Stuart and Patricia "decompressed" in the way we all do when we've survived a close call. They tried to remember what they were talking about in the moment before impact; they drew diagrams of the accident, relived the dramatic moments, and wondered at their good fortune.

I'll watch what happens next with great interest. This is a very small community where everyone knows everyone else, and it feels like the impunity machinations have already gone into action. I remember the four policemen's hospital visit and recall the response to Patricia's father's indignant comment that the pickup driver had been "crazy drunk": one of the policeman had answered defensively, "Remember, he's had a blow to the head, and that can make you crazy."

We can see the cover-up coming. *"Acá, la corrupción es bárbara!"* Here the corruption is barbarous, a Cañar friend said when I told him the story. He added that Stuart and Patricia could forget about any kind of compensation, especially since the accident involved the police.

Stuart and Patricia will be back on Friday to take up the endless paperwork and legal wrangling that awaits them. Meanwhile, behind a mattress in the guestroom, in a plastic bag, stands the nearly consumed bottle of Zhumir that Patricia took out of the policeman's truck, still smudged with his fingerprints.

A Birth in Cañar

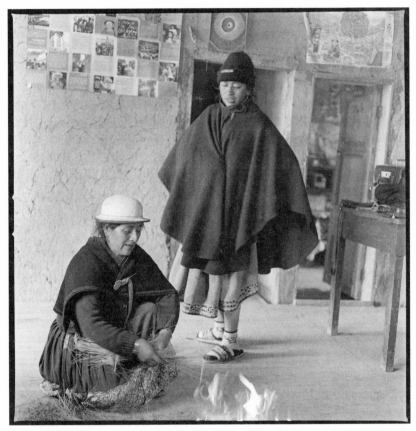

MARÍA JUMPING OVER THE FIRE, WITH MARIANA SOLANO, MIDWIFE

THE KNOCK COMES ON our door early Saturday morning. Mariana has sent a message: María, the young wife of her nephew Fausto, has gone into labor during the night and will be giving birth to her first child sometime today. I should come with my cameras as soon as possible.

Mariana and I have been trying to document a home birth for months — she wants photos to accompany a paper she's writing for her native medicine

course in Quito, and I've been anxious to photograph a traditional birth for my own work. She also wants a videotape to use for training. But all the births she's attended recently have been in the middle of the night, or I've been out of town. Today is perfect; it's early morning on a weekend day, and I have nothing else scheduled. I hurry to pack my gear: medium-format camera for my serious black-and-whites, two 35 mm cameras for color, a flash, a light meter, a tripod, and the camcorder—about the same weight as full-term twins, I figure.

Meanwhile Michael, who has been playing electronic chess, announces that he must go back to Cuenca to pick up the two packages of mozzarella he left yesterday in our apartment fridge—a four-hour round trip on the bus.

"You're kidding!" I say, incredulous. "All that trouble for two packages of cheese? Why not just buy some here?"

"It's not *just* cheese," he says, annoyed. "It's *mozzarella!* And there isn't any in Cañar. I want to make pizza, how can I make pizza without mozzarella?" Well, to each his own, I think as I hoist the cameras on my back. I tell Michael not to expect me anytime soon, except maybe much later for pizza with *real* mozzarella.

I walk down the hill to the crowded house where Fausto and María live with his parents and three older siblings. Fausto is about nineteen and still in high school. I've seen María, Fausto's equally young wife, a couple of times in the fields, but she is very shy and won't speak to me.

I find Mariana in the outside lean-to kitchen, bustling around a wood fire with boiling pots. "Judicita," she says, "it's good you came. There's going to be a birth today." Mama Michi's younger sister is a short, attractive woman in her forties, with lively, expressive eyes. She and Vicenta are the best educated of the four Chuma sisters. Both finished high school, and Mariana went on to a two-year community-nursing course before she married. For years now, she has worked as the sole attendant in two country clinics in outlying villages, alternating days at each clinic and earning a pittance from the government. A widow, she struggles to raise three children, and complained to me recently that she is not paid extra for the long hours she spends assisting births throughout the region. The families she serves don't want to pay her, beyond the ritual meals after a birth that tradition dictates, because they see her as a public employee.

Helping Mariana in the kitchen is Alegría, the beautiful young wife of Félix, Fausto's oldest brother. With three young children of her own, Alegría is considered experienced enough to help Mariana with the birth. Her youngest child, the fifteen-month-old Santiago, totters around the open

fire, playing with a sharp knife—children learn very young here how to avoid getting hurt. Alegría, sitting on a low stool beside a table, uses a piece of broken glass to scrape small black spines into a fine powder. Mariana stands over her, giving instructions. "What's this?" I ask, pulling out the video camera.

"The spines of the *penco* plant," Mariana says. (Agave, which is an integral part of the landscape here.) "It will help move along María's contractions."

Mariana steps over to the fire and begins to strip petals and leaves from flowers and plants, dropping them into a pot of boiling water. "And what's that for?" I ask, grateful that for once I'm in a situation where my questions are welcome. "An herbal tea that will calm María and help dispel any anger or rage she might be feeling," Mariana says. "I asked *la mamá* this morning if she had any problems, and she said she had a little fight with her husband last night. It's important that she give birth without anger."

Just then Fausto appears at the open doorway of the kitchen and hands Mariana a small plastic bag of eggs. She slips one into the boiling pot with the tea. When the egg is cooked she pulls it out, pours the steaming tea into a metal cup, and tells Alegría and me to come with her. Alegría, meanwhile, has carefully collected the fine black powder of the *penco* into a square of newspaper. They set off across an earthen courtyard; I follow with the video camera at my eye. Through the lens, I see Alegría's children playing in the courtyard with some new puppies, and Fausto and his brother, Ranti, cleaning a stable against one side of the house.

We climb crude concrete stairs and find María sitting on the edge of a long wooden bench, her arms tensely braced, tears streaming down her red and swollen face. Dressed in blue cotton pants, several layers of sweaters, green socks, plastic slip-ons, and a navy-blue stocking cap with a big Nike swoosh, she is watching cartoons on a small television. Although I know the family well, I don't know María, and when I'd asked how María felt about my being there to film and photograph the birth, Mariana said it was all right, that the young woman was totally preoccupied with her pains. I took this as consent.

I swing the video camera around the room and see a large, cluttered table where the TV sits, the wooden bench, and a smaller table against a back wall covered with piles of clothes. These are the only furnishings. One corner has been crudely partitioned, for a bed I assume, as this small house must accommodate seven people. Aware that this is a rare opportunity, I carefully film the details of the room: the plastic-covered windows and dusty wooden floor, an outdated calendar on the wall, an open door to a storeroom filled with bags of grain. Through another open doorway I can see a

neatly made bed surrounded by walls covered with posters and newspaper; this must be Fausto and María's room.

Mariana immediately takes charge. She instructs Alegría to turn off the TV and tells María to get up and walk around the room. "Brace yourself against a table when the pains come," she says, "but try not to sit down." Meanwhile, she cuts off the top of the soft-boiled egg, sprinkles the *penco* powder into it, and adds bits of a mashed-up plant she calls *mil-mil,* which she says will help with the *cólera,* or anger. She instructs María to stand in the middle of the room. "Take down all the contents of this egg," she commands, "and then throw the shell over your shoulder." María, shaky from a contraction, looks absolutely miserable, but she tips the egg into her mouth, gulps as much of it down as she can, and tosses it over her shoulder, where it smashes on the floor. Mariana walks over and looks down disapprovingly at what remains of the egg. "You didn't take it all," she says severely. With tears in her eyes and another pain obviously coming on, María just shakes her head. She walks over to the small table and braces herself with her arms, head down and waiting.

"Don't film this part, Judicita," Mariana says a few minutes later as she pulls latex gloves out of her UNICEF medical bag. "It's not native medicine." She spreads a thin blanket on the wooden floor and directs María to lie down, telling Alegría to bring a wool skirt. I realize Mariana is going to do an internal exam and wonder if this is what she means by "not native medicine." Alegría helps María slip off her pants and put on the skirt, and Mariana's hand disappears under the skirt.

"Only three fingers dilated," she says a minute later, snapping off her gloves. "We have hours and hours to go."

By eleven thirty María's pains are five minutes apart, but they don't last very long, and Mariana is not pleased. "It's time to do a *mantiada,*" she says. "Bring a blanket from the bed." I've never heard this word, and I watch with interest as Alegría lays the blanket on the dusty floor, and María lies down on it. Mariana grabs one side of the blanket with both hands, Alegría grabs the other, and by alternately pulling up on the sides, they roll the laboring María back and forth several times like a sausage in a . . . well, blanket. "What's that for?" I ask (my favorite refrain of the day). "To move the baby down," Mariana says, as she gives her side of the blanket one last pull. María, who has accepted this treatment stoically, is finally released, and with another pain coming she gets down on her knees on an old sheepskin in front of the long bench, her head on her arms. "Let your body open up," Mariana tells her sternly. "Let the baby come down."

When I showed the videotape months later to a group of North American midwifery students, they commented on how unsympathetic and uncaring Mariana seems throughout the labor and birth process. I tried to remember how I felt as an observer. It seemed to me that the message this midwife conveyed was that a home birth was a serious, potentially dangerous event and that only a no-nonsense, let's-get-this-done-quickly-and-safely attitude would do. I think María was reassured that someone like Mariana was in charge, and both understood that there was no room for niceties.

A while later, Fausto appears at the doorway and Mariana sends him to collect some dry straw from the four corners of the house. (I misunderstand and think she has sent him to collect straw from a house that sits at four corners, and I'm trying to imagine how far Fausto has to go to find such a house when he rushes back in with a sheaf of dry straw in his hand.) "Quick!" Mariana says, taking the straw. "Bring a metal plate or something to put on the floor." She arranges the straw on a flat square of tin that Fausto brings in from outside, explaining that she's going to light a fire to "generate the energy to help María give birth." The smoke, she adds, will *"llamar al niño,"* call the child, so that it will come soon. She lights an alarmingly large fire in the middle of the room and tells María to jump over it. María, still on her knees, gets up obediently and walks over to stand against one wall, looking dejected.

"Hurry! Hurry!" Mariana commands. "Jump over the flame. Cooperate!" Poor María, now dressed in a skirt with nothing underneath, must jump high enough not to get burned. I watch in horror . . . or maybe wonder, as she makes a little running leap over the flames; then she turns around and leaps again. "Ay, ay, ay," María groans each time, holding her bulging belly. When contractions come, she stops and leans against the table. Mariana rubs her back and seems sympathetic for a moment, but once the pains pass, she builds up the fire and orders María to jump again. María obeys, but looks absolutely wretched. This torture goes on for maybe ten minutes before María is finally allowed to get back on her knees on the sheepskin and lean on the bench.

When things are quiet and Alegría has gone off to check on her children, Mariana and I have a few moments to talk. She explains that the straw must be collected from the four corners of the house because it represents family and stability and provides a good foundation for the new soul. The heat, she says, gives energy to the mother, and the jumping exercise helps open up the body and bring the baby along.

DURING THE LULL I wander to the outdoor kitchen, where I find Alegría peeling potatoes. Santiago is asleep in a sling on her back. "I'm preparing a chicken soup to give warmth to the mother after the birth," she says. Earlier Zoila, herself a recent mother, had come by with a fat hen in her arms, which she had ceremoniously presented to Fausto. That, apparently, is the chicken going into the pot boiling on the open fire.

By one o'clock María is lying on the bed in the room she shares with Fausto. She seems quieter, but she's crying softly. Mariana sits next to her, rubbing her back when contractions come. Zoila walks in with a *santo*, a porcelain doll representing a child Jesus, that is dressed in a frilly white dress and sitting on a tiny wooden chair. Earlier I had noticed the saint on a table next to a burning votive candle (the same candle, perhaps, that will cause the fire that burns both the saint and the table a few days later). Mariana passes little *santo* over and around María, resting it briefly on her body. María, racked by a contraction, pays no attention.

Mama Vicenta, Fausto's grandmother who lives just up the hill, arrives with two eggs as an offering for the proceedings. She sits on the bed beside María and tells her, *"No grite, no grite,"* don't cry, don't cry. Later, when Mariana also says this—rather sternly I thought—I ask why María shouldn't cry out if she wants to. "Because that allows the life force to escape from the mouth," Mariana says. "When it's time, that force has to go for pushing."

Soon after Mama Vicenta leaves, Mariana sends Fausto to the pharmacy in town to buy an injection that will help María sleep and rest before the final labor. I follow Fausto outside and film him wobbling up the hill on his bicycle, wondering if the family has some money in reserve for the expenses related to the birth. When Fausto returns, Mariana administers the injection, again asking me not to photograph or film because "this is not native medicine." By two o'clock María is sleeping, and Fausto's sister Puri invites us for a wonderfully tasty lunch of piping hot chicken soup in the kitchen downstairs.

After lunch, we find María still sleeping. Mariana calculates that the baby will come at about five thirty, so I decide to check in on Michael and tell him what's happening. I ask if I can bring anything back, and Alegría hesitates a moment before saying with a smile, "Zhumir." Of course. Nothing important happens in Cañar without the eighty-proof cane liquor that is a part of every ritual.

Michael sits at the dining room table playing chess on his electronic board. *"Estoy muy contento,"* he declares with a satisfied smile when I ask how it went in Cuenca. His two mozzarellas rest safely in the fridge. "Will you be here for dinner? I'll make pizza." Dinner looks unlikely, I say. I fill him

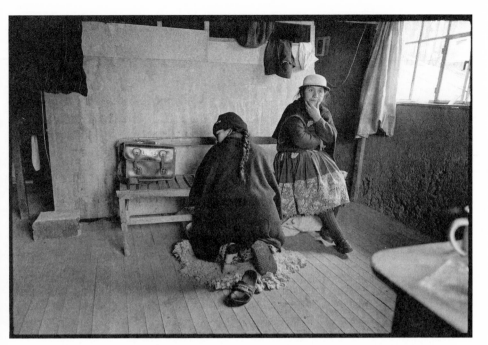

MARÍA AND MARIANA AWAITING THE BIRTH

in on the progress of the birth, then leave to buy the Zhumir and a dozen fresh rolls before walking back down the hill.

I find Fausto in the downstairs patio, working on his bicycle. Just like any expectant father, he's trying to keep busy around the house while the birth drama plays itself out behind closed doors. His brother is still cleaning the stables in the outer patio, and his sisters are somewhere in the downstairs quarters, probably cooking.

At four o'clock, Ecuador will play Peru in a critical soccer game. If Ecuador wins, it will be one step closer to qualifying for the World Cup, something that has never happened in the history of this small country. Earlier, Fausto came into the "labor room" to disconnect the TV and install it in the next room on the table with the saints. All of Ecuador is watching.

Mariana and I alone keep vigil over the sleeping *mamá*. All is quiet, and I can hear doves cooing under the eaves of the house. Gazing out the window, we see a funeral procession snaking its way up the road from Cuchucún, a community several kilometers to the north. Four men carry a silver casket; two others walk ahead with the elaborate metal legs with splayed feet and crossbars upon which the casket will rest at various points along the route. A group of thirty or forty Cañaris walks slowly behind, dressed in

black and deep purple. "One less of us," Mariana says, expressionless, without commenting on the obvious—that one more of us is on its way in the next room.

I remember when I first met Mariana eight years ago. Because of my friendship with her nephew José Miguel and her sister Mama Michi, Michael and I were invited to the baptism of Mariana's youngest child, Juan Carlos. Her husband, Juanito, was the pride of the Cañari community. A trained agronomist who worked for a state agency, he owned a truck, a rare acquisition at that time. But even more impressive was the fact that he had once been sent to Italy for professional training by an Ecuadorian labor organization. At the baptism party I saw a framed photo of Juanito posed in front of a fountain in Bologna. Arms crossed proudly, handsome, young, and aware how far he had come for a Cañari man, he looked on top of the world. At the baptism party Mariana too seemed happy, with her three beautiful children and a house that was large by Cañari standards.

One month later, during a Sunday afternoon soccer game, Juanito was kicked in the stomach, and within the week he was dead. It was probably a ruptured spleen, but in keeping with country ways around here, no one mentioned the cause of death—or the medical negligence that is routine when Indians require urgent care from white-run hospitals. All we heard from José Miguel was that by the time they did surgery, it was too late.

"Goooooooooaaaaaaaaal!" from the TV in the next room, followed by delighted yells. Ecuador has scored. By now María is in hard labor. Mariana instructs her to lie on a thin woolen blanket on the dusty, wooden floor of the main room. Her contractions are coming very fast. *"Madre mía,"* she groans with each one. *"No puedo aguantarlo más."* I can't take it anymore. She is writhing on the thin blanket, still fully dressed in a bright pink skirt, shawl, and stocking cap. She is really suffering, and there is nothing to do but wait. Finally Mariana says it's almost time, and after several tries she convinces María to get on her knees on the sheepskin in front of the bench. Zoila and Alegría, who have been watching the game next door, join us and Mariana instructs Alegría to sit on the bench in front of María so María can hang on to her for the last contractions. (I witnessed one other home birth in Cañar several years ago, and remember that a "hanging post" person is designated as the birth nears.)

Mariana gets out her UNICEF bag again: latex gloves, plastic apron, plastic sheet, a sterile cloth, and a tray of sterilized instruments. She arranges these behind María's bare feet. "Don't film this," she says to me again as she takes a drip IV out of her bag. I regretfully turn off the camera. She explains to María that the medicine in the drip will help her push the baby

out, but by this point María seems oblivious to everything. Half-slumped, half-sitting on the floor, her head down on the bench, she is racked by hard contractions and sobbing. Mariana expertly prepares the infusion bag and Zoila and I hang onto María's outstretched arm while Mariana tries to get the needle into a vein on the top of her hand. As I hold María's arm, my hand slips toward the needle, and somehow I get two punctures just below my thumbnail. So much for my help with the birth, I think each time I see the faint blue bruises in the days that follow.

María is finally in an upright, kneeling position on the sheepskin, facing Alegría, and she's ready to push. Fausto has come to watch, as well as his sisters, who have kept in the background today. Mariana, positioned on the floor behind María, slips her gloved hands under the bright pink skirt. "Push! María, push!" she commands. We all stand quietly, breathless. Suddenly, María stops crying. From behind my camera I can see her white-knuckled hands gripping the back edge of the bench, with Alegría holding her under the arms. Her head is down and she appears to be concentrating. It's dead quiet.

Again, Mariana yells, "PUSH!" and then, unexpectedly, as we wait for more pushes, Mariana brings a little creature out from under María's skirt: curled in a ball, black hair, eyes shut tight, normal size. Mariana puts a towel over the baby's back and pats it gently. It cries. She lays the baby down on its side on the sterile sheet, just beyond María's bare feet, and everyone gathers around. Is it a girl or a boy? With the towel draped over it, we can't see. I'm dancing around with my cameras, trying to film and shoot photos at the same time. María stays in her kneeling position, absolutely still. Mariana measures the umbilical cord with her hand span and ties it off. The baby stops crying and lies still, curled on its side, blinking. Finally, someone is able to maneuver around and see that it's a boy, a *varón*. I see a slight smile on María's face when someone calls out the news, but still she does not turn around.

"Goooooooooaaaaaaaaaaal!" we hear, and Fausto runs away briefly to see that Ecuador has scored again.

Mariana takes a bit of blood from the baby's umbilical cord and makes two little stripes on each of his cheeks. Then she picks him up and calls for a dollar bill; everyone in the room gets busy finding a dollar and trying to get the rolled-up bill into the baby's tiny fist. He finally latches onto it. "This can't be very hygienic," I think for the first time that day. The significance of the dollar bill is obvious, but later I ask Mariana about the blood. "A sign of life," is all she says.

A few minutes later, Fausto and Ranti dance into the room, announcing

that Ecuador has beaten Peru. An unexpected victory under any circumstances, but with the World Cup at stake it's absolutely incredible. Everyone cheers . . . except poor María, who is still on her knees, head down and covered with a sheet. She has not said a word or tried to turn to look at the baby; she won't lay eyes on her new son for about fifteen minutes more. Alegría is still at her post, half-supporting María, waiting silently for the afterbirth.

Mariana hands the baby to one of the young aunts standing by, who wraps him tightly in a shawl. We gather around to see his perfect little face, eyes blinking. The dollar bill waves in his tiny fist.

Ten minutes later, when the afterbirth comes, Mariana takes a thorough look at it and declares that everything's fine. Zoila brings a clean skirt for María, who puts her arms up to receive the skirt and shakily stands. Fausto and Ranti half carry her into the bedroom, and Mariana asks us to leave the room so she can check the new mother to see that she's not *quebrada,* broken or torn.

"Completely healthy!" she says a minute later, stripping off the latex gloves and looking pleased. "A normal birth." Mariana brings the baby into the bedroom and we all trail along. "Let's see how much he weighs," she says, finally taking the dollar bill out of his little hand. She lays him on the sterile green cloth, ties the four corners into a knot, and hangs the bundle from a hand-scale with a spring. In the dim light we gather around the crude scale, using my Maglite to read its numbers. Eight pounds! "I need one of those," Mariana says as she hands me the Maglite. I make a mental note to give it to her when I leave Ecuador.

Next, the swaddling. Mariana puts several layers of cloth on the bed, beginning with an old piece of embroidered wool skirt and ending with a new, clean flannel. The first layer wraps the baby's torso, the next encloses his arms, with his tiny fingers straightened flat, and then there are a few more layers, ending with the bright orange skirt fragment. Finally, a hand-woven belt is wound around the bundle from top to bottom. I can hardly believe how tightly Mariana is wrapping the baby, although he doesn't seem to mind. In fact, he was crying when she started, but now he has quieted down. A little stocking cap goes on his head and a cotton cloth is draped over his head and neck, with the two ends tucked into the woven belt.

The swaddling finished, Mariana picks up the bundle and bounces it once, as if to show that nothing can harm this kid now. She hands the baby to Fausto, and I take some photos. Then, at long last, María, who has been straining to watch the swaddling process, gets to hold her newborn son, or at any rate the tightly wrapped bundle with her son somewhere inside.

(Five days later, I return to watch Mariana swaddle María's torso in much the same way for a ritual called *"el cinco,"* or "the fifth." The new mother is given an herbal bath before a concoction of flour, oil, and eggs is placed on her stomach and topped with cotton wool. Then she is tightly wrapped with cloths and shawls from just under her breasts to her knees. She must lie completely flat and wrapped for about six hours. Mariana explains that this helps the new mother's matrix, or uterus, assume its proper place.)

Alegría serves Zhumir and rolls all around, and Puri brings in a brimming bowl; we all watch as María finally gets her special chicken soup. She looks exhausted but serene. The baby nestles beside her in the bed, where mother and son will stay, more or less, for the next twenty to thirty days. When I first heard that new mothers are confined to bed in a darkened room for a month, I was shocked; it seems to me that staying in bed for weeks would make a new mother weaker, not stronger. On reflection, however, I realize that the custom makes sense in a farming culture where a woman is usually out in the fields doing heavy work, at home cooking over a wood fire and tending the children, or in bed sleeping. (Actually the thirty days of bed rest is loosely interpreted; in fact, the new mother can get up and do chores around the house if she feels like it. But she will not be left alone during this time; a mother or grandmother or aunt is always nearby.)

Puri calls us to the downstairs kitchen for dinner, and we leave the young parents alone with their baby. Sitting around the low table in the kitchen, eating yet another bowl of chicken soup, we hear a truck stop outside and someone yelling, "Fausto!"

"His teammates, calling him to play soccer," says Puri, looking amused. When we go back upstairs a half hour later, María is alone with her baby. In the previously neat-as-a-pin room, drawers are open and clothes are flung about. After a frantic search for his uniform, apparently, Fausto has gone off to play soccer with his league team.

Mariana calls for a cup of water. She takes the little bundle out of the bed, expertly flips him over faceup, pulls off his little scarf and stocking cap, and asks María, "What's his name?"

"Fausto," comes María's faint reply, with the proud dreaminess of a new mother. Mariana dribbles water over the little black-haired head, saying in a brusque voice, "I baptize you Fausto in the name of the Father, the Son, and the Holy Ghost."

We Walk the Inca Trail

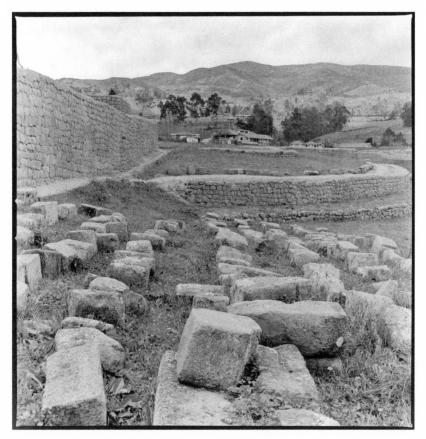

INCA STONES AT INGAPIRCA

OUR YEAR IN CAÑAR is more than three-quarters gone, and this week we are marking it with a long-planned adventure: a three-day walk along part of the high Inca Trail, the astonishing road system built by the Incas more than five hundred years ago. Our hiking companion is our friend Lynn Hirsch-kind, an anthropologist who has lived in Ecuador for more than twenty years and who we consider expert in all things concerning the Inca Trail in Ecuador (although she would probably demur).

Lynn has become a mountain climber of late, following the breakup of a long marriage; she recently returned from Peru, where she climbed two mountains. Her assault on Huascarán, Peru's highest mountain at more than twenty-two thousand feet, required ice-axe climbing and involved a close call when the roped lead climber fell into a crevasse. Ninety-five-pound Lynn had to both keep herself from being pulled in *and* hold onto the climber who was swinging above the abyss until help came. "We still made the summit that day," she said matter-of-factly.

"My God, how awful!" I said, shaking my head. "How did it feel to reach the top?"

"Wonderful!" Lynn replied. The higher I got, the better I felt." Lynn's offhand account of her strength should have given us a clue about what was in store, but Michael and I were flattered that she had agreed to come with us. Perhaps knowing that she will be way out in front on the trail, Lynn is bringing her collie dog, Xena, for company.

A week before the scheduled walk, we invited José Miguel and his cousin, Ranti, to come along. They were initially very excited about the idea, but the night before they are still looking for sleeping bags and other warm gear, which is essential as we will be hiking at more than fourteen thousand feet. Still, Michael, the food planner, packs extra provisions, and we arrange to borrow an extra tent from Lynn. We have repeatedly told "the boys" that we are leaving at seven a.m. sharp. We've arranged for a truck and a driver, Orlando, to take us to Achupallas, a mountain village about two hours north of Cañar, where we'll pick up the trail.

When Orlando beeps outside our door early Monday morning, the three gringos are dressed, breakfasted, packed, and ready to go, but there is no sign of José Miguel or Ranti. Michael and Lynn hoist their packs, march out the door, and load the gear into the back of the truck; by 7:03 they are standing in the street in front of the house waiting, tapping their toes with impatience.

I try to stall, hoping the boys will come. No Ecuadorian arrives on time, anywhere, much less first thing in the morning. "Why don't you go on down the road and check on José Miguel while I brush my teeth, and then come back for me," I suggest to Michael. "No way," he says. "We have hired Orlando to take us to Achupallas at a certain time, and we must leave directly—just as soon as you brush your teeth." Lynn, who I suspect is accustomed to having her own arrangements go pretty smoothly, agrees. We made it clear to the boys that the truck would be here at seven, and we should stick with our plan. I am clearly in the minority.

At 7:10 we pull away from the house, Lynn and Xena in the covered back

of the truck, Michael and I in front. Michael brought the extra food but left the extra tent and bedding at the house, piled in a heap. I am furious and don't feel like talking for the first half hour, imagining José Miguel and Ranti arriving at our house, expectant and excited, loaded with their packs and makeshift gear, to find us gone. Even the high courts of Ecuador have a law to accommodate tardiness. Called *la hora jurídica*, or judicial hour, it states that no legal business can be concluded without waiting an extra hour for the concerned parties to show up, whether lawyer, plaintiff, or defendant. (The Ecuadorian government has since launched a "punctuality campaign" in an effort to correct this national characteristic.)

As we head north on the Pan-American, however, the spectacular landscape soon takes my mind off anything but the view out the truck window, and I feel my anger melt away. We leave the green mountains of Cañar and enter Chimborazo, the next province north, with a drier, more severe landscape of steep treeless mountains and a mosaic of fields from river valleys to the sky. I'm always amazed that near-vertical slopes can be cultivated, but around Cañar I have seen farmers do this with two bulls and a wooden plow, the whole outfit tilting at a perilous angle. As Orlando expertly drives around switchbacks with heart-stopping drop-offs just inches from the truck, it seems to me we are losing altitude at an alarming rate. Shouldn't we be climbing? I dread the thought that we'll have to use our legs to regain the altitude.

I glance out the window to my right, craning to see the Andean *cordillera*, the mountain chain that shapes the curving spine of South America and where climate can vary from polar to equatorial in four vertical miles. At about 4,500 miles, it is the longest mountain range in the world, stretching from Tierra del Fuego on the southern tip of South America to Colombia in the north. By the fifteenth century, at the height of their brief civilization (which lasted barely one hundred years), the Incas had constructed a network of roads to every corner of their empire. The main imperial highway ran from Cuzco, in Peru, to Quito, in northern Ecuador, a distance of 2,500 miles. Although the Incas never developed written language, they were administrative geniuses and controlled their empire with the help of relay runners (*chaskis*), who carried news and messages using a unique system of knotted strings called *quipus*. With these, they could keep track of numerical and other information.

We leave the Pan-American at a crossroads called La Moya and climb twelve kilometers on a serpentine, dusty road to reach Achupallas. An ancient village of crumbling adobe buildings with lichen-covered tile roofs, Achupallas is tucked into a mountain valley at about 11,500 feet. (Cañar is

at 10,300 feet, so we have actually gained altitude.) Orlando pulls into the main square, not much more than a bare expanse of hardened earth, and stops by a beautiful old church. A tiny, hand-painted bust of Bolívar, South America's liberator, perches on a small plinth dead center in the square, looking west. Hardly a soul moves, although one young man appears from nowhere and offers to be our guide on the *camino de los Incas*, reminding us that this is a popular starting point for trekkers. We assure him that we are prepared to find our own way. According to our guidebook, the Inca road passed through this settlement on its way to Quito, though no evidence remains other than a stone waterway.

We strap on our packs (as does Xena the dog, who carries her own food in little saddlebags) and strike out down a cobblestone street that runs through the quiet town. Three women dressed in the bright red shawls and dark green fedoras of Chimborazo province pass us by without a glance. Only their dress distinguishes them from their Cañari neighbors; ethnically they are the same people.

Using our two maps and an article by John Rowe, an Inca trail researcher, we find the graveyard, cross a footbridge, and follow the small Río Cadrul up a mountain valley to the south. We see a few women and children working the fields beside small adobe houses and stone corrals; close up they look extremely poor, with tattered dark clothes and shapeless green or black fedoras, but of course they are in work clothes, not expecting visitors. Every child, without exception, runs over to beg for *caramelitos*, or candies, which escalates to *monedas*, coins, and finally *dólares*, dollars, the unfortunate result of the generosity of European and American hikers that regularly pass by. These include the four young hikers ahead of us, judging by the fresh candy wrappers that litter the trail.

On our first rest stop earlier in the day, the group caught up with us and one of the young men told us they were from Belgium. They appeared at first glance to be two couples, but one woman lagged far behind the others. When she came close I could see she was unhappy, with slumped shoulders and a loosely rolled sleeping bag thumping down her back. She sat down to rest at a distance from the others, and eventually one of the young men went back to talk to her. A very bad sign at the beginning of a difficult three-day hike, I thought.

Now, as we walk along the river, Lynn keeps an eye out for signs of "the road," as those familiar with Inca history call it. It's not always easy to tell when you are on the Inca Trail, as five hundred years of cattle and cart traffic have displaced the paving stones, turning long stretches into muddy jumbles of rocks. Occasionally the road leaves the most obvious route, like the river

valley, Lynn tells us, and runs diagonally up the contour of a mountain. She soon spots such a place, and she and Xena scramble up a steep, zigzag trail, quickly leaving Michael and me behind. We both need to stop every few minutes to rest, but Michael tires more quickly than I do. We realize later that he is carrying way too much weight, about fifty or sixty pounds, including all the food. Also, he is sniffling and coughing with an allergy that has been bothering him for months.

In a bizarre moment, we come across the unhappy young Belgian woman sitting alone beside the trail in the bushes at a switchback, crying. The other three are about fifty yards ahead. Later, Lynn tells us that when she passed by a few minutes earlier, the girl asked if she could come along with our group. Lynn said sure and continued walking, but the girl is still sitting there when Michael and I reach her a few minutes later. By then, the second Belgian girl has come back to see what's wrong, a look of genuine concern on her face. As we pass by, the first girl bursts into full-fledged sobs, while the two boys watch warily from farther up the trail. My heart goes out to them; they look so young!

As we walk on I imagine a story about this foursome. Two young couples, I imagine, perhaps traveling together for the first time, having a big adventure in South America. Three of them are strong and enthusiastic hikers, invigorated by the challenge and impatient with the one girl who is weak and frightened and ill-prepared. Or perhaps one couple is simply fighting, and the unhappy girl doesn't want to continue with her boyfriend. Too bad, I think, he's the cutest one.

We leave the Belgians behind to sort out their crisis and climb over a low pass. A level stretch that appears to be a present-day cart road gives our aching muscles and exhausted lungs some relief before we begin a long hard climb up the side of a mountain. Michael and I, gasping for breath in the thin air, stop about every fifteen minutes to rest. Looking at the topographic map, we figure we are now at around thirteen thousand feet, the upper limits of human habitation. In fact, we've seen no people or houses since we crossed the tree line a couple of hours ago at about twelve thousand feet. The only foliage around us is low brush and brownish-beige *páramo* grass, and across the valley we can see undulating waves of dry bare mountains stretching to the east.

Lynn routinely stays about fifteen minutes ahead, but every once in a while she and Xena sit by the trail and wait for us to catch up. I have the feeling Lynn would be miles ahead if it weren't for us, but she's patient and good-humored about her less-than-superhuman companions. Panting, we shuck our packs, admire the view, eat some snacks, and then continue on.

The day is perfect for hiking, with a clear sky and warming sun, and we have developed a rhythm that seems to be working for all.

At several points on this part of the climb, with the help of our maps and guidebooks, we see signs of the Inca: in the valley below us, the remains of a foundation for a large structure that might have been a storehouse; and at a high point just off the trail, an *apacheta,* cairn, that marks an Inca lookout. In places the Inca road itself is evident, with a beautifully constructed embankment wall here, or a span of stone pavement there. Then, inevitably, it all disappears into a jumble of rocks and we find ourselves on a rough footpath.

The Incas did not have the wheel, so their road system was only for walking humans and the llamas and alpacas they used to carry cargo. Lynn reminds us that through the ages the hooves of horses and cattle, along with the wheels of carts, have slowly destroyed the road, as has five hundred years of weather erosion and no maintenance. It's amazing that anything remains.

At two in the afternoon, as we are resting yet again, I look back to see two figures striding up the trail behind us. "They're walking too fast to be tourists," I laugh. "They must be Ecuadorians." A minute later we are astonished and delighted to see José Miguel and Ranti, one with a loaded feed sack slung over his shoulder, the other with a bedroll wrapped in plastic on his back.

It is a happy reunion, without recriminations but full of questions: What time did you get to our house? How did you get to Achupallas? When did you start out from there? How many hours did it take to catch up with us? Their story is pure ingenuity. When they arrived to find us gone (at 7:30 and 7:45, respectively), they packed up the extra gear we had left in the house (José Miguel has a key), raided the fridge for Michael's leftover pizza so they'd have something for lunch, and caught a bus on the Pan-American for La Moya. There, they hired a truck to bring them to the square of Achupallas, where they asked someone—probably the same young man who wanted to be our guide—if three *gringos* and a dog had passed by. Without maps or guidebooks, they struck out in the right direction and kept asking the children along the way if three *gringos* and a dog were ahead. Easy. Even if they didn't remember us, the children would certainly have taken note of the beautiful collie dog.

Although José Miguel and Ranti had left Achupallas at least two hours behind us, their youth, Andean lung capacity, and strong legs allowed them to easily catch up. We tell them repeatedly how happy we are to see them, and they look very pleased. In addition to Michael's leftover pizza, they have brought along two food contributions: a bag of roasted corn kernels

RANTI CHUMA AT LAGUNA TRES CRUCES

with bits of pork and another of sugarcoated kernels. We enjoy both these offerings enormously over the next two days.

The group strikes out again, with Lynn leading, José Miguel and Ranti second, and Michael and I bringing up the rear. The two of us are soon left behind in solitude, alternately sweating as we climb and—as the sun moves toward the western horizon—growing quickly chilled when we stop to rest. We haven't seen a sign of human habitation for hours, or even a human being for that matter—the Belgians passed us by during our lunch stop. As the light falls, the stark *páramo* and desolate dry mountains that surround us feel a little intimidating and sinister. The thought of our companions ahead of us is comforting.

Our destination for the night is a high mountain lake, Laguna Tres Cruces (Three Crosses Lake), which we locate on the topographic map, but by four thirty we are still rounding craggy point after rocky rise to see nothing but rippling waves of *páramo* grass ahead of us. Where *is* that damn lake? It's getting cold and dark, and we have already accepted that we'll have to make camp without a fire—we haven't seen a tree or bush for hours. Another

worrisome development is that I am easily outpacing Michael. He is really struggling. His heavy pack and allergies, along with the thin air at fourteen thousand feet, have taken a toll on his energy. When I slow my pace, I hear him breathe in a series of loud, ragged gasps. He can barely lift his legs, and instead of simply stopping on the trail every few minutes to catch his breath, he is searching out places to sit down. This is not a good sign, I think to myself, but I pretend not to be concerned and say nothing.

Finally, on one of his sit-downs, Michael calls ahead, saying, "I don't think I can go any farther"—words I have never heard him say in all the years I've known him. I walk back to find him slumped dejectedly in the *páramo* grass by the side of the trail, his head down, breathing hard. I sit down beside him and we talk over our options: camp by the trail or continue on. We decide that Michael should rest while I catch up with the others to see what they think. Ranti and Lynn are completely out of sight, but in the waning light we can barely see José Miguel, maybe one hundred yards ahead. Michael crouches down in a place out of the wind. "Leave me your pack," he says plaintively as I start up the trail. "All my warm clothes are in the pack that José Miguel took." (José Miguel had relieved Michael of his big backpack earlier, in exchange for a lighter one.) This was a rather scary moment, but Michael and I have a modus operandi when things get tough: pretend that nothing is wrong. Had we been alone, I certainly would have been frightened, trying to figure out how we were going to survive the night. But with two Cañaris and an experienced climber along, I knew Michael's situation would be quickly solved; I just didn't know how.

Without my heavy pack I fairly bound up the trail. "I feel great," I think a bit guiltily, although there is probably some emergency adrenaline at work. "Has anyone seen the lake?" I yell to José Miguel. "Michael doesn't think he can go any farther." José Miguel nods that he understands, drops his pack, and runs ahead, looking for Ranti, who is silhouetted against the crest of a rise. As José Miguel reaches him, I see Ranti drop his pack and take off up the trail, presumably looking for Lynn. The three of us continue walking, maintaining the distance between us, until Ranti points east and yells that he can see the lake. It must be hidden in a fold of the mountain, just below the rocky summit. "And there's Lynn at the far end," he calls back. "She's setting up camp." He charges ahead in her direction, with José Miguel right behind him. I run back toward Michael. I can barely see him in the dusk.

What happened next was a beautiful rescue maneuver, without a plan, without discussion. "I think I can make it," Michael says cheerfully, walking toward me and waving two hands covered with my extra pair of hiking socks. "I just needed to rest. And it's too cold sit there any longer. Brrrrrr!" He

looks comical, wearing all my warm clothes on top of his own: turtleneck, down vest, and a big wool shawl tied in a knot around his shoulders. His body temperature must have plummeted the minute he stopped climbing.

I look up to see Lynn silhouetted on the horizon. She is trotting along the ridge above the lake, heading for the heavy pack that José Miguel dropped. José Miguel, meanwhile, starts down the trail to pick up the gear that his cousin had dropped, and Ranti is running directly across the *páramo* from the lake, heading for my backpack, which was left behind when Michael started walking again. Michael and I, with the knowledge that we are close to a hot meal and a good rest, realize that everything is going to be okay.

Within about fifteen minutes we reach the last crest and stop for a moment to catch our breath. By now the sun is behind the mountain peaks, and the lake, which we see at last, lies pristine, dark, and icy-cold in a perfect bowl at a little over fourteen thousand feet, surrounded by rocky peaks. A more desolate landscape I have never seen. It is devoid of any sign of human presence, and I imagine that one could die of the cold here among the ichu grass and lichen-covered boulders, to be found later, perfectly preserved.

The Belgians have already put up their single tent by the waterfall at the south end and have apparently crawled in, as we see no movement. We hurry toward our companions, making a hasty camp near a massive flat rock at the north end of the lake. In the waning light, Michael and I put up our tents with shaking hands, the temperature dropping by the minute, while Lynn starts a pot of water on her camp stove. José Miguel and Ranti pitch their tent just below ours. They are in great spirits, talking and laughing, seemingly unfazed by the day's effort or the cold and darkness moving in.

For the first time in his life, I think, Michael is too exhausted to cook. Lynn boils some pasta and we eat a fast dinner huddled in the lee of the big rock. Without a fire, we feel none of the languor and smug satisfaction I associate with the conclusion of a long, hard day of hiking. It is simply too cold, and the act of eating is nothing more than a necessity to refuel our wasted energies.

By six thirty it is utterly dark, and the stars and constellations are an incredible sight. Without a fire, there is nothing to do but crawl into our sleeping bags and survive the freezing night. I have commandeered all my warm clothes back from Michael and put most of them on, including gloves, hat, scarf, and three pairs of socks. We try to read for a few minutes by the light of our flashlights, but it is simply too cold to have our faces outside the sleeping bags.

We settle in for the night and agree that despite the cold and the tufts

of ichu grass under our sleeping bags, we are actually pretty comfortable. We are warm enough, and Michael says he's just glad not to be moving any longer. He and Lynn talked about his situation over dinner. His cough is still bad, his chest congested, so they agree that if he doesn't feel better in the morning he should probably go back the way we came rather than continue on for two more days. I kept silent because I can't bear to contemplate Michael not being able to complete this trek, and of course I don't want to think about having to go back with him either. Always optimistic, I figure he is just exhausted from carrying too much weight earlier in the day and the effects of the strenuous high-altitude climb on his allergies. After all, we were on the trail for about eight hours and climbed almost three thousand vertical feet. At Tres Cruces we are nearly at the highest point of the trail; the next two days will be easier.

I too am dead tired, but as often occurs at high altitudes, I can't sleep. (Lying there, I think about a terrible night of altitude sickness in Cuzco, Peru, and my inevitable first sleepless nights in Quito when I fly in from the United States.) I lose consciousness for fifteen minutes when a weird dream wakes me, then catch another fifteen minutes or so of sleep before I wake again. It makes for a long night, and I sense that Michael is also sleeping fitfully.

When we wake at six thirty I ask Michael to see if the sky is clear— before I venture out of my sleeping bag I want to anticipate that high mountain sun hitting the tent and warming the air. Yes! Michael reports a pale blue, cloudless sky and heavy frost on the ground all around us. "The sun has already hit the waterfall on the other side of the lake, and it's headin' our way!" he says, adding, "And I feel so much better!"

By about seven thirty we are out of the tents and drinking coffee, talking animatedly about how cold the night was and giving "sleep reports." Lynn says she slept badly, but was warm enough in her waterproof bivouac bag with Xena beside her. Even José Miguel and Ranti, with their homemade bedroll of blankets and ponchos and a cheap sleeping bag, say they were warm. Everyone is in good spirits. Michael announces that there is no question that he won't continue. We pack up and by nine are climbing out of the lake basin and heading for the Cuchilla de Tres Cruces, or "knife edge" of the mountain range.

At 14,700 feet we come upon an *apacheta* that was an Inca marker. According to our guidebook, this is the highest point of the Inca road in Ecuador, but we see a footpath heading up to an even higher point, and as long as we're here we can't resist reaching the top of the world. From this crest, at more than fifteen thousand feet, the views are spectacular: to our east we

see the blue ridges of the Andes cascading down toward the Amazon basin; to the west the Pacific, with deep green valleys and more mountains. We have four cameras between us, and we take way too many panoramic photographs of one another, trying to keep our hats from blowing away in the fierce winds. We continue along the *cuchilla* for another hour or so, enjoying incredible views. Lynn spots a long, straight, grassy line in the valley below us to the west. She is sure it is the remains of the Inca road, and is tempted to descend, but it looks too boggy.

By noon we are in sight of a mountain lake deep in a valley to our left. José Miguel says the Cañari call the lake Mama Sansahuín, the mother of Lake Culebrillas, which according to myth is the birthplace of their people. We won't be going down to Mama Sansahuín, but its sighting marks the point where we begin our descent from the high *cordillera*. Ahhhhh, that feels good. Our mood is celebratory. The sun is still strong, we are losing altitude for the first time since we left Achupallas, and we know we aren't that far from our next campsite, Lake Culebrillas, at about twelve thousand feet.

On the way down, in the lee of the mountain above the lake, we see the first local inhabitants. A few men and women are gathered around some stone structures near the bottom of the mountain slope, and horses graze in the boggy grasslands beyond. The buildings are crude shelters, meant to provide humans and animals protection from the weather. José Miguel says this land is still too high for normal cultivation, and no one lives here — the people are from villages farther down the mountain, and they've come up to graze their cattle and sheep.

In late afternoon we cross the remains of a beautiful Inca levee built across the boggy bottom at the head of Lake Culebrillas, reminding us again what excellent civil engineers the Incas were, and reach the Inca ruins above Lake Culebrillas called Paredones, our destination. Paredones was to have been our campsite, but the Belgians have beaten us there. They have been alternately ahead or close behind us all day, and by the time we reach the walled area of the ruins they are preparing to set up their tent. (I notice that the interpersonal crisis seems to be resolved; the crying girl and her boyfriend have been walking together since the incident the first day.)

We are left with a small meadow beyond the ruins, which we decide is actually nicer, because the enclosed area is full of cow and sheep dung. We set up camp in a protected spot next to a stone wall. It isn't an authentic Inca wall, Lynn points out, although a few of the original worked stones are strewn about. The Inca site was largely destroyed by the Ecuadorian military and rebuilt into a small garrison in the nineteenth century. The original Inca structure was undoubtedly a *tambo*, or rest stop and storehouse, Lynn

says, for the Inca runners and warriors. Paredones, the Spanish name for this place, means "big walls," but the local people have carried away most of the original Inca stones to make fences and corrals, and all that is left are some finely fitted, trapezoidal foundation stones.

Tonight Michael is back in cooking form, and as he bustles around preparing a curry rice dinner over the camp stove, I sit nearby and dreamily try to time travel back to this place five hundred years ago. I imagine a small group of Incas preparing an evening meal, probably of dried meat and dehydrated potatoes. The potato, then as now, was the staple of the Andean diet and was first domesticated in the highlands of Peru and Bolivia. In fact, the Incas probably invented the freeze-dry process by exposing potatoes to freezing nights and sunny days until they were dehydrated and could be stored for years and easily transported.

And how had the Incas stayed warm at this altitude? We know they had llamas, alpacas, and vicuñas, and therefore wool to spin for warm clothes, but drawings by the Spanish chroniclers generally depict the Indians of the period dressed in short, sleeveless tunics, with cloaks or ponchos. Father Bernabé Cobo, a seventeenth-century Spanish priest who lived in Peru and chronicled the Inca culture, reported that the Incas "sleep by the road whenever night overtakes them, uncovered to the sky; though a palm width of snow may fall, they sleep as if in soft beds." (This sounds like a historical exaggeration to me, because even without a palm width of snow, I'm covered from head to toe with wool and microfibers.) And shoes? Simple leather sandals, probably, the prototypes of the rubber tire sandals worn by older Cañaris today. (I gaze down at my feet, protected with extra-thick socks and my well-worn, Vibram-soled hiking boots.) My literal mind is having a hard time with this fantasy, but it feels wonderfully strange to be able to layer our momentary history onto this place, still isolated, uninhabited, and relatively unspoiled five hundred years after the Incas passed by.

Our night is comfortable. The ground under our tent is soft with grassy turf and, at an altitude of more than two thousand feet lower than last night, we are almost cozily warm. I sleep, Michael sleeps, and everyone wakes up rested. While we are waiting for the coffee to brew, José Miguel and Ranti announce that they are going for a ritual immersion in the lake. I am impressed, given that the water must be about forty degrees, but Ranti says it is important they make an offering to Mama Culebrillas, and José Miguel reminds us that the lake existed as a religious Cañari site long before the arrival of the Incas. According to legend, Culebrillas is the place where the Cañari people originated, created from the union of a *guacamayo*, a mythical bird, and a man. Several years ago, a government plan to dam the river

that runs out of the lake for an irrigation project was halted by the persistent protests and blockades of the Cañaris, who argued that if the area were flooded, they would lose their ancient birthplace.

As José Miguel and Ranti prepare to go to the lake, I notice they are carrying a pint bottle of Zhumir. The liquor will be useful both to screw up their courage to make the plunge, I suppose, and to make an offering to Mama Culebrillas. Our campsite is behind a rise, so unfortunately we can't see the lake, but José Miguel and Ranti return looking exultant about an hour later, their long hair hanging wet down their backs. "The lake was rough when we got there," José Miguel says, "but when we made an offering of Zhumir it calmed right down. Then we washed away all our bad energies." Later I saw the photos José Miguel had taken; they had smeared themselves with mud, either as part of the ritual or as insulation against the cold, cold water.

We strike camp, load our packs, and start out on our third and final day. Our destination is Ingapirca, the most important Inca archeological site in Ecuador (*pirca* means "wall" in Quichua). Before the Inca arrived in the late fifteenth century, it was a significant religious center for the Cañari people, who had inhabited the area for thousands of years. Huayna Capac, one of the last Inca rulers in Ecuador, ordered the construction of Ingapirca on top of a Cañari site, and opinions are mixed about its precise purpose, whether as a military fortress or for religious and ceremonial uses. In either case the site, looking out over the Cañar valley, contains an impressive Temple of the Sun that boasts some of the Inca's finest mortarless stonework.

The air is foggy with a fine mist when we start out; by the end of the first hour there is a steady drizzle. How lucky we were to have had two sunny days. With visibility at near zero and no landmarks to guide us, Michael has to use his compass to keep us on a southerly route. He's pleased to be our navigator. Plodding behind the others and peering down from inside my slicker hood, I become intrigued with the small alpine plants that grow at ground level in this wetter region: gentians, valerians, madders, lupines, and violas, according to the guidebook. I dig out several to transplant to our patio, but I doubt they'll survive outside the rainy microclimate of the mountains.

The Inca road, an amazing twenty feet wide as it leaves Lake Culebrillas, soon dissolves into a mush of scattered stones and mud. Local people use the area around the lake to graze their cattle, and this part of the road has obviously been worn out by the sharp hooves of animals. Within a couple of hours we are in inhabited countryside, with fields, animals, and houses. Before long a chorus of howling dogs welcomes us to our first village. "What

is this place?" we yell over the racket to a group of kids standing outside their tiny school. "San Carlos!" they reply. *"¿Tienen caramelos?"* Do you have any candy?

At four o'clock Michael and I trudge down the last hill approaching Inga-pirca, very tired and, as usual, well behind the others. We round a corner to find our companions blissfully lying in the grass, having a good rest. The rain has stopped. No rest for Michael and me, however, as we need to push on to Ingapirca, which we can see about a mile ahead. We don't plan to stop here, as we know the place well. Our goal is to catch a bus to Cañar in the village beyond.

As we pass the entrance to the site, two tourist guides descend on us as though we had just dropped off the moon and quickly dispel the lingering high of our last three days. Their main concern seems to be that we might not pay the entrance fee to the complex. One, who wears an Indiana Jones fedora, speaks to Michael and me in halting English: "You are at the most important ruin in Ecuador. You must buy a ticket to go in."

"We won't be going in," I mutter in Spanish, irritated. He switches to Spanish: "I think you should put down your packs and rest and we will discuss it." No thanks, we say, and trudge on.

Although Michael had been talking for hours about "that first beer" in the village, a bus for Cañar sits at the ready right outside the entrance to the site, and we can't resist jumping on and going directly home. There, several beers wait in the fridge to aid us in deconstructing, reliving, and revising our incredible Inca Trail experience.

Saying Good-bye

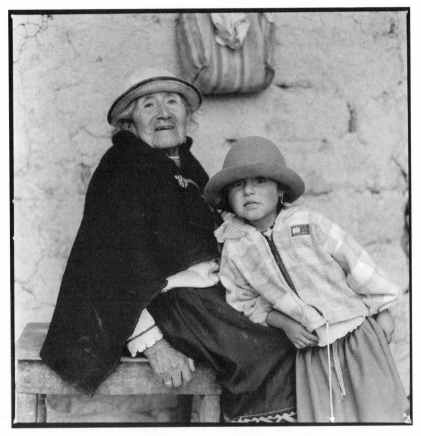

MAMA VICENTA WITH PACARI, OUR LAST DAY

OUR SECOND FAREWELL PARTY, on the Sunday night we left Cañar, wasn't
supposed to be a party at all. A week earlier we had been royally feted with
an all-day fiesta at Mariana's house, organized around the slow but complete
consumption of a medium-sized pig, starting with chitterlings in the after-
noon and ending with an open-air, sit-down dinner in the dark at around
nine. Like most Cañari social gatherings, the celebration included drinking,
dancing, a fight, tears, and the added novelty of Mariana padlocking her

gate to keep us inside until two thirty in the morning, when a hired truck appeared to take us all home. Everyone deemed the event a great success, although I suspect some were disappointed it had ended so early.

As one of my last tasks, I had planned to prepare a box of things to donate to the cultural foundation our Cañari friends created this year with our help. Along with a laptop computer and printer, I wanted to leave the inexpensive cameras and tape recorders I had used for my courses, photo and office supplies, posters, books, and so on. At one of our last Chaskis meetings, when I casually mentioned that I would simply leave these things stored in boxes, I was sternly informed by Puri, the secretary, that we must have a legally documented presentation of donated goods, called an *acto de entrega*, along with the proper paperwork: an official list of all the items and signatures of the foundation's officers.

To follow protocol, Puri added, the *entrega* had to be done in person in front of the foundation's fifteen members. What's more, it was decided at that last meeting, we would hold the ceremony at six on the night of October 14, our final evening in Cañar. When I mentioned that Michael and I had to catch a bus to Cuenca that very night, José Miguel replied, "We'll just have a small drink or two, and then you'll be on your way." Of course, there is no such thing as "a small drink or two," but something had been put into motion over which we had no control. There was no way Michael and I could quietly sneak out of town.

We were touched by all this attention, but we had hoped to get our emotional farewells finished and have this final day free to attend to the details of leaving. We had a lot of furniture and goods to hand over to people who had bought but not paid, we had to finish packing our own things, and we had to clean the house and turn it over to our landlady, Nelly Cantos.

The day begins with a series of visits, some from close friends wanting to say one last good-bye, others from people we don't even know, like the young Cañari woman who stops by simply to say that she has always wanted to meet us and she's sorry we are leaving and, by the way, could Michael help her with an English lesson? Michael actually stops what he is doing and helps her for an hour.

The first visitor, early in the morning, is our old friend Taita Isidoro, still in deep mourning for his daughter Juliana, who died ten months ago now. After Michael serves *canelazo*, Taita Isidoro half-jokingly calls us *ingratos*, ingrates, for not having visited him more this year. Then, with tears in his eyes, he repeats several times like an incantation: "Will we ever see one another again?"

"Certainly we will," Michael says cheerfully, pouring another glass of *canelazo*. "There'll be a next time."

"Only if God wills it and we're still alive," Taita Isidoro answers morosely, shooting down the drink.

As a parting gift, Michael presents him with a machete from the pile of odds and ends we planned to sell or give away today. Holding it like a sacred sword, Taita Isidoro says, "I'm never going to use this machete; I'll keep it as a memento to remind me of you, Mikito . . . along with some other things," he adds. He is referring to the electric razor that, years ago, he had asked Michael to give him for his few whiskers. After one more drink and a few more tears (he's the most sentimental Cañari we know), he leaves, but not before saying he might come back later in the day for another farewell. None of us want to say the definitive goodbye.

Around midday I walk down to the cluster of houses where the various Chuma families live to say good-bye to Mama Vicenta. I had sent a message that I was coming, and she is waiting for me in the doorway of her falling-down adobe.

"Sit down and eat, the *cuy* is ready," she says. She hands me an enamel plate piled high with boiled potatoes and a roasted guinea pig. I am starving and the food looks delicious. As it happens, Mama Vicenta's *cuy* is the only roasted guinea pig I really like—it's always well seasoned and cooked to a crisp. I sit down on the low stool outside the door, in front of a tiny wooden table, and Mama Vicenta crouches in the doorway, her skirts wrapped around her.

"*¿Cuando seráaaaaaa la próxima vez?*" she asks, drawing the verb out on a high note for emphasis as only Cañaris do. When will the next time be? "You'll not be seeing me again," she adds mournfully, "I'm too old, no good, thrown away . . ." It's like Taita Isidoro's incantation.

It's true that Mama Vicenta has aged greatly in the year we've been here, and I do fear we might not see her again, but I say, "Next year, Mama Vicenta. Maybe I'll come back next year. You'll be here." (Sadly, I was wrong. We would not meet again, for Mama Vicenta died two months later.)

Just then Zoila, Mama Vicenta's granddaughter, comes up the small rise to the house with two of her children, Pacari and Rantin, our little godson. They scramble over me to get to the *cuy*, and together the three of us quickly finish it off, competing for the crispy parts. Pacari, the little five-year-old girl, goes for the tiny, clinched feet and the head. "Now I'm going to eat this EYE!" she says with relish. The little three-year-old, Rantin, chews on the lesser parts and the bones. I take some photographs and we videotape a

message for Benedicto, Zoila's husband. She proudly presents her handsome children to the camera so their father can see how they've grown.

As I am leaving, Mama Vicenta says, "I'll be up to see you later with a little something to send to my beloved Delfina." She is referring to her granddaughter, Mama Michi's oldest girl, who left Cañar more than a year ago to join her husband in the United States. "We can't take much," I say, "just letters." That is cruel, I think as I leave—Mama Vicenta is illiterate. Nonetheless, I know she will pay no attention to my admonition.

I walk on down the hill to look for Paiwa. I discovered this week that Esthela and José Miguel have not mentioned to her that we are leaving. We've had a couple of talks to prepare her in the last few days, and I think she's grasped the idea that when she passes by our house on Monday on her way home from school, it will be empty and we'll be gone. "Marca Mama and Marca Taita are going to the United States," she reported to her mother after one of these talks, "and they'll be crying." A good enough interpretation from all points of view, I think.

The ancient wooden doors to the family compound where Paiwa lives are padlocked. I walk back into town in the brilliant sun, trying to visually record the beauty of the countryside in my memory so I can recall it at will: the newly harvested fields, the adobe houses, the people in their bright Sunday clothes coming home from market. *Cuando seraáaaaaaaa la próxima vez?* I can hear Mama Vicenta asking. When will I ever see this place again?

Back at the house, there is a steady stream of visitors. People stop by for the things they have bought earlier in the week or for last-minute favors and farewells—Jacinto to pick up a translation of some songs Michael and I worked on, Antonia for the letter she insisted I write inviting her to the United States, Benedicto's father to drop off a letter to take to his son. I try to be patient with everyone, but I'm worried that the day is speeding by too fast. Michael, cleaning the kitchen between visitors, seems relaxed and cheerful enough, given that he hasn't done his personal packing. But then, he always leaves it to the last moment.

Late in the afternoon the three young scholarship women appear. Manuela, Mariana, and Alexandra are studying at the University of Cuenca with scholarships from an education fund I established eight years ago in memory of Ana Margarita Gasteazoro, a good friend from El Salvador who died too young of breast cancer. In recent years, all contributions from family and friends have gone to support Cañari women's education. The three women are impeccably dressed and groomed; they are treating this as a special occasion. We sit at one of the remaining tables and make small talk. From their giggles and secretive glances, I guess they have brought me a gift.

In fact, I suspect that the gift is a *pollera*, a traditional Cañari skirt, and I am right. After a short speech of thanks for the scholarships that are allowing them to continue their educations, Manuela pulls out a new, black, pleated skirt, embroidered around the bottom and still damp from the ironing in of the pleats. I put it on, and the girls are delighted to see that it falls all the way to the floor. Fashions change, even in "traditional" clothing, and the latest in Cañari skirts is fine pleats and length. We all agree I look pretty good—a tall thin *gringa* in a long Cañari skirt. The girls want me to put on a Cañari hat for a photograph, but I refuse; I've already seen how foolish I look in them.

Mama Michi, Mama Vicenta, and Zoila appear with packages for their relatives. "Did you remember that we can't take anything but letters?" I remind them. "Oh yes," Mama Michi says, "but these are *remedios*," home remedies. She and Zoila pull out an amazing array of bottles, small parcels, dried herbs, and plastic packets of powders and potions. "What's all this for?" I ask in amazement. "Nerves, and other things," Mama Michi says gravely. "Now, this *medicina feminina* is for my daughter, Delfina, and the *medicina masculino* is for Benedicto. These herbs are medicinal teas, and . . ." She continues to pull out bottles and packets from the depths of her shawl.

After standing by helplessly for a few minutes, I come to my senses. "Okay, we can take this and that, and that, but not this!" I say, pointing around the table, eliminating the big bottles. "Two *feminina* packets and two *masculinos*, but no more! And we'll take the dried herbs." Mama Michi sighs, and begins to repack half the stuff she had brought from the shelves of her native clinic. Then Mama Vicenta steps forward and solemnly puts into my hands a two-pound packet of *máchaca*, a sort of barley meal that is roasted and eaten as a snack. To me, it tastes like fried cornstarch, but I know it will be a great treat for the Cañaris in the United States. I sigh and accept the package. We are definitely losing the battle, but how can I deny Mama Vicenta?

Suddenly, the street in front of the house seems full of people. Investigating, I see clusters of young men milling around and gathering in clumps, talking excitedly. Some have obviously been drinking. I recognize a few men from the Chaskis, those, in fact, who had promised to be here at six for the *entrega*. It is now about seven. And here are Manuela, Mariana, Esthela, and Paiwa sitting on the curb, watching.

"What's going on? Why is everyone drinking in the street?" I turn to Zoila, who stands beside me. "Because you are going away," she says with a mischievous grin. "They're sad." Obviously, this does not make much sense, but I am too busy to think about it. Just then, someone arrives for the last

two tables and our chairs. Mama Michi and Mama Vicenta move to the floor and sit with their backs against the wall. Nelly, our landlady, is suddenly there too, along with her mother, Mercedes, and her father-in-law, Don Diego. Her husband Victor is out front with his truck, picking up a bit of business by hauling away furniture. In the course of the evening, through snatches of conversation with Nelly, I learn that she is pregnant with her second child and that Victor is planning to go back to New York as soon as the baby is born. After ten years working a good job in construction in New York, she says, he can't get accustomed to the slow pace and low wages of Cañar. (I assume that Nelly and her family have simply come to say good-bye, but later, after they stay around until the end of the evening and follow us out the door, I understand that they have come to take possession of the house.)

In the meantime, Don Diego patrols the rooms and asks if he can have things that it appears we are going to leave. "How about that plastic pitcher of milk?" he asks. This is annoying enough, but then I notice a couple of boys I have never seen before milling from room to room, asking if they can have this and that.

It is way beyond time for the *entrega* ceremony, and I am worried about the time. I need to finish cleaning and packing my own things. Most of the Chaskis men and women are here, but we are still waiting for the president, Félix Chuma. Where is Félix? Earlier Michael saw him in the street, drinking with the crowd. When Michael went to give him a going-away present and a hug, Félix sobbed uncontrollably and collapsed to the ground. Now he is passed out, propped up against the fence in front of the house. Everyone has long been concerned about Félix's drinking, but there is nothing to do now but go ahead with the ceremony without him.

Just as I step out into the street to look for the missing members of our group, a scuffle breaks out across the intersection. "What *is* going on?" I ask José Miguel.

"Our soccer team won the league championship this afternoon!" he says ebulliently. "First time ever! Want a drink?" Finally, all the drinking and milling about and excitement make sense. A soccer victory is a serious thing in this part of the world. The Cañar team, which includes several Chaskis, beat a team from a larger, better-known town. We had been so busy getting ready to leave that we hadn't even noticed that the tournament was happening.

Finally, around eight thirty, José Miguel and the other men drift into the house, along with a few complete strangers who stand swaying on the sidelines, holding bottles of Zhumir. I try to move things along by placing

a cardboard box in the middle of the room. "Okay," I say, reaching into the pile of donations I have arranged on the built-in bar, the only piece of furniture left in the room. "Here's a stapler and a box of staples." I hold up the items for all to see. Puri the secretary solemnly ticks them off a list I had made up earlier and puts them in the cardboard box. Posters, books, scissors, cameras, tape recorders . . . I hold up every item so the group can see, and it is duly checked off the list and carefully stashed away in the box. I point to the laptop computer and printer on the floor. Earlier, we had a discussion about who would be responsible for the computer and printer, obviously the most expensive items. Puri offered to keep them at her house, and we all agreed that as the foundation secretary, she was the appropriate caretaker.

The excessive formality regarding donations is a result of the problem of stealing and graft that affects many groups, organizations, and government agencies in Ecuador (and everywhere else in Latin America). I've heard the refrain all year: "We *used* to have a camera, but it disappeared," or, "We *had* a collection of photos, but they seem to be gone now," or, "The video camera just vanished." So, on this occasion, I'm patient with the process.

Box closed, document signed. Now for the speeches. José Miguel, swaying slightly but very serious, speaks first. Looking directly at Michael and me, he says that although we are leaving Cañar, we are Chaskis forever, and we should never forget it. He hopes we will continue to support the foundation from the United States and look for funding. Finally, he concludes, changing tone with a beaming smile, he must insist that we carry these two bottles of Zhumir to his sister and brothers-in-law in the United States. He holds two half-gallon jugs of Zhumir over his head, and everyone claps. I contemplate again the spiritual significance this alcohol seems to have for the Cañaris. Michael responds with a nice speech saying what an honor it has been to be included in the lives of our Cañar friends this year, concluding with, "And I'll be proud to take the Zhumir." Everyone cheers; I groan inwardly, imagining how difficult it will be to travel with a gallon of Zhumir. (The bottles were not destined to arrive, though Michael certainly tried. After passing through numerous security searches at the Quito airport, the bottles were confiscated during our final check-in at the gate.)

Mama Michi speaks next, reminding Michael and me that we are now family—godparents to her grandson, Rantin, and granddaughter, Paiwa. Therefore the link between those in Cañar and those in Portland is even closer. Then Mariana, always sentimental, speaks in a quavering voice about how important our presence has been to the creation of the Chaskis Foundation this year, and how they will struggle to keep it going without us and

without our house as the meeting place. I made a speech too, but I don't remember what I said. I only recall steeling myself not to be emotional and thinking that I had to stay focused on getting us out of here tonight.

Drinks are served all around, with the uninvited soccer celebrants in our midst getting more looped by the minute. The last items sold are carried away, and other people from the street begin to drift in and mill around the rooms. It's definitely time to get everyone moving, I think as I go into the bedroom to pack my last things. While I am finishing up, the three scholarship women—Mariana, Manuela, and Alexandra—come in separately to give a formal thank you and farewell hug. "I couldn't speak out there in front of everyone in case I cried," each one says. I am reminded of our first Chaskis meeting earlier in the year, when the women wept while describing their lives and I realized how tenderhearted and passionate the Cañari are beneath a public facade that shows little emotion.

I take off my still-damp new skirt, pack it, and put on jeans and a sweater while Michael finishes packing in the other room. Zip up the bags and drag them to the front door. Then, using gentle crowd management, Michael and I slowly sweep friends and strangers from the bedrooms, hall, kitchen, eating area, and *sala*. All the while the celebration continues, with laughter and jokes and bottles passing from hand to hand. Behind us are Nelly and her mother and father-in-law, enjoying the spectacle and seeming in no hurry to receive the keys. Even Victor has reappeared; he also seems in a celebratory mood. At one point he stops us to say that if we ever come back to Cañar, we have to consider living with his family. "Even here, in this house," he says emphatically. "If we are living here, you must live with us!"

The crowd slowly bulges out the front door and into the patio space between the house and gate. We urge folks to keep moving until, finally, we are all in the street. Michael clangs the wrought iron gate shut one last time, locks it with the padlock, and hands the keys to Nelly.

With Mama Michi and the three scholarship women, who insist on carrying our bags, we slowly make our way through the celebrating crowd in the street, saying a final good-bye to those we recognize. Most are now oblivious to our departure. We walk down the Paseo de los Cañaris for the last time, toward the Pan-American.

"Don't go tonight," Mama Michi says suddenly in her shrill, commanding voice. "There'll be no buses! Come down and sleep at my house."

"Oh, thanks for the offer," I say, "but let's see if a bus doesn't come." I sound casual but I fear to think of all it would mean to stay over: dragging our luggage down to Mama Michi's compound, more drinking, sleeping on the floor, and tomorrow the boundless Cañari generosity that would require

another farewell meal. I am exhausted, physically and emotionally, and can only think of moving ahead. As we reach the Pan-American, I pray for a bus. It is about nine thirty by now, late for the local buses, but those from Quito and Guayaquil still pass by.

Our little group stands huddled in the darkness on the two-lane highway that runs most of the length of South America. Mama Michi, who has celebrated liberally today, is joking in Quichua and the girls are laughing and talkative. Michael too is enjoying this sweet moment.

I stand facing north, staring at the curve in the road where I would first see the headlights of a bus. Although this moment marks the end of our extraordinary year in Cañar, I cannot allow myself to feel anything. Right now I must keep focused on getting us to Cuenca tonight, to Quito in a day or two, and back to Portland within the week. At the moment it all seems impossible.

There! A bus! Michael steps into the dark roadway and waves frantically. The bus stops. The driver's helper jumps out and opens the luggage compartment; everyone helps stow our things. Michael and I scramble on and find seats on the right side, where we can look out the window to see Alexandra, Mariana, Manuela, and Mama Michi lined up in the dim light of the roadside, smiling broadly and slowly waving good-bye. Although they cannot see us, we wave back.